World Musical Instruments

Musikinstrumente der Welt · Instruments de musique du monde
Instrumentos musicais do mundo · Instrumentos musicales del mundo
Strumenti musicali del mondo · Музыкальные инструменты мира · 世界の楽器

Maria da Gandra *&* Maaike van Neck

THE PEPIN PRESS | AGILE RABBIT EDITIONS

AMSTERDAM · SINGAPORE

For permission to use images in this book and CD-ROM, please contact the publishers. Unauthorized use will be subject to legal proceedings, and the charging of all costs involved and a penalty.

The Pepin Press BV
P.O. Box 10349
1001 EH Amsterdam
The Netherlands

T +31 20 420 20 21
F +31 20 420 11 52
mail@pepinpress.com
www.pepinpress.com

Series Editor Pepin van Roojen
Editorial Co-ordinator Kevin Haworth

Concept, Images Maria da Gandra & Maaike van Neck
Design Mwmcreative ltd
Cover Design Mwmcreative ltd
www.mwmcreative.co.uk

ISBN 978-90-5768-116-5

Every effort has been made to ensure that all information in this book is accurate. However, due to historical ambiguities inherent to the subject matter, the Authors are not in the position to guarantee, with absolute certainty, the historical information provided.

Manufactured in Singapore

The authors would like to thank

Andrew Haslam *England*
Bart Hopkin *USA*
Ben Neill *USA*
Brian Ransom *USA*
Dann Skutt *USA*
Ferdinand Försch *Germany*
Greta Friggens *England*
Harvey Starr *USA*
Historisches Museum Basel *Switzerland*
Jim Doble *USA*
John Gzowski *USA*
Keith Spears *USA*
Ken Butler *USA*
Korg *Japan*
Kunsthistorisches Museum Wien *Austria*
Mark Hauenstein & Tom Jenkins *England*
The Metropolitan Museum of Art *USA*
Moog Music *USA*
Museu da Música *Portugal*
Museum of Fine Arts Boston *USA*
Nationaal Museum van Speelklok tot Pierement *The Netherlands*
National Music Museum *USA*
Noack Organ Company *USA*
The Nydahl Collection *Sweden*
Richard Cooke *USA*
Susan Rawcliffe *USA*
Tim Putnam *England*
University of Portsmouth *England*
Victor Gama *Portugal*

Family van Neck *The Netherlands/ Oman*
Amélia Duarte de Almeida *Portugal*
Manuel J. Gandra *Portugal*
David Lobina *England*
Miguel Almeida *England*
Peppi Stunkel *Finland*
Vinca Kruk *The Netherlands*
Jodie Silsby *England*

Contents

Maria da Gandra was born in Portugal in 1980. She came to England in 1998 and is currently principal artistic director at Mwmcreative and associate lecturer at Central Saint Martins.

Maaike van Neck was born in Oman in 1981. She came to England in 1998 and is currently principal artistic director at Mwmcreative and senior lecturer at the University of Portsmouth.

Maria and Maaike met at Central Saint Martins, London in 2002 where they were both studying for a Master in Communication Design. In 2004 they founded their own studio under the name Mwmcreative. Original and multi-disciplinary, the studio has a rich output of both print and screen-related projects. Mwmcreative has been featured in various magazines and publications such as *Eye Magazine*, *Creative Review*, *Grafik*, *Tres Logos* and *Logology*.

Maria da Gandra est née au Portugal en 1980. Elle s'est rendue en Angleterre en 1998 et est actuellement directrice artistique principale de Mwmcreative et Maîtresse de conférences adjointe au collège Central Saint Martins.

Maaike Van Neck est née en Oman en 1981. Elle s'est rendue en Angleterre en 1998 et est actuellement directrice artistique principale de Mwmcreative et Maîtresse de conférences à l'université de Portsmouth.

Maria et Maaike se sont rencontrées à Londres, au collège Central Saint Martins, en 2002 où elles étudiaient toutes deux le programme de maîtrise en design des communications. En 2004, elles fondent leur propre studio sous le nom de Mwmcreative. Original et multidisciplinaire, le studio réalise de nombreux projets tant pour la publication que pour l'écran. Mwmcreative est apparu dans divers magazines et publications comme *Eye Magazine*, *Creative Review*, *Grafik*, *Tres Logos* et *Logology*.

Maria da Gandra wurde 1980 in Portugal geboren. Sie kam 1998 nach England und arbeitet zurzeit als Leitende Art-Direktorin bei Mwmcreative sowie als Außerordentliche Dozentin am Central Saint Martins College in London.

Maaike van Neck 1981 wurde in Oman geboren. Sie kam 1998 nach England und arbeitet zurzeit als Leitende Art-Direktorin bei Mwmcreative sowie als Dozentin an der University of Portsmouth.

Maria und Maaike lernten sich 2002 am Central Saint Martins College in London kennen, wo beide einen Masterstudiengang in Kommunikationsdesign absolvierten. 2004 gründeten sie ihr eigenes Studio unter dem Namen Mwmcreative. Dieses originelle und multidisziplinäre Studio hat bereits eine Vielzahl an Projekten für Printmedien und den Film-, Foto- und Videobereich herausgebracht. Mwmcreative wurde ausführlich in verschiedenen Magazinen und Publikationen vorgestellt, darunter *Eye Magazine*, *Creative Review*, *Grafik*, *Tres Logos* und *Logology*.

Maria da Gandra nasceu em Portugal em 1980. Foi para Inglaterra em 1998 e é actualmente directora artística principal da Mwmcreative e assistente estagiária na Escola Superior Central Saint Martins.

Maaike van Neck nasceu em Omã em 1981. Foi para Inglaterra em 1998 e é actualmente directora artística principal da Mwmcreative e assistente na Universidade de Portsmouth.

Maria e Maaike encontraram-se na Central Saint Martins, em Londres, em 2002, onde frequentavam ambas o curso de Mestrado em Design de Comunicação. Em 2004, fundaram o seu próprio estúdio a que chamaram Mwmcreative. Original e multidisciplinar, o estúdio produz uma quantidade significativa de trabalhos, quer na forma de objectos impressos quer na forma de imagem. O estúdio Mwmcreative tem surgido em várias revistas e publicações como a *Eye Magazine*, *Creative Review*, *Grafik*, *Tres Logos* e *Logology*.

Sobre las autoras

Maria da Gandra nació en Portugal en 1980. Afincada en el Reino Unido desde 1998, actualmente es directora de arte de Mwmcreative y profesora adjunta en la Central Saint Martins College of Art and Design.

Maaike van Neck nació en Omán en 1981. Afincada en el Reino Unido desde 1998, actualmente es directora de arte de Mwmcreative y profesora titular en la Universidad de Portsmouth.

Maria y Maaike se conocieron en la Central Saint Martins College of Art and Design de Londres en 2002, donde ambas realizaban un máster de diseño aplicado a la comunicación. En 2004, fundaron su propio estudio, al que bautizaron como Mwmcreative. Original y multidisciplinar, el estudio cuenta en su haber numerosos proyectos impresos y digitales. Sus trabajos se han publicado en revistas y libros como *Eye Magazine*, *Creative Review*, *Grafik*, *Tres Logos* y *Logology*.

Об авторах

Мария да Гранда, уроженка Португалии 1980 года. Приехала в Англию в 1998 году и является на данный момент художественным руководителем студии Mwmcreative, а также младшим доцентом лондонского университета искусств.

Маайке ван Некк, уроженка Омана 1981 года. Переехала в 1998 году и в настоящее время является художественным руководителем студии Mwmcreative, а также старшим доцентом университета в Портсмуте.

Мария и Маайке познакомились в лондонском колледже Central Saint Martins, где они в магистратуре обучались графическому дизайну. В 2004 году они основали свою собственную студию под названием Mwmcreative. Будучи междисциплинарной и самобытной, студия выпускает разнообразные проекты, как в области печати, так и на экран. Деятельность Mwmcreative неоднократно освещалась в периодической прессе, как например, в журналах Eye Magazine, Creative Review, Grafik, Tres Logos и Logology.

Gli autori

Maria da Gandra nasce in Portogallo nel 1980 e si stabilisce in Inghilterra nel 1998. Attualmente è direttrice artistica principale di Mwmcreative e lecturer associata presso il Central Saint Martins.

Maaike van Neck nasce in Oman nel 1981 e si stabilisce in Inghilterra nel 1998. Attualmente è direttrice artistica principale di Mwmcreative e senior lecturer all'Università di Portsmouth.

Maria e Maaike si incontrano nel 2002 a Londra, al Central Saint Martins, dove seguono il Master in Design della Comunicazione. Nel 2004 fondano Mwmcreative, uno studio originale e multidisciplinare molto attivo nel campo di progetti riguardanti la stampa e il mondo digitale. Mwmcreative è comparso su diverse riviste e pubblicazioni come *Eye Magazine*, *Creative Review*, *Grafik*, *Tres Logos* e *Logology*.

著者略歴

マリア・ダ・ガンドラ（Maria da Gandra）
1980年ポルトガル生まれ。1998年渡英。現在、Mwmcreative社の主要アート・ディレクター。セントラル・セント・マーティンズ・カレッジ・オブ・アート・アンド・デザインの准講師も務める。

マーイク・ヴァン・ネック（Maaike van Neck）
1981年オマーン生まれ。1998年に渡英。現在、Mwmcreative社の主要アート・ディレクター。ポーツマス大学の講師も務める。

ふたりは、2002年、ロンドンのセントラル・セント・マーティンズ芸術デザイン大学のコミュニケーション・デザイン科の修士課程で学んでいたときに出会い、2004年にMwmcreative社を設立。様々な分野のプロジェクトを扱う同社は、印刷媒体及びウェブ媒体で、オリジナルかつユニークな作品を制作。"Eye Magazine" "Creative Review" "Grafik" "Tres Logos" "Logology"など様々な雑誌で紹介されている。

CD-ROM and Images Rights

The images in this book can be used as a graphic resource and for inspiration. All the illustrations are stored on the enclosed CD-ROM and are ready to use for printed media and web page design. The pictures can also be used to produce postcards, either on paper or digitally, or to decorate your letters, flyers, T-shirts, etc. They can be imported directly from the CD into most software programs. Some programs will allow you to access the images directly; in others, you will first have to create a document, and then import the images. Please consult your software manual for instructions.

The names of the files on the CD-ROM correspond with the page numbers in this book. The CD-ROM comes free with this book, but is not for sale separately. The files on Pepin Press/Agile Rabbit CD-ROMs are sufficiently large for most applications. However, larger and/or vectorised files are available for most images and can be ordered from The Pepin Press/Agile Rabbit Editions.

For non-professional applications, single images can be used free of charge. The images cannot be used for any type of commercial or otherwise professional application – including all types of printed or digital publications – without prior permission from The Pepin Press/Agile Rabbit Editions. Our permissions policy is very reasonable and fees charged, if any, tend to be minimal.

For inquiries about permissions and fees, please contact:
mail@pepinpress.com
Fax +31 20 4201152

CD-ROM und Bildrechte

Dieses Buch enthält Bilder, die als Ausgangsmaterial für grafische Zwecke oder als Anregung genutzt werden können. Alle Abbildungen sind auf der beiliegenden CD-ROM gespeichert und lassen sich direkt zum Drucken oder zur Gestaltung von Webseiten einsetzen. Sie können die Designs aber auch als Motive für Postkarten (auf Karton bzw. in digitaler Form) oder als Ornament für Ihre Briefe, Broschüren, T-Shirts usw. verwenden. Die Bilder lassen sich direkt von der CD in die meisten Softwareprogramme übernehmen. Bei einigen Programmen lassen sich die Grafiken direkt einladen, bei anderen müssen Sie zuerst ein Dokument anlegen und können dann die jeweilige Abbildung importieren. Genauere Hinweise dazu finden Sie im Handbuch Ihrer Software.

Die Namen der Bilddateien auf der CD-ROM entsprechen den Seitenzahlen in diesem Buch. Die CD-ROM wird kostenlos mit dem Buch geliefert und ist nicht separat verkäuflich. Alle Bilddateien auf den CD-ROMs von The Pepin Press/Agile Rabbit wurden so groß dimensioniert, dass sie für die meisten Applikationen ausreichen; zusätzlich können jedoch größere Dateien und/oder Vektorgrafiken der meisten Bilder bei The Pepin Press/Agile Rabbit Editions bestellt werden.

Einzelbilder dürfen für nicht-professionelle Anwendungen kostenlos genutzt werden; dagegen muss für die Nutzung der Bilder in kommerziellen oder sonstigen professionellen Anwendungen (einschließlich aller Arten von gedruckten oder digitalen Medien) unbedingt die vorherige Genehmigung von The Pepin Press/Agile Rabbit Editions eingeholt werden. Allerdings handhaben wir die Erteilung solcher Genehmigungen meistens recht großzügig und erheben – wenn überhaupt – nur geringe Gebühren.

Für Fragen zu Genehmigungen und Preisen wenden Sie sich bitte an:
mail@pepinpress.com
Fax +31 20 4201152

CD-ROM et droits d'auteur

Les images contenues dans ce livre peuvent servir de ressources graphiques ou de source d'inspiration. Toutes les illustrations sont stockées sur le CD-ROM ci-joint et sont prêtes à l'emploi sur tout support imprimé ou pour la conception de site Web. Elles peuvent également être employées pour créer des cartes postales, en format papier ou numérique, ou pour décorer vos lettres, prospectus, T-shirts, etc. Ces images peuvent être importées directement du CD dans la plupart des logiciels. Certaines applications vous permettent d'accéder directement aux images, tandis que d'autres requièrent la création préalable d'un document pour pouvoir les importer. Veuillez vous référer au manuel de votre logiciel pour savoir comment procéder.

Les noms des fichiers du CD-ROM correspondent aux numéros de page de cet ouvrage. Le CD-ROM est fourni gratuitement avec ce livre, mais ne peut être vendu séparément. Les fichiers des CD-ROM de The Pepin Press/Agile Rabbit sont d'une taille suffisamment grande pour la plupart des applications. Cependant, des fichiers plus grands et/ou vectorisés sont disponibles pour la plupart des images et peuvent être commandés auprès des éditions The Pepin Press/Agile Rabbit.

Des images seules peuvent être utilisées gratuitement à des fins non professionnelles. Les images ne peuvent pas être employées à des fins commerciales ou professionnelles (y compris pour tout type de publication sur support numérique ou imprimé) sans l'autorisation préalable expresse des éditions The Pepin Press/Agile Rabbit. Notre politique d'autorisation d'auteur est très raisonnable et le montant des droits, le cas échéant, est généralement minime.

Pour en savoir plus sur les autorisations et les droits d'auteur, veuillez contacter :
mail@pepinpress.com
Fax +31 20 4201152

CD-ROM e direitos de imagem

As imagens neste livro podem ser usadas como recurso gráfico e fonte de inspiração. Todas as ilustrações estão guardadas no CD-ROM incluído e prontas a serem usadas em suportes de impressão e design de páginas web. As imagens também podem ser usadas para produzir postais, tanto em papel como digitalmente, ou para decorar cartas, brochuras, T-shirts e outros artigos. Podem ser importadas directamente do CD para a maioria dos programas de software. Alguns programas permitem aceder às imagens directamente, enquanto que noutros, terá de primeiro criar um documento para poder importar as imagens. Consulte o manual do software para obter instruções.

Os nomes dos ficheiros no CD-ROM correspondem aos números de páginas no livro. O CD-ROM é oferecido gratuitamente com o livro, mas não pode ser vendido separadamente. A dimensão dos ficheiros nos CD-ROMs da Pepin Press/Agile Rabbit é suficiente para a maioria das aplicações. Contudo, os ficheiros maiores e/ou vectorizados estão disponíveis para a maioria das imagens e podem ser encomendados junto da Pepin Press/Agile Rabbit Editions.

Podem ser usadas imagens individuais gratuitamente no caso de utilizações não profissionais. As imagens não podem ser usadas para qualquer tipo de utilização comercial ou profissional, incluindo todos os tipos de publicações digitais ou impressas, sem autorização prévia da Pepin Press/Agile Rabbit Editions. A nossa política de autorizações é muito razoável e as tarifas cobradas, caso isso se aplique, tendem a ser bastante reduzidas.

Para esclarecimentos sobre autorizações e tarifas, queira contactar:
mail@pepinpress.com
Fax +31 20 4201152

Este libro contiene imágenes que pueden servir como material gráfico o simplemente como inspiración. Todas las ilustraciones están incluidas en el CD-ROM adjunto y pueden utilizarse en medios impresos y diseño de páginas web. Las imágenes también pueden emplearse para crear postales, ya sea en papel o digitales, o para decorar sus cartas, folletos, camisetas, etc. Pueden importarse directamente desde el CD a diferentes tipos de programas. Algunas aplicaciones informáticas le permitirán acceder a las imágenes directamente, mientras que otras le obligarán a crear primero un documento y luego importarlas. Consulte el manual de software pertinente para obtener instrucciones al respecto.

Los nombres de los archivos contenidos en el CD-ROM se corresponden con los números de página del libro. El CD-ROM se suministra de forma gratuita con el libro. Queda prohibida su venta por separado. Los archivos incluidos en los discos CD-ROM de Pepin Press/Agile Rabbit tienen una resolución suficiente para su uso con la mayoría de aplicaciones. Sin embargo, si lo precisa, puede encargar archivos con mayor definición y/o vectorizados de la mayoría de las imágenes a The Pepin Press/Agile Rabbit Editions.

Para aplicaciones no profesionales, pueden emplearse imágenes sueltas sin coste alguno. Estas imágenes no pueden utilizarse para fines comerciales o profesionales (incluido cualquier tipo de publicación impresa o digital) sin la autorización previa de The Pepin Press/Agile Rabbit Editions. Nuestra política de permisos es razonable y las tarifas impuestas tienden a ser mínimas.

Para solicitar información sobre autorizaciones y tarifas, póngase en contacto con:
mail@pepinpress.com
Fax +31 20 4201152

Le immagini contenute in questo libro possono essere utilizzate come risorsa grafica e come ispirazione. Tutte le illustrazioni sono salvate sul CD-ROM incluso e sono pronte ad essere utilizzate per la stampa su qualsiasi tipo di supporto e per il design di pagine web. Le immagini possono anche essere utilizzate per produrre delle cartoline, in forma stampata o digitale, o per decorare le vostre lettere, volantini, magliette, eccetera. Possono essere direttamente importate dal CD nella maggior parte dei programmi software. Alcuni programmi vi permetteranno l'accesso diretto alle immagini; in altri, dovrete prima creare un documento, e poi importare le immagini. Vi preghiamo di consultare il manuale del vostro software per ulteriori istruzioni.

I nomi dei file sul CD-ROM corrispondono ai numeri di pagina indicati nel libro. Il CD-ROM viene fornito gratis con il libro, ma non è in vendita separatamente. I file sui CD-ROM della Pepin Press/Agile Rabbit sono di dimensione adatta per la maggior parte delle applicazioni. In ogni caso, per la maggior parte delle immagini sono disponibili file più grandi o vettoriali, che possono essere ordinati alla Pepin Press/Agile Rabbit Editions.

Delle singole immagini possono essere utilizzate senza costi aggiuntivi a fini non professionali. Le immagini non possono essere utilizzate per nessun tipo di applicazione commerciale o professionale – compresi tutti i tipi di pubblicazioni stampate e digitali – senza la previa autorizzazione della Pepin Press/Agile Rabbit Editions. La nostra gestione delle autorizzazioni è estremamente ragionevole e le tariffe addizionali applicate, qualora ricorrano, sono minime.

Per ulteriori domande riguardo le autorizzazioni e le tariffe, vi preghiamo di contattarci ai seguenti recapiti:
mail@pepinpress.com
Fax +31 20 4201152

World Musical Instruments

The most striking feature of this wonderful book is the overarching organisational principle. The musical instruments that appear here are arranged along a timeline, providing continuity from start to finish, from earliest to most recent. It is a simple, even obvious idea, but in no other book is this body of material presented in quite this way. With this approach, the book provides a perspective on the evolution of musical instruments that would otherwise not be apparent. But the book takes the idea a step further and invites the reader to see this field – the historical development of musical instruments – in a broader cultural perspective.

Although it is hard to date such things with confidence, it is clear that musical instruments were among the first of humankind's technological endeavours. Stone axes and spearheads stand out among our earliest surviving implements, but bone flutes appear remarkably early on. Those flutes may have been less necessary for survival than axes and spears, but they are arguably more sophisticated and a better indicator of the nascent potential for human artifice.

Moving ahead to the ancient classical world of over two thousand years ago we find that music was not only present, but was a key impetus in the first stirrings of what was to become scientific thought. This can be seen in the music of the spheres – the idea, articulated by Greek philosophers, that the movement of the heavenly bodies represents a divine celestial harmony, and that we might unlock its secrets by observation and mathematical analysis. If we also consider one of the very first recorded scientific experiments – Pythagoras' celebrated studies of the laws governing musical strings – it becomes apparent that instruments of music were among the very first scientific instruments as well, serving, in effect, as apparatus making possible the concept of controlled experiment.

We now move on again across another handful of centuries. It could be said that the architecture of the great Baroque cathedrals represents the greatest technological achievement of the era. But what about the magnificent organs that they housed? The physical scale is not the same, but when it comes to applied mathematics and technology, those organs are an equally impressive achievement.

Things are a little different today. It would perhaps be too much to claim that musical instruments represent the highest manifestations of contemporary technology. And yet a glance at some of the remarkable forms in the latter pages of this book will tell you that creativity in instrument design is as alive as ever.

The picture painted here is one of musical instruments seen not only as a particular field of endeavour, but one which, since the earliest times, has been a notable marker of human achievement and an indicator of human potential. Here, in *World Musical Instruments*, the sense of this is laid out for you, visually and iconically, across time.

It's quite a view. Enjoy it.

Bart Hopkin
Experimental Musical Instruments, California, USA

Introduction

This book is an extraordinary pictorial dictionary of musical instruments. Containing over 1500 drawings, its breadth of scope celebrates many different approaches to musical performance, craftsmanship and sound engineering throughout the world. Each instrument has been carefully selected to provide a balanced historical overview of musical development: aerophones, idiophones, membranophones, chordophones, mechanical and electrical instruments are all equally represented.

The oldest hand-made instruments illustrated date back over 50,000 years, while the newest are the product of a sophisticated machine and electronic age. There are many encyclopaedias of musical instruments but none makes such extensive use of detailed and scale pictorial presentation.

All of the drawings are original and have been created specifically for the publication by Maria da Gandra and Maaike van Neck. Each drawing is presented at a common of scale 1:16.3 making comparison between instruments a simple task and helping the reader to identify the instruments correctly. The drawings generally show an orthographic silhouette; in cases were the single viewpoint does not accurately describe the instrument, Maria and Maaike have developed simplified perspective drawings. The detail of features such as strings, frets and keys, together with characteristic decorative patterns, has been painstakingly drawn in white. Presenting these emblematic patterns accurately has been the driving force behind the designers' work, as these decorative embellishments reflect the culture from which the instruments derive and celebrate the craft skills and ingenuity of those who made them.

The drawings are organised into categories by type and are positioned relative to one another on a time line. In the index, instruments invented in a specific year are labelled accordingly; in cases where musical historians have not been able to attribute an exact year of invention, the date indicates the century.

World Musical Instruments will serve both as a source of information and as an object of fascination for: scholars, musicians, artists and designers. The accompanying CD-ROM with high-resolution jpeg illustrations of all the instruments provides the reader with an invaluable resource.

Andrew Haslam
Central Saint Martins College of Art and Design

Musikinstrumente der Welt

Das Verblüffendste an diesem Buch ist sein übergeordnetes Organisationsprinzip. Die einzelnen Musikinstrumente sind entlang einer Zeitachse angeordnet, wodurch eine Kontinuität entsteht, die von den Anfängen bis heute, vom allerersten zum allerneuesten Musikinstrument reicht. Eigentlich eine einfache, fast schon naheliegende Idee – doch bisher wurde noch in keinem anderen Buch zu diesem Thema der Inhalt so präsentiert. Dank dieses Ansatzes zeigt das Buch seinen Lesern die Entwicklung der Musikinstrumente aus einer Perspektive, die sich ihnen normalerweise nicht erschließen würde. Doch *Musikinstrumente der Welt* geht noch einen Schritt weiter: Es lädt die Leser ein, sein Themenfeld – die historische Entwicklung musikalischer Instrumente – in einer breiteren kulturellen Perspektive zu betrachten.

Obwohl sich genaue Datumsangaben nur schwer machen lassen, steht eindeutig fest, dass Musikinstrumente zu den ersten technischen Errungenschaften der Menschheit gehören. Natürlich sind Steinäxte und Speerspitzen die wichtigsten unserer frühen Überlebenshilfen, aber nur kurz danach entstanden bereits die ersten Knochenflöten – vielleicht nicht ganz so nötig für den Fortbestand der Menschheit wie Äxte und Speere, dorch vermutlich sehr viel komplizierter anzufertigen und damit ein besserer Indikator für das schlummernde Potenzial menschlicher Kunstfertigkeit.

In der klassischen Welt der Antike, also vor etwas über zweitausend Jahren, hatte sich die Musik nicht nur zum festen Bestandteil des menschlichen Lebens entwickelt, sondern war einer der Schlüsselfaktoren für die Anfänge dessen, was man heute als wissenschaftliches Denken bezeichnet. Dies äußerte sich in der Idee von der Musik der Sphären – eine von griechischen Philosophen entwickelte Vorstellung, nach der die Bewegung der Himmelskörper eine gottgegebene himmlische Harmonie repräsentierte, deren Geheimnisse sich durch genaue Beobachtung und mathematische Analyse enträtseln ließen. Wenn wir dazu auch noch eines der ersten dokumentierten wissenschaftlichen Experimente berücksichtigen – Pythagoras' berühmte Experimente mit unterschiedlich langen Saiten –, wird offensichtlich, dass Musikinstrumente nicht nur zu den ersten wissenschaftlichen Instrumenten überhaupt gehörten,

sondern letztlich auch als Auslöser dienten, die das Konzept eines kontrollierten wissenschaftlichen Experiments überhaupt erst möglich machten.

Begeben wir uns einige Jahrhunderte weiter in Richtung Neuzeit. Die Architektur der großen Barock-Kathedralen zählte zweifellos zu den größten technologischen Errungenschaften der damaligen Zeit. Doch was war mit den großartigen Orgeln, die sie beherbergten? Auch wenn die Größenverhältnisse sich nicht miteinander vergleichen lassen, so stellen diese Meisterwerke der Orgelbaukunst im Hinblick auf angewandte Mathematik und Technologie eine mindestens ebenso beeindruckende Leistung dar wie die Bauwerke, in denen sie erklangen.

In unserer Zeit liegen die Dinge ein wenig anders: Es wäre wahrscheinlich vermessen zu behaupten, dass die heutigen Musikinstrumente zu den höchsten Ausprägungen zeitgenössischer Technologie zählen. Und doch zeigt ein kurzer Blick auf einige der bemerkenswerten Formen im hinteren Teil dieses Buchs, dass die Kreativität im Instrumentendesign heute noch so lebendig und kraftvoll ist wie seit ewigen Zeiten.

Die Darstellung der Musikinstrumente in diesem Buch zeigt uns nicht nur einen kleinen Teilbereich des menschlichen Strebens, sondern beschreibt ein weites Feld, das seit Urzeiten ein bedeutendes Kennzeichen menschlicher Leistungen und ein Indikator für das Potenzial des Menschen gewesen ist. *Musikinstrumente der Welt* öffnet Ihnen dieses Feld – visuell, kulturell und über alle zeitlichen Grenzen hinweg.

Es ist ein toller Anblick – genießen Sie ihn.

Bart Hopkin
Experimental Musical Instruments, Kalifornien, USA

Dieser Band ist ein außergewöhnliches Bildlexikon der Musikinstrumente. Mit über 1500 Zeichnungen und einem breit gefächerten Ansatz ist er eine Hommage an die vielen unterschiedlichen Ausprägungen musikalischer Virtuosität, Handwerkskunst und Schalltechnik in aller Welt. Jedes einzelne Instrument wurde sorgsam ausgewählt, um einen ausgewogenen historischen Überblick der musikalischen Entwicklung zu gewährleisten. Egal ob Aerophone (Blasinstrumente), Idiophone (Selbstklinger), Membranophone (Fellklinger), Chordophone (Saiteninstrumente), mechanische oder elektrische Instrumente – alle Gruppen von Instrumenten haben in diesem Band ihren gleichberechtigten Platz.

Die ältesten von Menschenhand gefertigten Instrumente entstanden vor über 50.000 Jahren, während die neuesten Musikinstrumente Produkte eines hochentwickelten maschinellen und elektronischen Zeitalters sind. Natürlich gibt es inzwischen viele Enzyklopädien der Musikinstrumente, doch keines dieser Werke präsentiert seinen Inhalt in derart detaillierten und maßstabsgetreuen bildlichen Darstellungen wie dieser Band.

Sämtliche Zeichnungen sind Originale und wurden speziell für diese Publikation von Maria da Gandra und Maaike van Neck entworfen. Jede Zeichnung präsentiert ein Musikinstrument im Maßstab von 1:16,3 – was den Vergleich verschiedener Instrumente erleichtert und dem Leser die schnelle Identifikation einzelner Musikinstrumente ermöglicht. Dabei sind die Instrumente im Allgemeinen in Senkrechtdarstellung abgebildet, und in den Fällen, in denen ein einziger Blickwinkel nicht zur genauen Beschreibung des Instruments ausreichte, haben Maria and Maaike diese Darstellung um selbst entwickelte, vereinfachte Perspektivzeichnungen ergänzt. Einzelne Details wie Saiten, Bünde oder Tasten wurden ebenso wie charakteristische dekorative Muster mit größter Sorgfalt in Weiß gezeichnet. Gerade diese sorgfältige Präsentation emblematischer Muster war die treibende Kraft hinter der Arbeit der Designerinnen: Derartige dekorative Verzierungen sind kennzeichnend für die jeweilige Kultur, welche die jeweiligen Instrumente hervorgebracht hat, und sie spiegeln die Kunstfertigkeit und den Einfallsreichtum jener Männer und Frauen wider, in deren Händen sie entstanden.

Die Zeichnungen wurden in Kategorien eingeteilt und auf einer Zeitachse in relative Position zueinander gebracht. Im Register ist neben den jeweiligen Namen der Instrumente auch das Jahr ihrer Erfindung aufgeführt; in den Fällen, in denen die Musikhistoriker nicht in der Lage waren, das exakte Entstehungsjahr zu bestimmen, ist das Jahrhundert angegeben.

Musikinstrumente der Welt ist nicht nur ein umfangreiches Nachschlagewerk, sondern auch ein faszinierender Bildband für Schüler, Studenten, Musiker, Künstler und Designer. Die beiliegende CD-ROM mit hochauflösenden JPEG-Darstellungen aller im Buch abgebildeten Instrumente bietet dem Leser darüber hinaus unschätzbares Bildmaterial.

Andrew Haslam
Central Saint Martins College of Art and Design

Instruments de musique du monde

La caractéristique la plus saisissante de ce livre est son principe d'agencement global. Les instruments de musique présentés sont catalogués de manière chronologique, ce qui lui confère une continuité du début à la fin, du plus ancien au plus récent. Il s'agit d'une idée simple, voire évidente. Néanmoins, aucun autre livre auparavant n'avait réellement présenté cette documentation de cette façon. Grâce à cette approche, le livre offre une perspective sur l'évolution des instruments de musique qui, autrement, ne serait pas manifeste. Cet ouvrage va même encore plus loin en invitant le lecteur à voir ce domaine – le développement historique des instruments de musique – depuis une perspective culturelle plus large.

Bien qu'il soit difficile de dater de telles choses avec assurance, il est clair que les instruments de musique comptent parmi les premières tentatives technologiques de l'humanité. Les haches de pierre et les pointes de lance comptent parmi les plus anciens accessoires ayant permis notre survie, mais les flûtes d'os ont également fait leur apparition extrêmement tôt. Ces flûtes étaient assurément moins nécessaires à la survie de l'humanité que les haches et les lances. Cependant, elles étaient sans doute plus sophistiquées et constituent un meilleur indicateur du potentiel naissant du génie de l'homme.

Deux mille ans plus tard, dans le monde ancien à l'époque classique, on découvre que la musique était non seulement présente, mais qu'elle était la principale impulsion des débuts de ce qui allait devenir la pensée scientifique. On la retrouve dans la musique des sphères, l'idée, articulée par les philosophes grecs, que le mouvement des corps celestes représentait une harmonie divine et que l'on pouvait révéler ses secrets par l'observation et l'analyse mathématique. Si l'on considère également l'une des toutes premières expériences scientifiques documentées, les célèbres études de Pythagore des lois régissant les cordes musicales, il devient évident que les instruments de musique se trouvaient également parmi les tout premiers outils scientifiques, servant en réalité d'appareil rendant possible le concept d'expérience contrôlée.

Traversons encore quelques siècles. L'architecture des grandes cathédrales baroques pourraient être considérée comme le plus grand exploit technologique de l'époque. Mais alors, que dire des magnifiques orgues qu'elles abritaient ? Certes, l'échelle physique n'est pas la même, mais s'il est question de mathématiques appliquées et de technologie, ces orgues représentent un exploit tout aussi impressionnant.

La situation est quelque peu différente aujourd'hui. Il serait légèrement exagéré d'affirmer que les instruments de musique représentent la plus haute manifestation de la technologie contemporaine. Toutefois, un coup d'œil sur les formes remarquables des dernières pages de ce livre vous démontrera que la créativité dans la conception d'instruments est tout aussi vivante aujourd'hui.

Le tableau dépeint ici décrit les instruments de musique non seulement en tant que domaine d'activité particulier, mais un domaine qui, depuis la nuit des temps, a été le baromètre du dynamisme de l'homme et un indicateur du potentiel humain. Dans *Instruments de musique du monde*, cette notion vous est présentée de manière visuelle et iconique à travers le temps.

C'est un magnifique panorama. Profitez-en.

Bart Hopkin
Instruments de musique expérimentaux, Californie, États-Unis

Ce livre constitue un magnifique dictionnaire illustré des instruments de musique. Contenant plus de 1500 illustrations, son ampleur aborde un grand nombre d'approches différentes de l'activité musicale, du savoir-faire de l'artisan et des techniques sonores à travers le monde. Chaque instrument a été soigneusement sélectionné pour offrir un aperçu historique équilibré du développement de la musique: les aérophones, les idiophones, les membranophones, les cordophones, les instruments mécaniques et électriques y sont représentés de manière égale.

Les plus anciens instruments fabriqués à la main qui y sont illustrés ont plus de 50 000 ans d'âge, alors que les plus récents sont le produit de machines sophistiquées et de l'ère électronique. Il existe de nombreuses encyclopédies des instruments de musique, mais aucune n'utilise aussi généreusement des présentations picturales détaillées et à l'échelle.

Toutes les illustrations sont originales et ont été créées spécialement pour cette publication par Maria da Gandra et Maaike Van Neck. Chaque dessin est présenté à l'échelle 1:16,3, ce qui rend facile la comparaison entre instruments et aide le lecteur à les identifier correctement. Les dessins montrent généralement une silhouette orthographique. Au cas où une seule perspective ne représenterait pas exactement l'instrument, Maria et Maaike ont conçu des dessins de perspective simplifiés. Les détails de caractéristiques comme les cordes, les frets et les touches, ainsi que les motifs décoratifs distinctifs ont été minutieusement dessinés en blanc. La fidélité de la représentation de ces motifs distinctifs a été la préoccupation principale des designers, car ces ornements décoratifs reflètent la culture qui a produit ces instruments et met en évidence les qualités artisanales et l'ingéniosité de ceux qui les ont fabriqués.

Les dessins sont groupés en catégories et par type et sont situés chronologiquement les uns par rapport aux autres. Dans l'index, les instruments inventés au cours d'une année spécifique sont renseignés à cette année. Pour les cas où les historiens n'ont pas pu déterminer avec précision l'année d'invention, la date précise le siècle.

L'ouvrage **Instruments de musique du monde** peut représenter à la fois une source d'information et un objet de fascination pour universitaires, musiciens, artistes et concepteurs. Le CD-Rom d'accompagnement contenant des illustrations JPEG de haute définition constitue une ressource inestimable pour le lecteur.

Andrew Haslam
Collège d'art et de design Central Saint Martins

Instrumentos musicais do mundo

A característica mais notável deste livro maravilhoso é o seu princípio organizativo abrangente. Os instrumentos musicais aqui representados estão ordenados cronologicamente, oferecendo uma continuidade desde o início até ao fim, do mais antigo ao mais recente. É uma ideia simples, mesmo óbvia, mas não existe outro livro em que uma colecção de material desta natureza seja assim apresentada. Com esta abordagem, o livro oferece uma perspectiva sobre a evolução dos instrumentos musicais que, a assim não ser, não seria óbvia. Mas o livro desenvolve um pouco mais esta ideia e convida o leitor a olhar para este campo – o aperfeiçoamento histórico dos instrumentos musicais – com uma perspectiva cultural mais vasta.

Embora seja difícil datar este tipo de coisas com segurança, é claro que os instrumentos musicais se encontram entre os primeiros esforços tecnológicos da humanidade. Machados de pedra e lanças destacam-se entre os nossos instrumentos de sobrevivência mais antigos, mas as flautas de osso surgem também espantosamente cedo. Estas flautas poderão ter sido menos necessárias para a sobrevivência do que os machados e as lanças, mas são possivelmente mais sofisticadas e um melhor indicador do promissor potencial do artifício humano.

Prosseguindo para a antiguidade clássica de há mais de dois mil anos, descobrimos que a música não só estava presente como era a força motriz subjacente aos primeiros movimentos daquilo que se viria a tornar o pensamento científico. Isto pode observar-se na música das esferas – a ideia, expressa pelos filósofos gregos, de que o movimento dos corpos celestes representa uma harmonia celestial divina e que podemos descobrir os seus segredos através da observação e da análise matemática. Se considerarmos também uma das primeiras experiências científicas registadas – os famosos estudos de Pitágoras das leis que governam as cordas musicais – torna-se evidente que os instrumentos musicais também se encontravam entre os primeiros instrumentos científicos, servindo, com efeito, de aparelho para possibilitar o conceito de experiência controlada.

Avançamos agora, uma vez mais, através de outra mão cheia de séculos. Poder-se-ia dizer que a arquitectura das grandes catedrais barrocas representa a maior realização tecnológica da época. Mas, e então os magníficos órgãos que abrigavam? A escala física não é a mesma, mas quando se trata de matemática aplicada e tecnologia, aqueles órgãos são uma realização igualmente impressionante.

As coisas são ligeiramente diferentes hoje em dia. Seria talvez excessivo afirmar que os instrumentos musicais representam as mais elevadas manifestações da tecnologia contemporânea. No entanto, um olhar sobre algumas das formas notáveis presentes nas últimas páginas deste livro irão revelar que a criatividade na concepção de instrumentos está mais viva do que nunca.

A imagem aqui reproduzida é de instrumentos musicais, vistos não só como um campo de realização particular, mas um campo que, desde as épocas mais remotas, tem sido um símbolo notável da realização humana e um indicador do potencial humano. Em *Instrumentos musicais do mundo*, esta noção é apresentada, visual e expressivamente, através dos tempos.

É uma visão extraordinária. Apreciem-na.

Bart Hopkin
Experimental Musical Instruments, Califórnia, EUA

Este livro é um extraordinário dicionário ilustrado de instru-
mentos musicais. Contendo mais de 1.500 desenhos, o seu vasto
âmbito celebra muitas abordagens diferentes à execução musical,
capacidade artística e engenharia de som em todo o mundo. Cada
instrumento foi cuidadosamente escolhido para oferecer uma visão
histórica geral do desenvolvimento musical: aerofones, idiofones,
membranofones, cordofones, instrumentos mecânicos e eléctricos
todos estão igualmente representados.

Os instrumentos feitos à mão mais antigos aqui descritos têm
mais de 50.000 anos, ao passo que os mais recentes são o resultado
da sofisticada época da máquina e da electrónica. Existem muitas
enciclopédias de instrumentos musicais, mas nenhuma utiliza
tão exaustivamente a apresentação pormenorizada de imagens
e escalas.

Todos os desenhos são originais e foram criados especificamente
para esta publicação por Maria da Gandra e Maaike van Neck.
Cada desenho é apresentado numa escala comum de 1:16,3,
fazendo da comparação entre instrumentos uma tarefa simples
e ajudando o leitor a identificar os instrumentos correctamente.
Os desenhos são representados na generalidade por uma silhueta
ortográfica. Nos casos em que uma única perspectiva não é
suficiente para descrever o instrumento com precisão, Maria e
Maaike desenharam perspectivas simplificadas. O pormenor de
componentes como as cordas, os trastes e os leques, em conjunto
com padrões decorativos característicos, foi cuidadosamente
desenhado a branco. Apresentar estes padrões emblemáticos com
precisão foi a força motriz subjacente ao trabalho das artistas, uma
vez que estes ornamentos decorativos reflectem a cultura de onde
os instrumentos são originários e celebram a capacidade artística e
o engenho daqueles que os construíram.

Os desenhos organizam-se em categorias, por tipo, e estão
colocados em posição relativa cronologicamente. No índice, os
instrumentos inventados num determinado ano estão catalogados
em conformidade. Nos casos em que os musicólogos não
conseguiram atribuir o ano exacto da invenção, a data indica
o século.

O livro **Instrumentos Musicais do Mundo** será simultaneamente
uma fonte de informação e um objecto de fascínio para eruditos,
músicos, artistas e designers. O CD-ROM que o acompanha, com
ilustrações jpeg de alta resolução de todos os instrumentos, brinda
o leitor com um recurso inestimável.

Andrew Haslam
Escola Superior de Arte e Design Central Saint Martins

Instrumentos musicales del mundo

Lo más sorprendente de este libro es su estructura organizativa. Los instrumentos musicales están distribuidos a lo largo de una línea cronológica, ofreciendo una continuidad de principio a fin, desde los primeros instrumentos hasta los más recientes. Pese a tratarse de una idea sencilla, incluso obvia, es la primera obra de estas características publicada hasta hoy. Así, ofrece una perspectiva de la evolución de los instrumentos musicales que de lo contrario pasaría desapercibida pero, además, invita al lector a observar la evolución histórica de los instrumentos musicales desde una perspectiva cultural más amplia.

Si bien no resulta fácil datar este tipo de cosas con exactitud, no cabe duda de que los instrumentos musicales fueron uno de los primeros inventos tecnológicos de la Humanidad. Las flautas de hueso, por ejemplo, fueron muy anteriores a las hachas y las puntas de lanza de piedra. Aunque menos necesarias para la supervivencia, al parecer estas primeras flautas eran más sofisticadas y constituyen un mejor indicador del floreciente potencial del artificio humano.

Unos dos mil años atrás, ya en el mundo clásico, la música no solo estaba presente, sino que tuvo una importancia clave en los primeros cambios que desembocarían en el pensamiento científico. Uno de los primeros ejemplos es la música de las esferas, un concepto postulado por los filósofos griegos según el cual el movimiento de los cuerpos celestes representa una armonía celestial divina cuyos secretos solo pueden desvelarse a través de la observación y el análisis matemático. Si también tenemos en cuenta uno de los primeros experimentos científicos de los que tenemos constancia, como son los célebres estudios de Pitágoras sobre las leyes que gobiernan las cuerdas musicales, es evidente que los instrumentos de música fueron unos de los primeros inventos científicos, además de hacer las veces de elementos que posibilitaban el concepto de experimento controlado.

Avanzando en los siglos, podría decirse que la arquitectura de las majestuosas catedrales barrocas representa la mayor gesta tecnológica de la época. ¿Y los magníficos órganos que albergaban? Aunque la escala física no es la misma, en cuanto a matemáticas aplicadas y tecnología estos órganos suponen un logro de igual magnitud.

Hoy en día todo es distinto. Quizá sería excesivo afirmar que los instrumentos musicales representan la manifestación suprema de la tecnología contemporánea. Aun así, algunos de los ejemplos más destacados de las últimas páginas de este libro son una clara muestra de que la creatividad sigue siendo un activo importante en el diseño de instrumentos musicales.

Esta obra no solo analiza los instrumentos musicales como un hecho aislado, sino como elementos que desde los orígenes de la Humanidad han sido un indicador importante de los logros y del potencial del hombre. Estas páginas plasman todo ello de una forma visual e iconográfica a lo largo de los siglos.

Todo un lujo. Disfrútelo.

Bart Hopkin
Experimental Musical Instruments, California, Estados Unidos

Este libro es un extraordinario diccionario visual de instrumentos musicales. Con más de 1.500 dibujos, recoge numerosas formas de entender la interpretación de la música, la construcción de instrumentos y la ingeniería de sonido en todo el mundo. Cada uno de los instrumentos se ha elegido cuidadosamente para ofrecer una visión histórica objetiva de la evolución musical. Así, se representan instrumentos aerófonos, idiófonos, membranófonos, cordófonos, mecánicos y eléctricos por igual.

Los primeros instrumentos construidos a mano se remontan a 50.000 años atrás, mientras que los más recientes son el producto de una época dominada por la electrónica. Si bien es cierto que existen muchas enciclopedias de instrumentos musicales en el mercado, ninguna reúne la exhaustividad de ilustraciones a escala realizadas con todo lujo de detalles de este libro.

Maria da Gandra y Maaike van Neck han creado todos los dibujos en exclusiva para esta publicación. Representados a una escala estándar de 1:16,3, el lector podrá comparar los distintos modelos con facilidad e identificar los instrumentos correctamente. En general, los dibujos revelan una ortografía proyecta, aunque cuando no ha bastado un único punto de vista para describir el instrumento con precisión, Maria y Maaike han creado dibujos en perspectiva simplificados. Los detalles de elementos como cuerdas, trastes y teclas, al igual que los motivos decorativos, se han dibujado minuciosamente en blanco. La representación exquisita de estos ornamentos emblemáticos ha sido la piedra angular de las diseñadoras, puesto que reflejan la cultura de la que proceden los instrumentos y son un claro exponente de la habilidad y el ingenio de quienes los construyeron.

Los dibujos se agrupan por categorías según el tipo de instrumento y se distribuyen a lo largo de una línea cronológica. En el índice, el nombre de los instrumentos aparece junto al año de su invención excepto cuando los historiadores no lo han podido determinar con exactitud, en cuyo caso se indica el siglo.

Además de obra de referencia, este diccionario visual pretende ser un objeto de culto para estudiosos, músicos, artistas y diseñadores. Asimismo, las ilustraciones de todos los instrumentos en formato jpeg de alta resolución que contiene el CD-ROM serán un recurso de valor incalculable para el lector.

Andrew Haslam
Central Saint Martins College of Art and Design

Strumenti musicali del mondo

La caratteristica più sorprendente di questo meraviglioso libro è l'organizzazione dei contenuti. Gli strumenti musicali sono presentati secondo un ordine cronologico, che conferisce continuità al volume dal principio alla fine, dai primi fino ai più recenti. È un'idea semplice e perfino ovvia, ma nessun'altra pubblicazione offre un materiale così vasto presentato in questo modo. Attraverso tale approccio, il libro fornisce una panoramica centrata sull'evoluzione degli strumenti musicali che altrimenti non risulterebbe così chiara, e trasporta il concetto un po' più in là, invitando il lettore ad osservare la tematica, lo sviluppo degli strumenti musicali nel corso dei secoli, da una prospettiva culturale più ampia.

Sebbene sia difficile stabilire con sicurezza il periodo a cui appartengono, è chiaro che gli strumenti musicali rappresentano uno dei primi tentativi dell'umanità di costruire oggetti tecnologici. Tra i primi strumenti fabbricati dall'uomo per sopravvivere spiccano le asce di pietra e le punte di lancia, ma i flauti ricavati dalle ossa risalgono a un periodo assai più remoto. Forse non si tratta di arnesi fondamentali per la sopravvivenza come nel caso delle asce e delle lance, ma è pur vero che questi flauti sono strumenti molto più sofisticati e un indicatore ancor più valido delle potenzialità dell'uomo primitivo.

Più di duemila anni fa, durante il periodo classico, la musica non si limita alla mera presenza, ma funge perfino da impulso fondamentale per la nascita del pensiero scientifico. Ne è una prova la musica delle sfere, concetto elaborato dai filosofi greci per cui il movimento dei corpi celesti rappresenta un'armonia celestiale e divina che possiamo svelare grazie all'osservazione e all'analisi matematica. Se consideriamo inoltre uno dei primissimi esperimenti scientifici di cui si ha testimonianza, i celebri studi di Pitagora sulle leggi che governano le corde degli strumenti musicali, risulterà evidente che essi sono anche uno dei primi strumenti scientifici, dato che, in effetti, furono utilizzati per realizzare esperimenti controllati.

Spingendoci più avanti nel tempo, a qualche secolo di distanza, si può affermare che l'architettura delle grandi cattedrali barocche rappresenti la più grande conquista tecnologica dell'epoca. E cosa dire, allora, dei magnifici organi che custodivano? La scala fisica non sarà la stessa, ma a livello di matematica applicata e di tecnologia questi strumenti musicali costituiscono una conquista altrettanto notevole.

Attualmente le cose sono un po' diverse e forse sarebbe esagerato sostenere che gli strumenti musicali siano la più alta manifestazione della tecnologia contemporanea. Tuttavia basta dare un'occhiata ad alcune delle straordinarie figure che compaiono nelle ultime pagine del libro per capire come la progettazione di strumenti musicali riesca ancora a raggiungere grandi livelli di creatività.

Il quadro appena esposto raffigura la sfera degli strumenti musicali non solo come un settore determinato a cui l'umanità ha dedicato il suo impegno, ma come un'attività che, sin dalla preistoria, funge da importante indicatore delle conquiste e delle potenzialità dell'uomo. *Strumenti musicali del mondo* intende esporre al lettore questi concetti attraverso un percorso cronologico, iconico e visivo.

Un vero spettacolo, tutto da godere.

Bart Hopkin
Experimental Musical Instruments, California, USA

Questo libro costituisce uno straordinario dizionario illustrato degli strumenti musicali. Contiene più di 1.500 immagini e prende in esame una vasta gamma di differenti approcci nei confronti degli strumenti di tutto il mondo, in quanto a prestazioni, fabbricazione e ingegneria del suono. Tutti gli strumenti sono stati accuratamente selezionati al fine di fornire un'equilibrata panoramica del loro sviluppo nel corso dei secoli: aerofoni, idiofoni, membranofoni, cordofoni, meccanici ed elettrici, sono rappresentati tutti in ugual modo.

I più antichi strumenti fatti a mano illustrati nel volume risalgono a più di 50.000 anni fa, mentre i più moderni sono il frutto di una sofisticata era meccanica ed elettronica. Esistono molte enciclopedie dedicate agli strumenti musicali, ma nessuna di loro presenta in modo così esauriente illustrazioni dettagliate e in scala.

Tutti i disegni sono originali e sono stati realizzati appositamente per questa pubblicazione da Maria da Gandra e Maaike van Neck. Le immagini sono riprodotte in scala 1:16,3 facilitando al massimo la comparazione tra gli strumenti e aiutando il lettore a identificarli correttamente. In genere si tratta di proiezioni ortografiche ma, nei casi in cui una figura da sola non basta a descrivere accuratamente lo strumento, Maria e Maaike hanno realizzato disegni con prospettive semplificate. I dettagli di elementi quali le corde, le sbarrette trasversali e i tasti, assieme ai motivi decorativi caratteristici, sono stati meticolosamente tracciati in bianco. La riproduzione accurata di questi emblematici motivi ha stimolato significativamente il lavoro delle designer, dato che tali abbellimenti decorativi sono un riflesso della cultura da cui deriva lo strumento e mettono in risalto l'abilità artigianale e la maestria dei rispettivi artefici.

I disegni sono organizzati in categorie secondo il tipo e sono collocati in sequenza seguendo un ordine cronologico. Nell'indice, viene riportato l'anno in cui sono stati inventati i diversi strumenti; nei casi in cui gli storici della musica non sono stati in grado di definirlo con precisione viene indicato il secolo.

Strumenti musicali del mondo rappresenta sia una fonte di informazione che un libro affascinante rivolto a studenti, musicisti, artisti e designer. Il CD-ROM accluso contiene immagini ad alta risoluzione in formato jpeg di tutti gli strumenti: una risorsa preziosa per il lettore.

Andrew Haslam
Central Saint Martins College of Art and Design

Музыкальные инструменты мира

Самой яркой чертой этой замечательной книги является всеобъемлющий организационный принцип. Обсуждаемые здесь музыкальные инструменты размещены на временной шкале, что обеспечивает последовательность от начала и до конца, начиная с более ранних, вплоть до новейших. Идея в общем-то простая, даже очевидная. Однако ни в одной другой книге весь комплекс материала не подан в сравнимой форме. Благодаря такому подходу книга открывает перспективу на эвлюцию музыкальных инструментов, которая при другом раскладе осталась бы незамеченной. Но книга и эту идею развивает на шаг дальше и приглашает читателя взглянуть на данную область – историю развития музыкальных инструментов – в свете более широкой культурной перспективы.

Хотя точная датировка подобных вещей затруднительна, ясно одно – музыкальные инструменты были в ряду самых первых технологических усилий человечества. Каменные топоры и наконечники копий выделяются среди древнейших сохранившихся орудий, но и костяные флейты обнаруживаются удивительно рано. Флейты эти были, пожалуй, не так важны для выживания, как топоры и копья, но они куда как более сложны и являются лучшим показателем зараждающегося потенциала человеческого умельства.

Если перейти к древнему классическому миру 2000 лет назад, можно увидеть, как музыка не просто сопутсвовала, но и служила ключевым толчком той активности, которой впоследствии суждено стало перерости в научную мысль. Пример тому – музыка сфер (доктрина изложенная древнегреческими философами, о том, что движение небесных тел представляет собой божественную небесную гармонию, и о том, что мы можем освоить ее тайны с помощью наблюдений и математического анализа). Если еще учесть один из первых зафиксированных научных экспериментов – знаменитые исследования Пифагора о законах, которым подчиняются музыкальные струны – становится очевидным, что музыкальные инструменты были в числе самых первых научных инструментов и послужили, в сущности, аппаратурой, с помощью которой и удалось претворить в жизнь понятие контролируемого эксперимента.

Еще раз шагнем на пару столетий во времени. Можно утверждать, что архитектура великих барочных соборов представляет собой величайшее технолоическое достижение тех времен. Но как же размещавшиеся в них великолепные органы? В плане маштабности они может быть и уступают, но что касается прикладной математики и технологий, органы эти являются не менее впречатляющими достижениями.

Ситуация сегодня несколько изменилась. Было бы дерзко заявить, что музыкальные инструменты являются высшими достижениями современной технологии. И все-таки, взглянув на некоторые из удивительных форм на последних страницах книги, вы поймете, что творческая мысль в разработках инструментов не дремлет и поныне.

Представленная здесь картина старается осмыслить музыкальные инструменты не как изолированную область достижений, но как неотъемлный индикатор прогресса человечества и человеческого же потенциала. Зрительно и пиктографически подготовленное изложение такого видения предмета простирается сквозь века и находится здесь, в «Музыкальных инструментах мира».

Прекрасная перспектива! Наслаждайтесь ей!

Барт Хопкин
Экспериментальные Музыкальные Инструменты,
Калифорния, США.

У вас в руках замечательный и иллюстрированный справочник музыкальных инструментов. Его размах охватывает более 1 500 рисунков, отдавая таким образом дань множеству рознящихся подходов к музыкальному исполнительству, ремесленному мастерству и звукотехнике во всем мире. Выбор инструментов обусловлен желанием представить наиболее взвешенный исторический обзор музыкального развития: аэрофоны, идиофоны, мембрафоны, хордофоны, механические и электрические инструменты – все представлены в равных долях.

Самым древним из представленных инструментов около 50000 лет, в то время как новейшие являются детищами изощренной эры машин и электротехники. Существует множество энциклопедий музыкальных инструментов, но ни в одной из них не задействовано столь обширное количество подробного и масштабного наглядного материала.

Все рисунки были специально созданы Марией да Гранда и Маакой ван Некк конкретно для данного издания. Каждый рисунок выполнен в масштабе 1:16,3, позволяя таким образом без затруднений сравнивать инструменты, а также, помогая читателю правильно опознавать отдельные инструменты. Рисунки, как правило, изображают силуэт (ортоганальный), для тех же случаев, когда вид из одной точки не в состоянии адекватно изобразить инструмент, Мария и Маайке разработали упрощенные рисунки в перспективе. Детали отдельных элементов, как то: струны, лады и клавиши, равно как и характерные декоративные узоры, тщательно вырисовывались белым цветом. На точное воспроизведение этих знаковых элементов был сделан основной упор стараний дизайнеров, поскольку декоративное оформление отражает культуру, породившую тот или иной инструмент и славит мастерство умельцев, его создавших.

Рисунки распределены по категориям, в соответствии с типом, и размещены относительно друг друга на временной оси. В указателе инструменты, изобретенные в определенном году, соответственно обозначены, в случаях, когда историки музыки не в состоянии однозначно определить дату изобретения, она обозначена столетием.

«*Музыкальные инструменты мира*» послужит источником информации и объектом интеллектуальной услады для исследователей, музыкантов, художников и дизайнеров. Прилагающийся компакт-диск содержит электронные иллюстрации (jpeg) высокого разрешения ко всем инструментам и обеспечивает читателя незаменимыми материалами.

Эндрю Хаслам
Колледж Central Saint Martins, факультет искусства и дизайна

世界の楽器

このすばらしい本の大きな特徴は、きちんと系統だった構成です。紹介されている楽器は、古いものから最新のものまでが年代順に並べられています。これは簡単なコンセプトではあるものの、この分野においてそれを実現した本は他にありません。本書は、楽器の進化をわかりやすく表現しているだけでなく、楽器を文化的な側面からも紹介しています。

それぞれの楽器を時代別に特定することは困難ですが、楽器が人類の技術の進歩に大きく関わっていることは否めようがありません。石斧や槍は人類最初の道具として知られていますが、骨から作られた笛もかなり昔に登場しています。笛は石斧や槍に比べ、生存のための必需品ではなかったかもしれませんが、よりはっきりと、人類の初期における創造性を示しています。

2000年以上昔より、音楽は科学的思考を呼び覚ます要素として存在していました。ギリシアの哲学者が唱えた「天球の音楽」とは、天体の運動は神々の調和を表しており、その秘密は観察と数学的分析によって解くことができるというものでした。歴史上初めて記録された科学実験は、ピタゴラスによる音楽弦の法則の研究でした。つまり、楽器は最初の科学実験道具としても用いられていたのです。

それから数百年後のバロック時代になると、建築技術は発達し、巨大な大聖堂が作られました。その大聖堂の中に設置されたオルガンは、規模こそ建築物の比ではないものの、建造物と同様に数学や技術工学を駆使したすばらしい芸術作品といえます。

現代では事情が少し異なるため、楽器が現代技術の最先端を反映していると断言するのは誇張になるかもしれません。とはいえ、本書の後半ページに収録された楽器を見れば、楽器のデザインにおける創造性は今も変わりなく生き続けていることがわかります。

楽器は、音楽という特殊な一分野ではなく、古代から人間の進歩と可能性を表す指針となってきました。「世界の楽器（World Musical Instruments）」は、それをイラストでビジュアルにわかりやすく紹介しています。

本当に美しい本です。ご堪能ください。

バート・ホプキン
エクスペリメンタル・ミュージカル・インスツルメント（カリフォルニア）

本書は、1500点を越えるイラストにより楽器をビジュアルに紹介するユニークな楽器事典です。演奏性や音響技術、技巧性など数々の面から世界各国の楽器を紹介しています。管楽器、体鳴楽器、膜鳴楽器、弦楽器、自動演奏楽器、電子楽器が、音楽の歴史に沿って年代順にバランスよく選択されています。

古いものでは5万年前の手作り楽器から、高度なエレクトロニクスを用た最新の楽器までが、他の楽器事典では表現しきれなかった精巧なイラストで紹介されています。

イラストはすべて、本書のために、マリア・ダ・ガンドラとマーイク・ヴァン・ネックにより描かれたオリジナル作品です。各楽器の大きさを比較しやすいよう、イラストはいずれも実物の16.3分の1のスケールで描かれており、楽器全体を把握できるよう、作者が考案した簡単な遠近法を用いた正投影図でも表現されています。弦やフレット、鍵盤、特殊な装飾模様などの細かい特徴も精巧に描かれています。実際、これらの装飾は、楽器が作られた時代の文化だけでなく、楽器職人の優れた技術も反映しており、マリア・ダ・ガンドラとマーイク・ヴァン・ネックが他に類をみない優れたイラストを作成するための推進力ともなりました。

イラストは、楽器タイプ別に分類され、年代順に配置されています。インデックスにより、いつどのような楽器が発明されたかがひと目でわかります。正確な発明時期が音楽史の専門家により識別されていない楽器については、発明年度ではなく、その世紀が表示されています。

「世界の楽器（World Musical Instruments）」は、学者や音楽家、アーティスト、デザイナーの参考書として、また鑑賞用としても最適です。附録のCD-ROMには、本書に掲載されている全イラストが高解像度のJPEGで収録され、様々な用途に使用できます。

アンドリュー・ハスラム
セントラル・セント・マーティンズ・カレッジ・オブ・アート・アンド・デザイン

Musical Instruments – *scale* 1:16,3

Image numbers correspond to entry numbers in the Index and to image numbers on the accompanying CD-ROM.

When a musical instrument is played using an implement such as a bow or a beater, a second (and sometimes a third) number is shown. These additional numbers – beginning with a "B" – refer to illustrations in the ***Bows, Beaters & Other Implements*** section.

Musikinstrumente – *maßstab* 1:16,3

Die Zahlen neben den Bildern entsprechen den Zahlen der Einträge im Register und den Zahlen der Bilder auf der beiliegenden CD-ROM.

Wenn ein Musikinstrument mithilfe eines Hilfsmittels wie einem Bogen oder einem Schlegel gespielt wird, ist dieses mit einer zweiten (und ggf. einer dritten) Zahl gekennzeichnet. Diese Zusatzzahlen – immer beginnend mit einem »B« – beziehen sich auf die Illustrationen im Kapitel ***Bögen, Schlegel und andere Hilfsmittel***.

Instruments de musique – *échelle* 1:16,3

Le numéro de l'image correspond au numéro de son inscription dans l'index et au numéro de l'image sur le CD-ROM d'accompagnement.

Lorsqu'un instrument se joue à l'aide d'un accessoire, comme un archet ou une baguette, un deuxième (et parfois un troisième) numéro apparaît. Ces numéros supplémentaires – commençant par un « B » – correspondent aux illustrations dans la section ***Archets, baguettes et autres accessoires***.

Instrumentos musicais – *escala* 1:16,3

Os números nas imagens correspondem a entradas de índice e a números de imagens no CD-ROM que acompanha a obra.

Quando um instrumento musical é tocado com um elemento de controlo ou estímulo, tal como um arco ou uma baqueta, é-lhe aposto um segundo (e às vezes um terceiro) número. Estes números adicionais – que se iniciam com um «B» – referem-se a ilustrações da secção ***Arcos, baquetas e outros elementos***.

Instrumentos musicales – *escala* 1:16,3

Los números de las imágenes corresponden a los números de las entradas del índice y a los de las imágenes incluidas en el CD-ROM.

Los instrumentos que se tocan con algún accesorio, como por ejemplo un arco o una maza, incorporan un segundo número (y en ocasiones también un tercero). Estos números adicionales –que empiezan por «B»– remiten a las ilustraciones del apartado ***Arcos, mazas y otros accesorios***.

Strumenti musicali – *scala* 1:16,3

I numeri delle immagini corrispondono ai numeri delle voci dell'indice e delle immagini contenute nel CD-ROM.

Accanto agli strumenti musicali con cui si utilizzano accessori come archi o bacchette compare un secondo (a volte anche un terzo) numero. Tali numeri aggiuntivi, preceduti da una «B», fanno riferimento alle illustrazioni della sezione ***Archi, bacchette e altri accessori***.

Музыкальные инструменты – масштаб 1:16,3

Номера рисунков соответствуют номерам записи в указателе и номерам рисунков на прилагающемся компакт-диске.

Если на инструменте играют с помощью приспособления, например, смычка или палочек, указан второй (а иногда и третий) номер. Эти дополнительные, обозначенные буквой «B», номера ссылаются на раздел «***Смычки, палочки и другие приспособления***».

楽器 – 縮小率 1:16.3

各イラストの番号は、インデックスの番号及び附録のCD-ROMのイラスト番号に対応しています。

弓やバチを使って演奏する楽器には、番号が2つ、あるいは3つ付いています。b"で始まる番号は、「弓、バチ、その他の道具」の章のイラストであることを意味します。

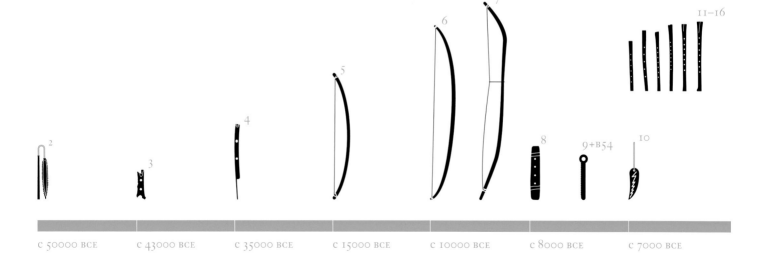

C 50000 BCE C 43000 BCE C 35000 BCE C 15000 BCE C 10000 BCE C 8000 BCE C 7000 BCE

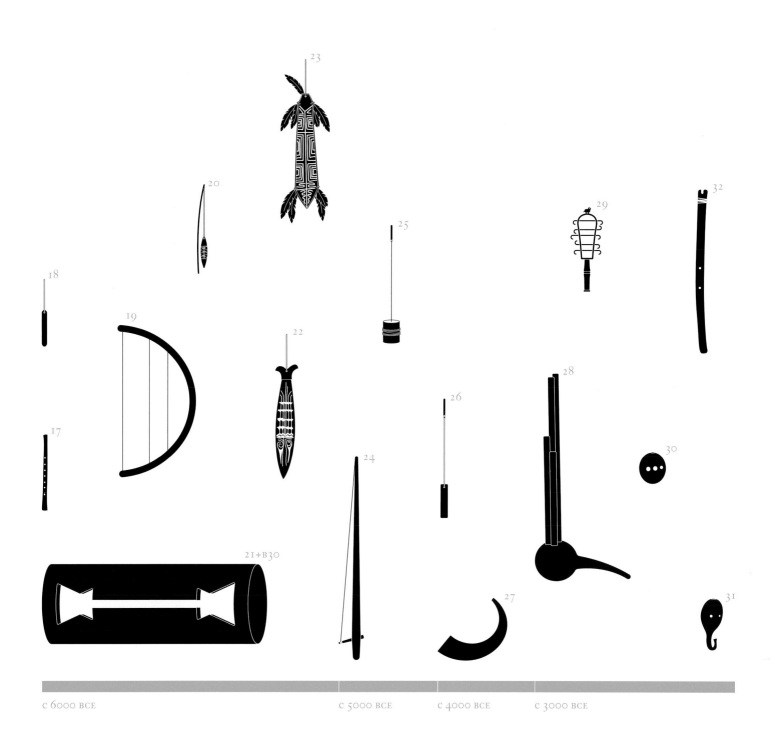

c 6000 bce c 5000 bce c 4000 bce c 3000 bce

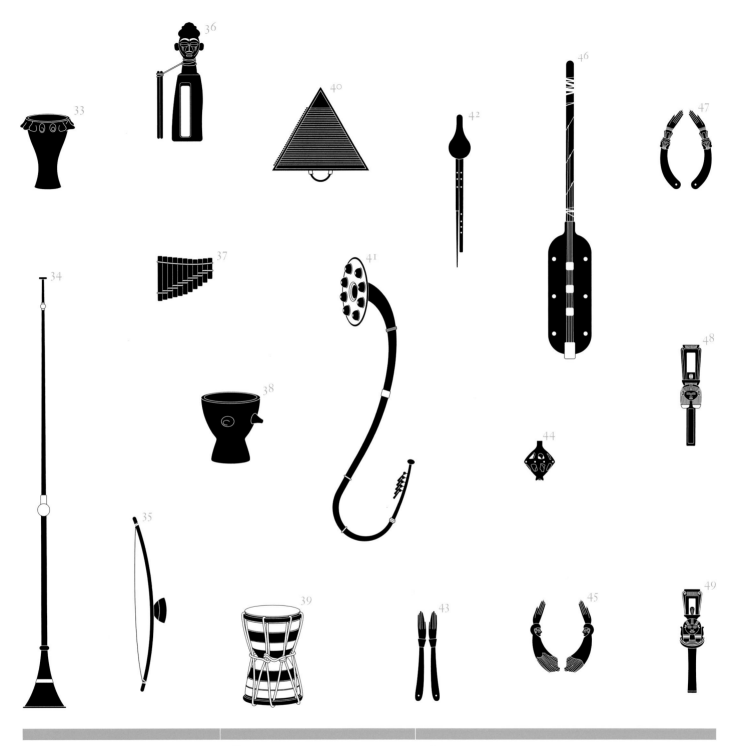

33

36

40

42

46

47

37

34

41

38

44

48

35

39

43

45

49

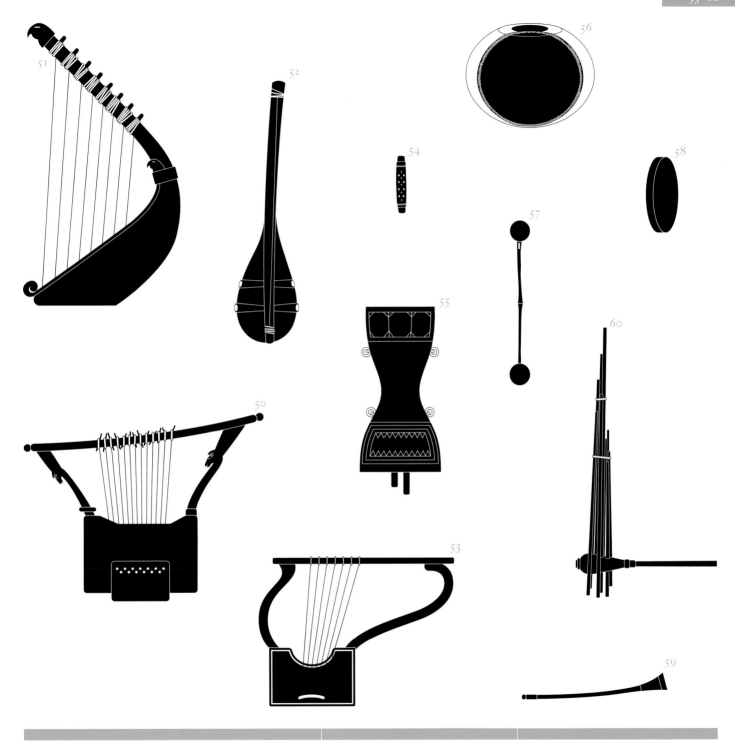

51

56

52

54

58

57

55

50

60

53

59

C 1500 BCE C 1400 BCE

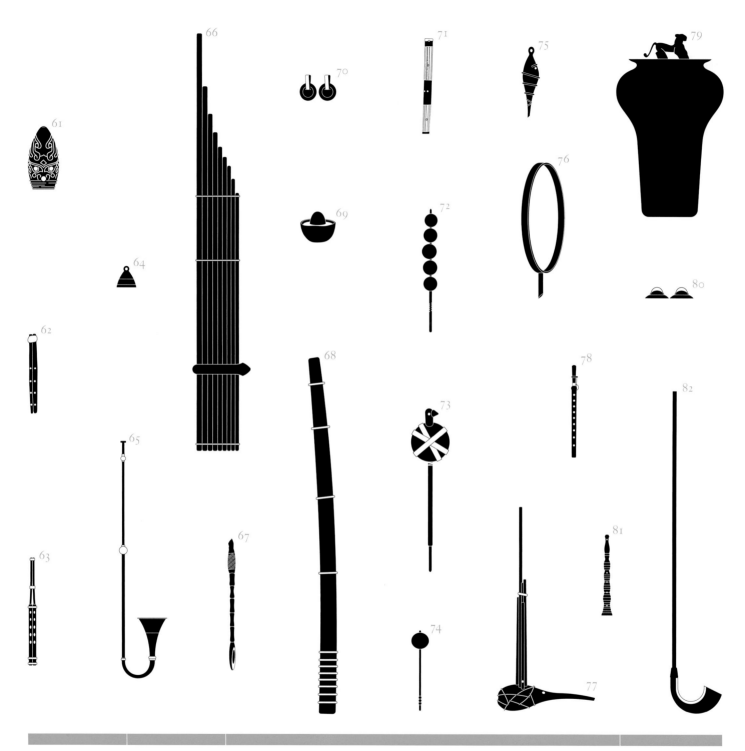

61

64

62

65

63

66

70

69

68

67

71

75

79

76

72

73

74

77

78

81

82

80

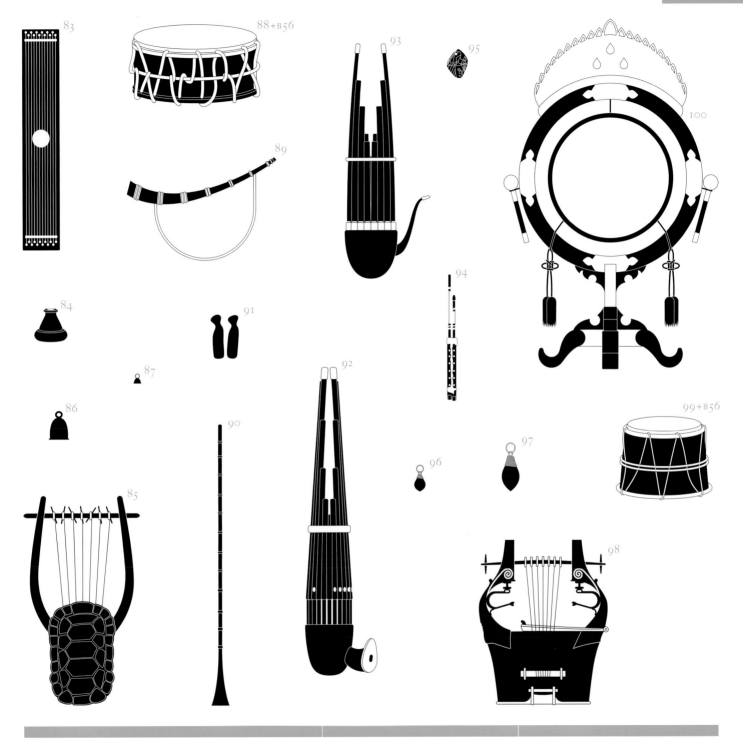

c 800 BCE

c 600 BCE

c 500 BCE

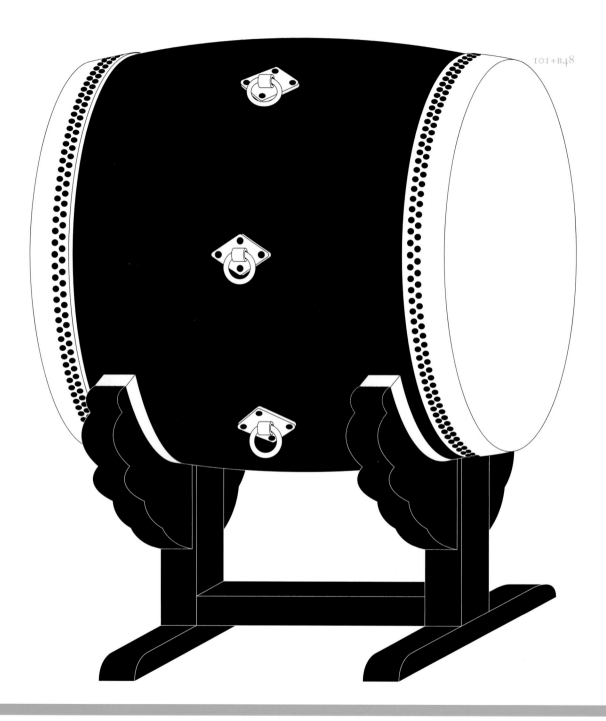

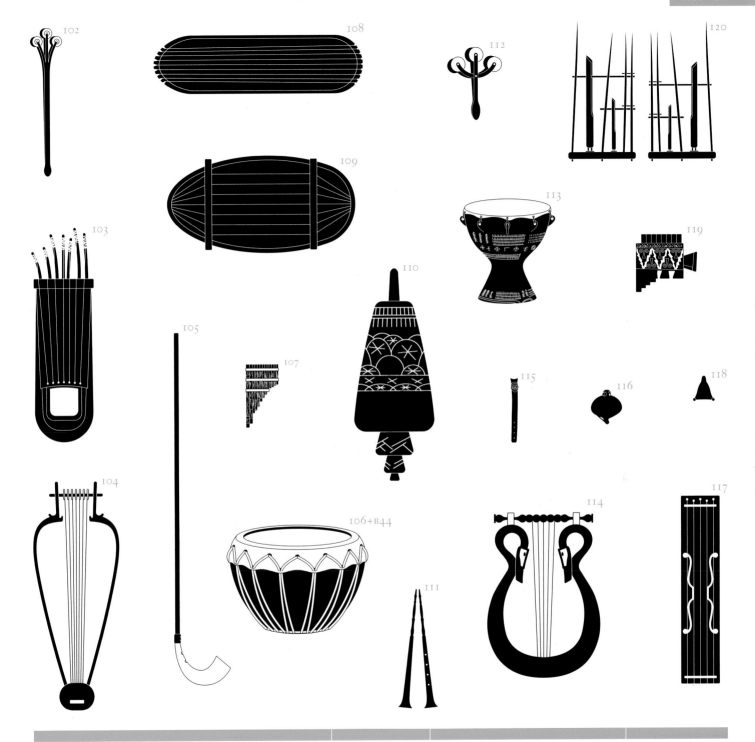

102

108

112

120

109

113

119

103

110

105

107

115

116

118

104

106+B44

111

114

117

C 400 BCE C 300 BCE C 200 BCE

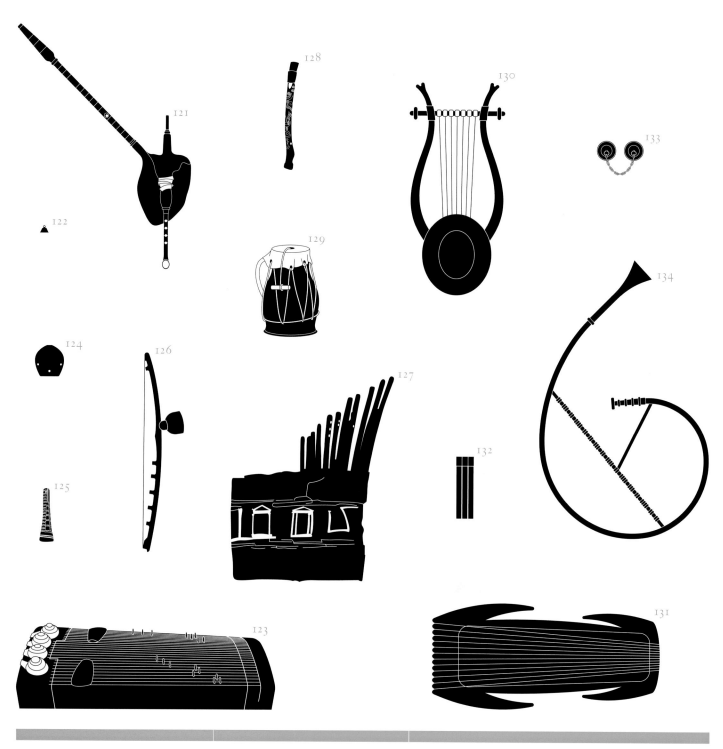

121

128

130

133

122

129

134

124

126

127

132

125

123

131

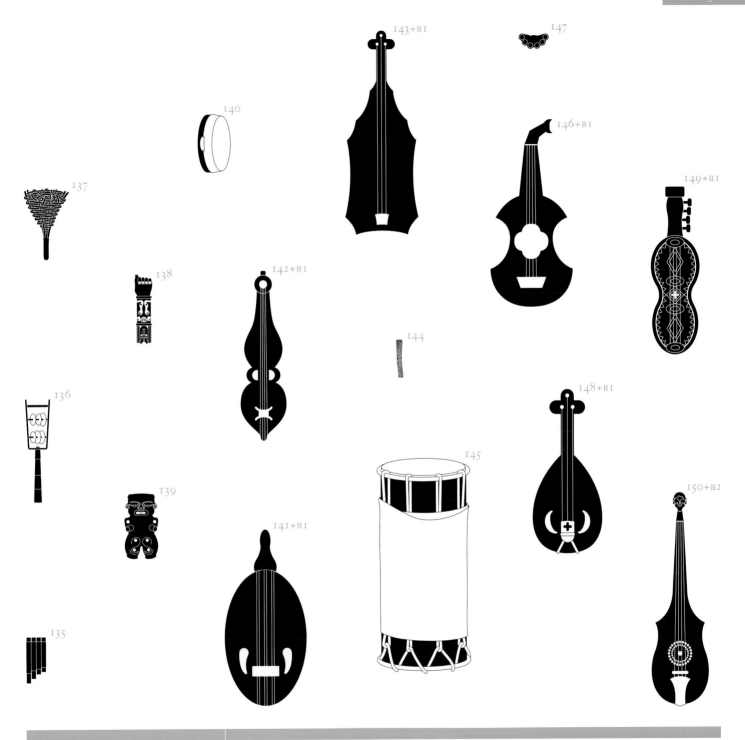

C 100 CE

C 200 CE

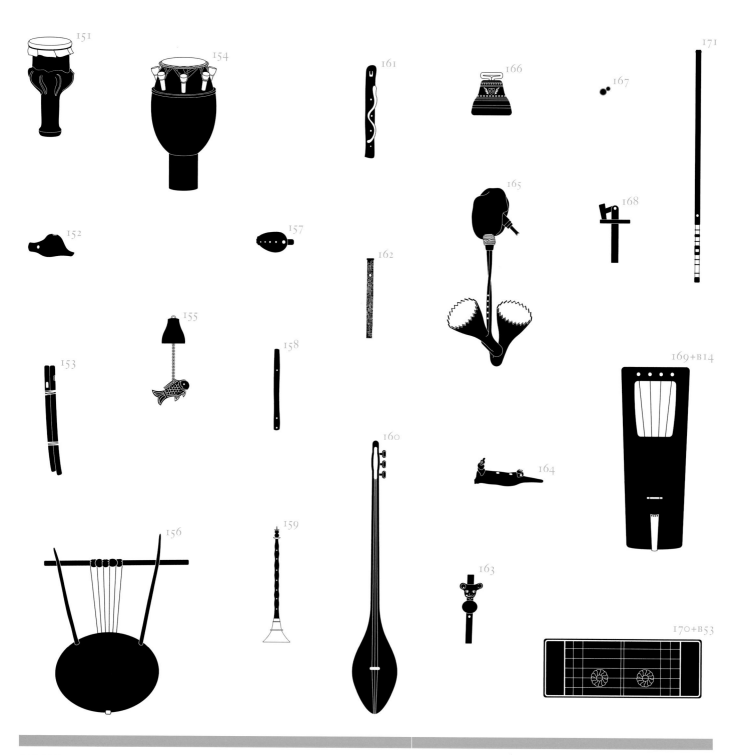

151

154

161

166

167

171

152

157

165

168

162

155

153

158

169+B14

156

160

164

159

163

170+B53

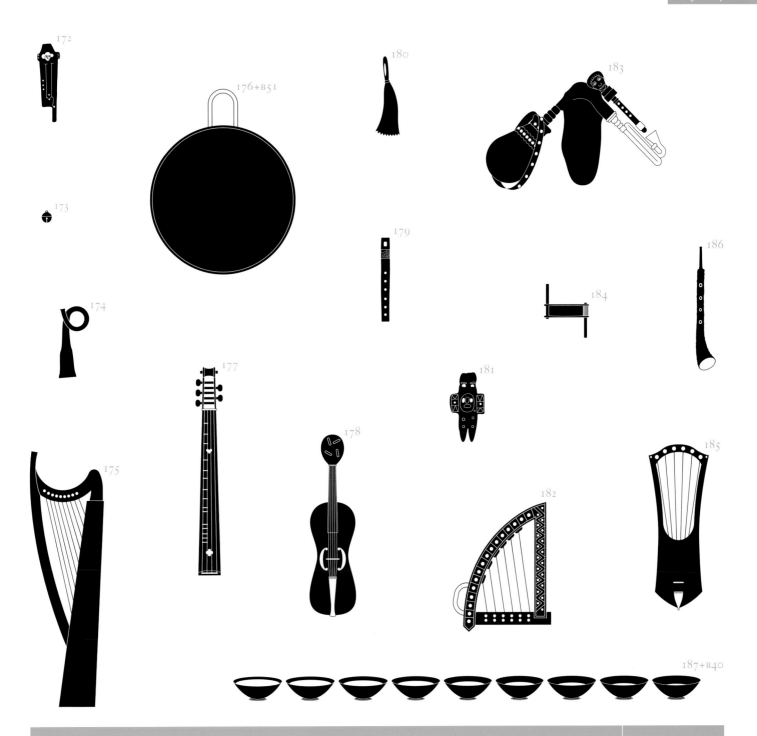

C 500 CE

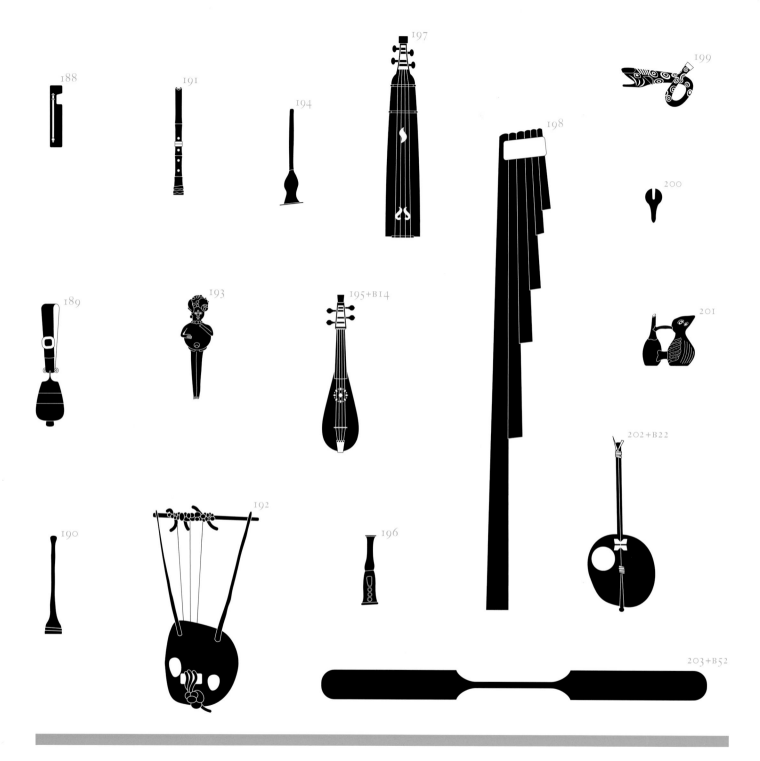

188

191

194

197

199

198

200

189

193

195+B14

201

192

190

196

202+B22

203+B52

42

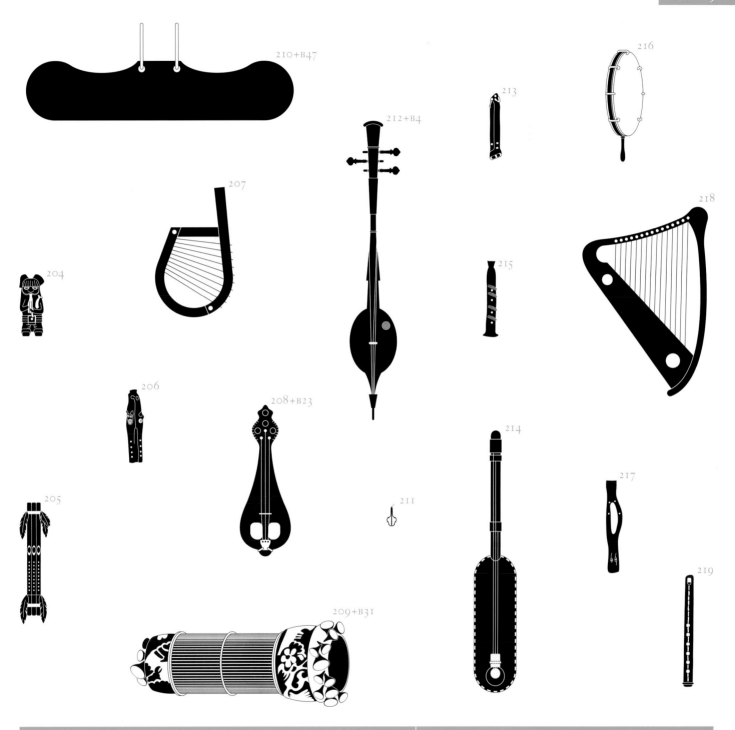

210+B47

216

213

212+B4

207

218

204

215

206

208+B23

205

217

211

214

219

209+B31

c 600 CE

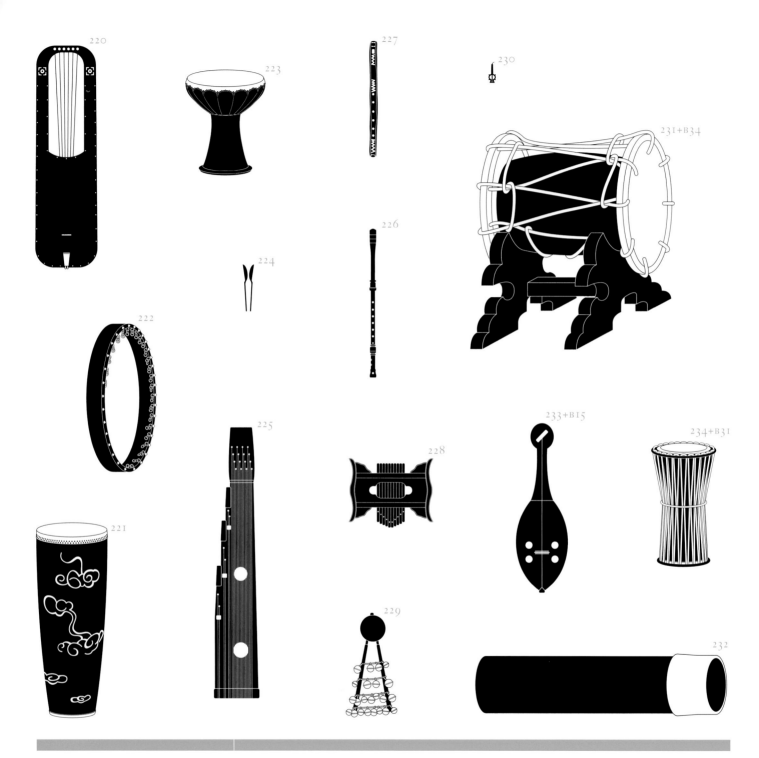

220

223

227

230

231+B34

226

224

222

225

228

233+B15

234+B31

221

229

232

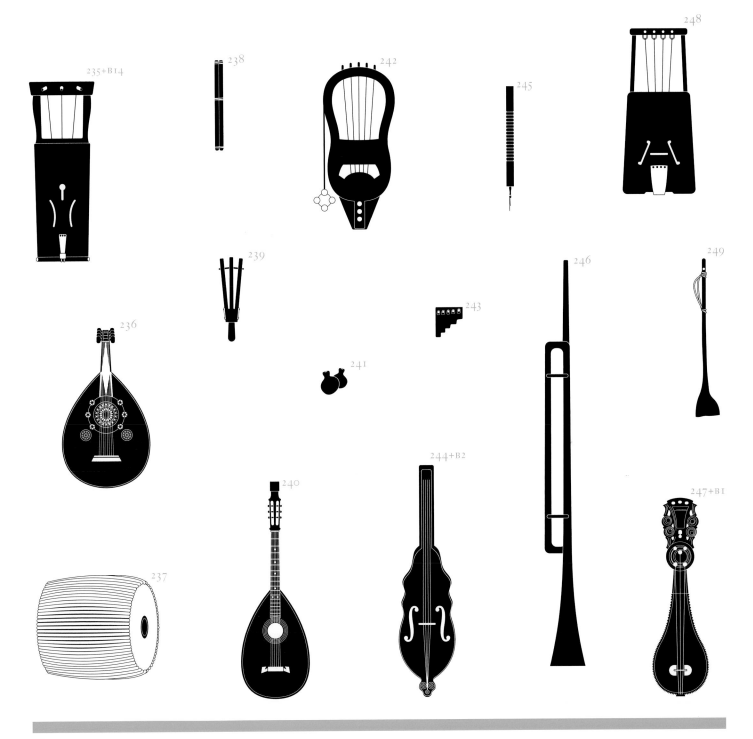

235+B14
238
242
245
248
239
236
243
246
249
241
244+B2
240
247+B1
237

c 800 CE

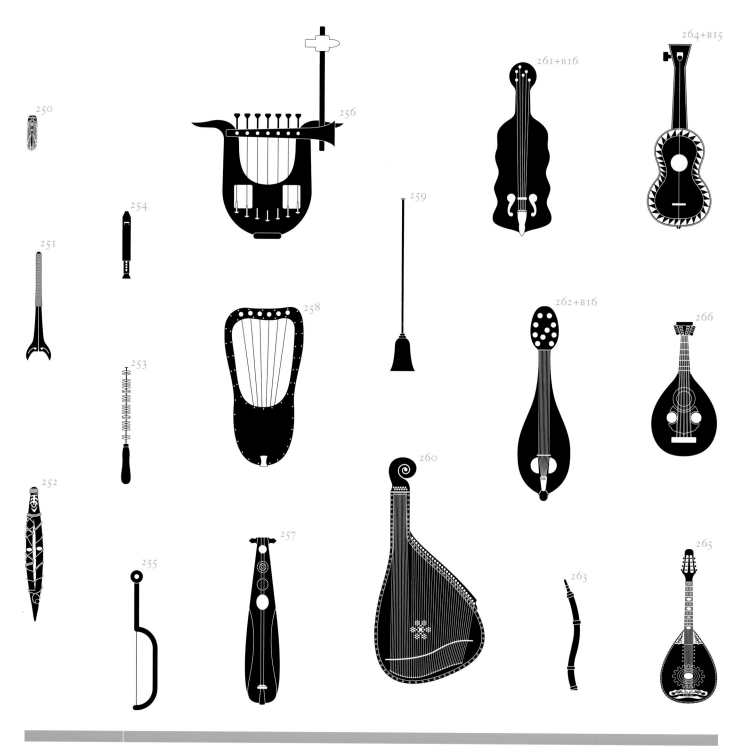

250

251

252

253

254

255

256

257

258

259

260

261+B16

262+B16

263

264+B15

265

266

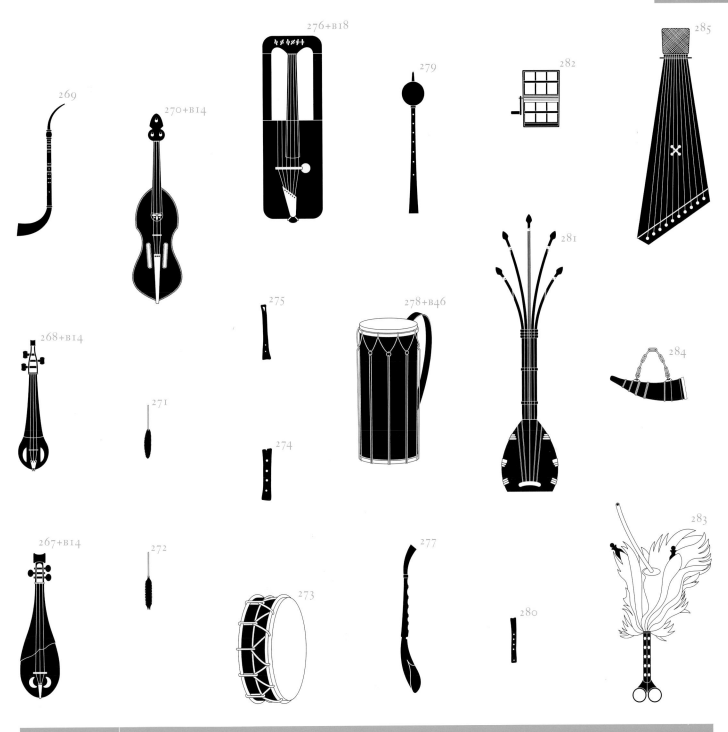

269

270+B14

276+B18

279

282

285

268+B14

275

278+B46

281

284

271

274

267+B14

272

273

277

280

283

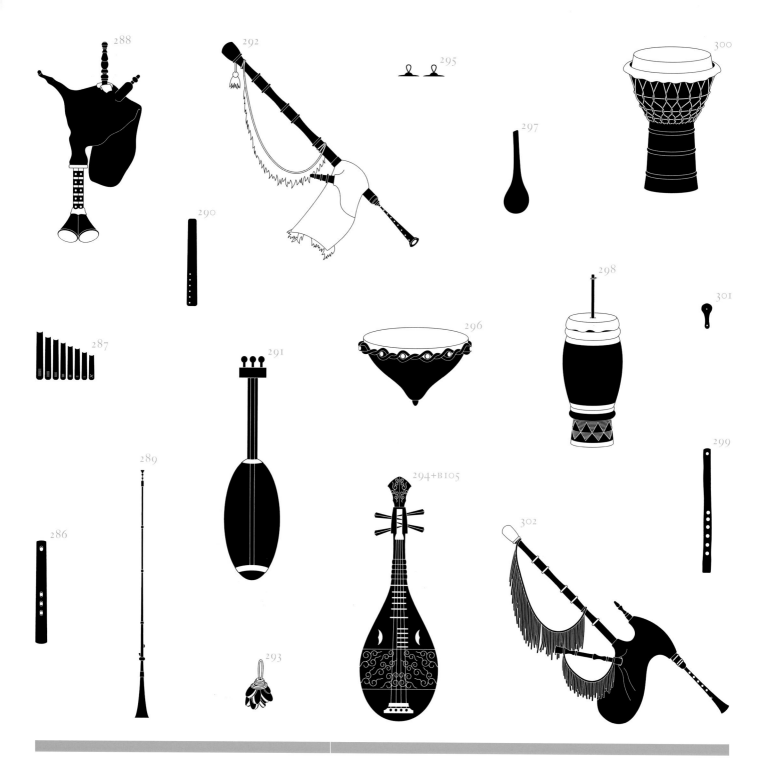

288

292

295

300

290

297

287

296

298

301

291

299

289

294+B105

286

302

293

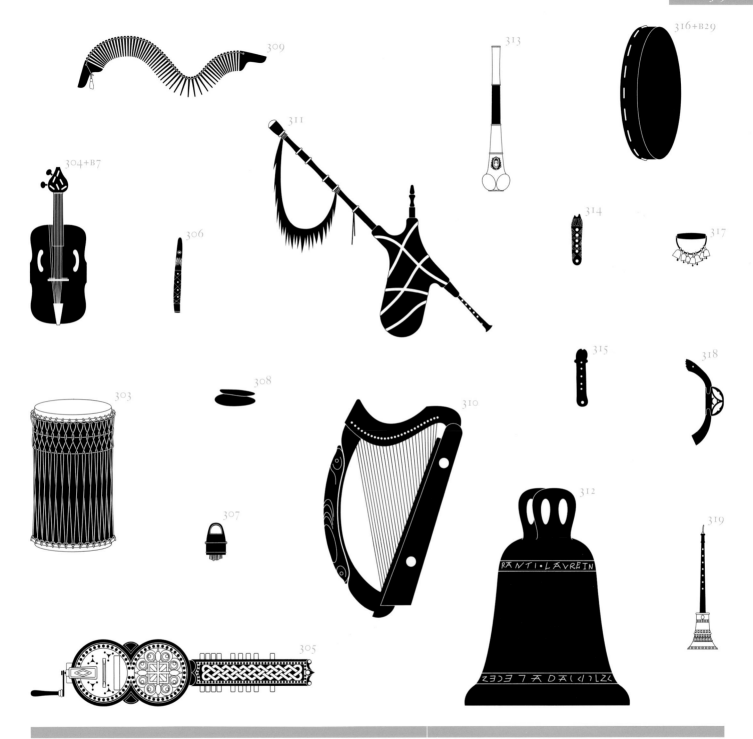

309

316+B29

313

311

304+B7

306

314

317

315

318

303

308

310

307

312

RANTI·LAVREIN

319

305

C 1200 CE

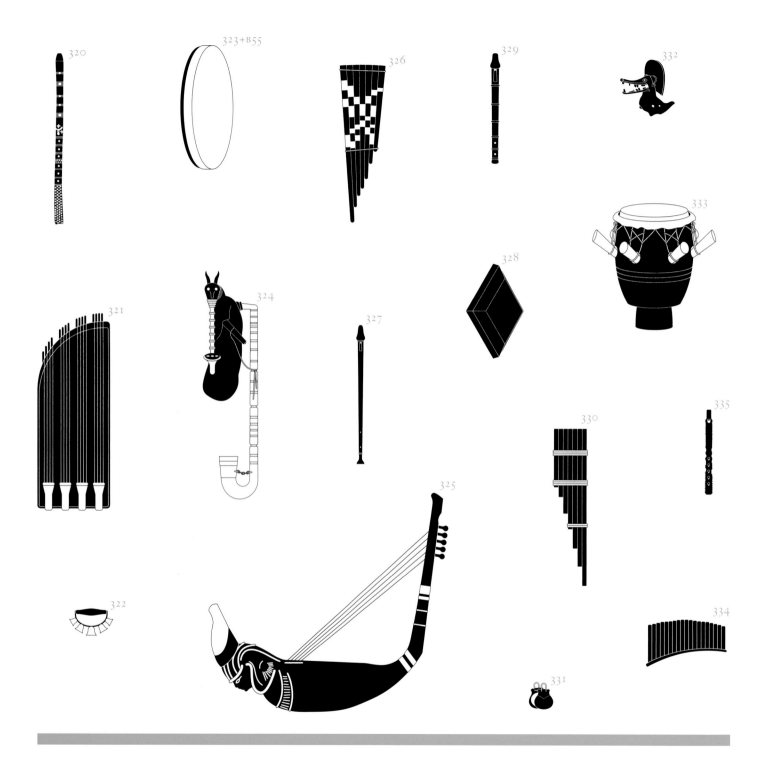

320

323+B55

326

329

332

321

324

327

328

333

322

325

330

335

331

334

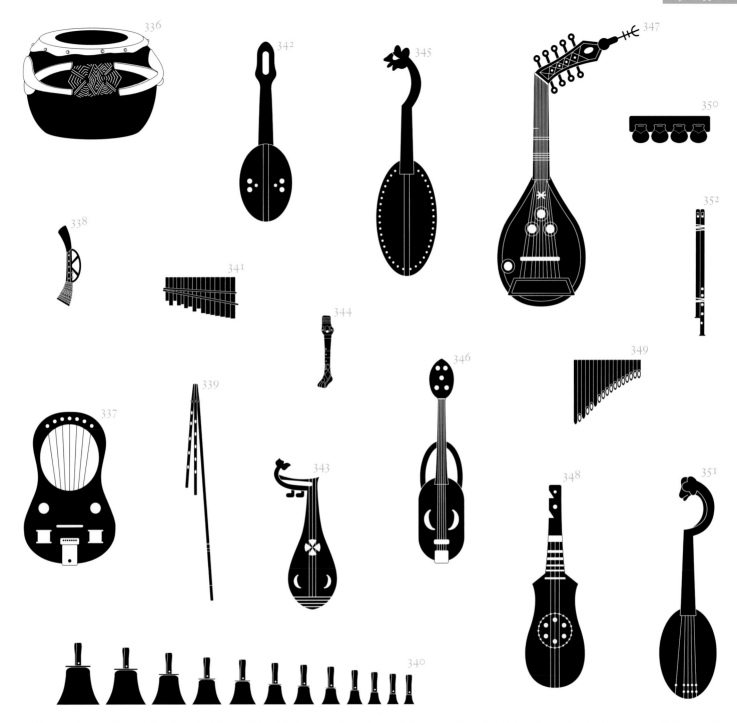

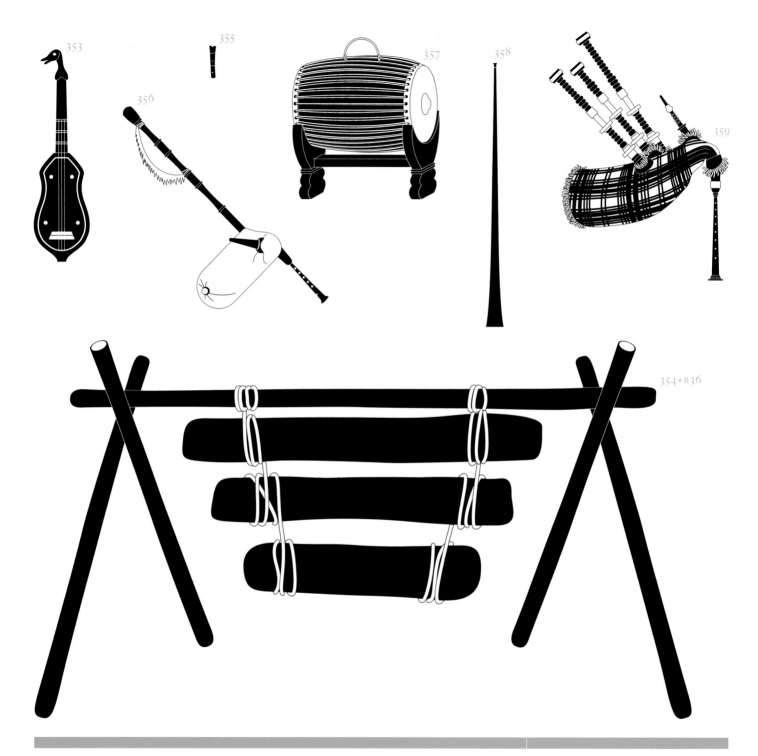

353

355

356

357

358

359

354+B36

C 1300 CE

52

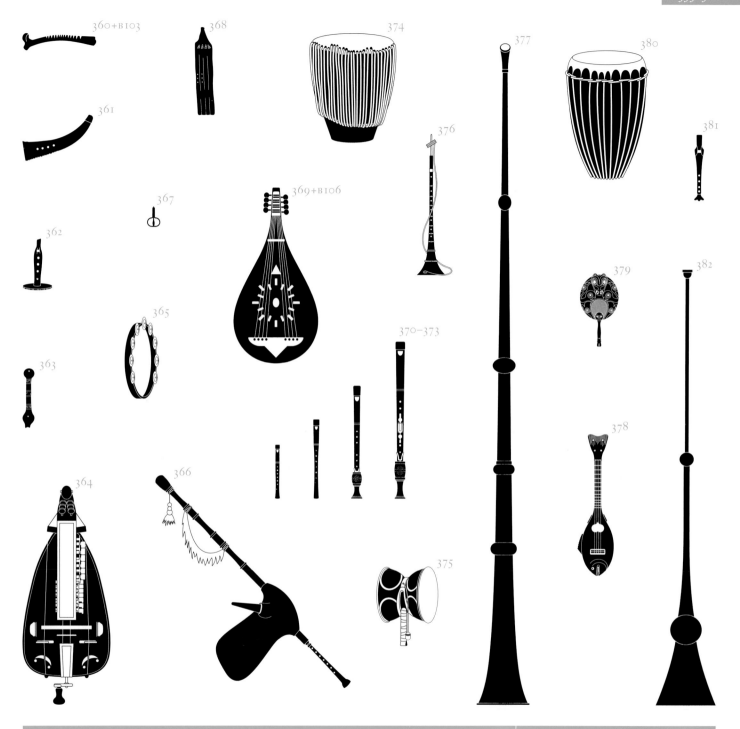

360+B103
361
362
363
364
365
366
367
368
369+B106
370-373
374
375
376
377
378
379
380
381
382

C 1400 CE

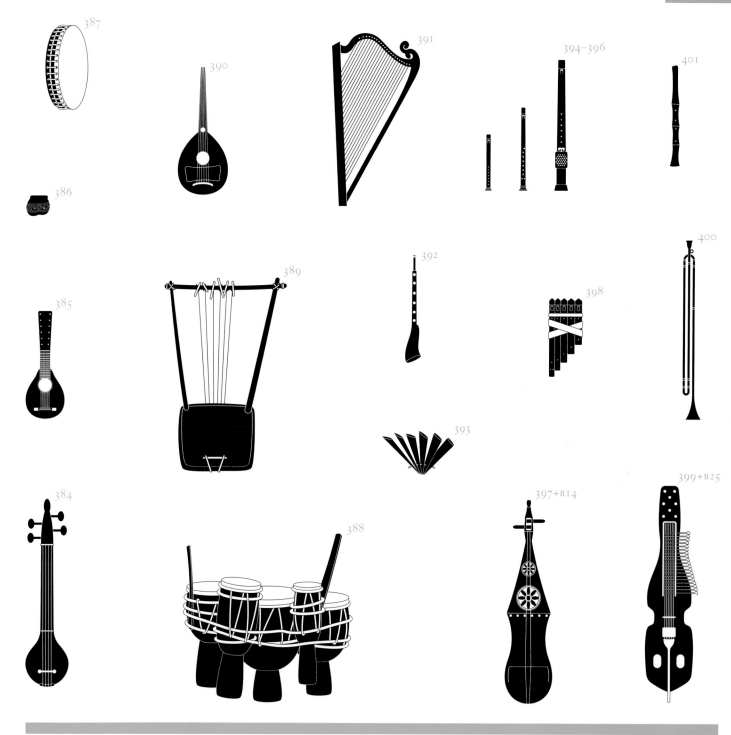

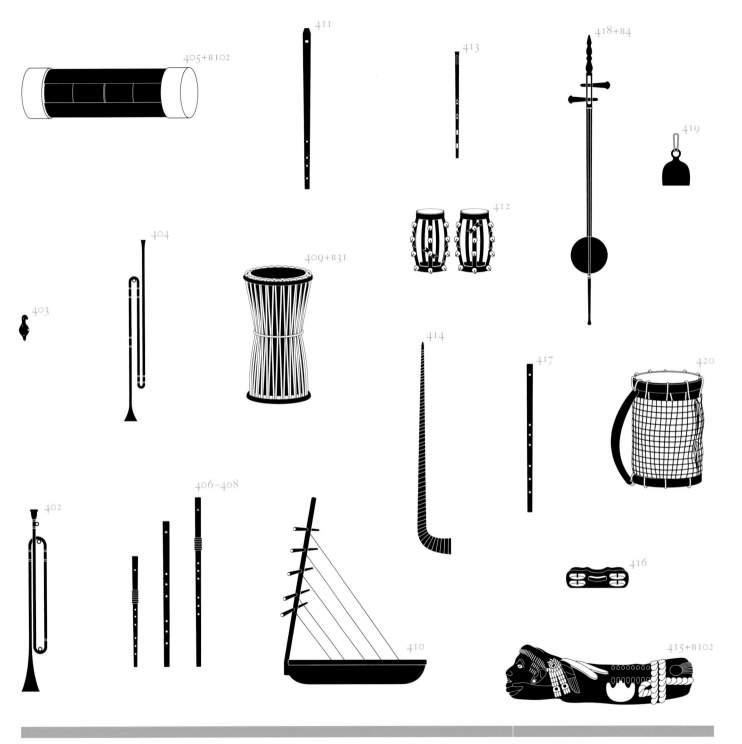

405+B102

411

413

418+B4

419

404

409+B31

412

403

414

417

420

402

406–408

416

410

415+B102

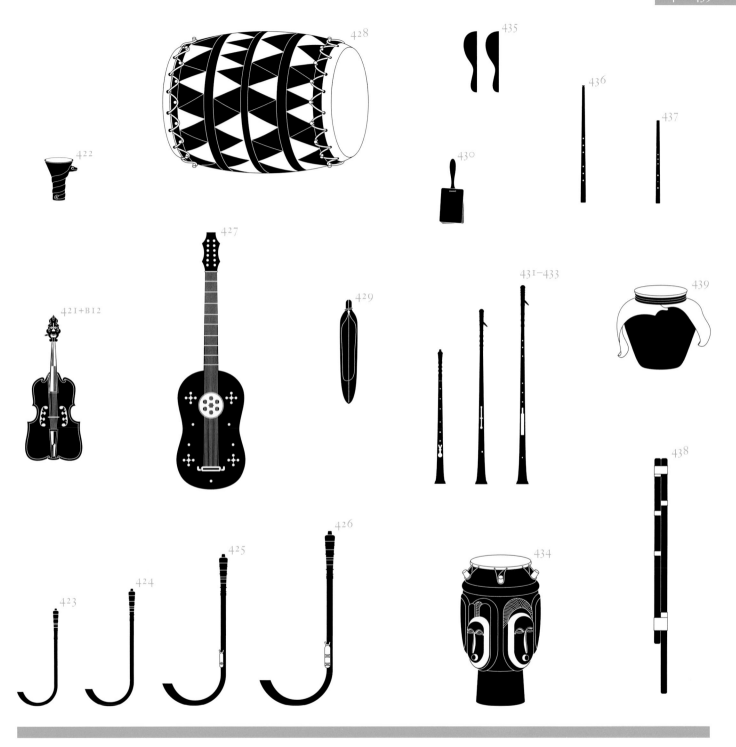

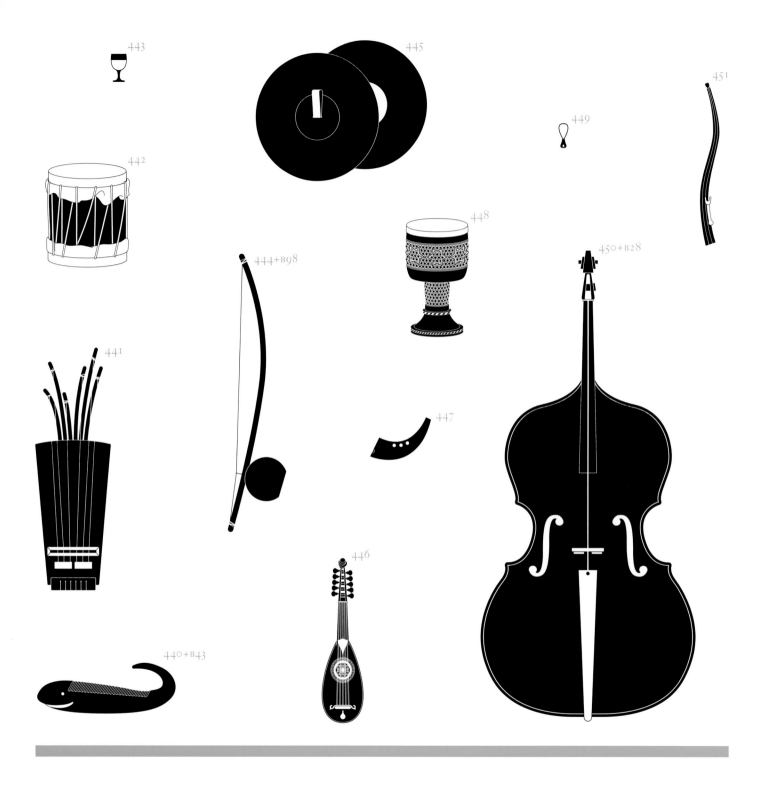

443

445

451

449

442

448

450+B28

444+B98

441

447

446

440+B43

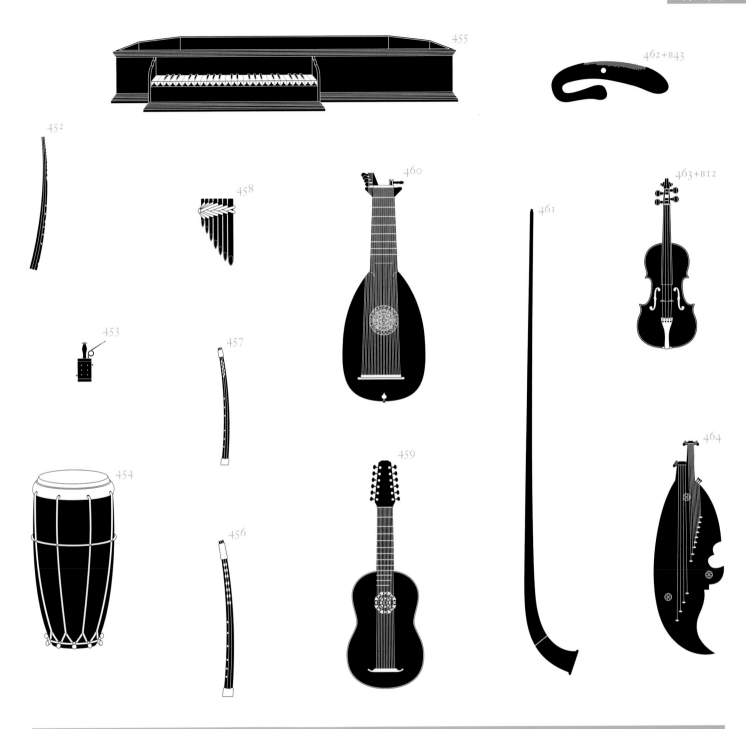

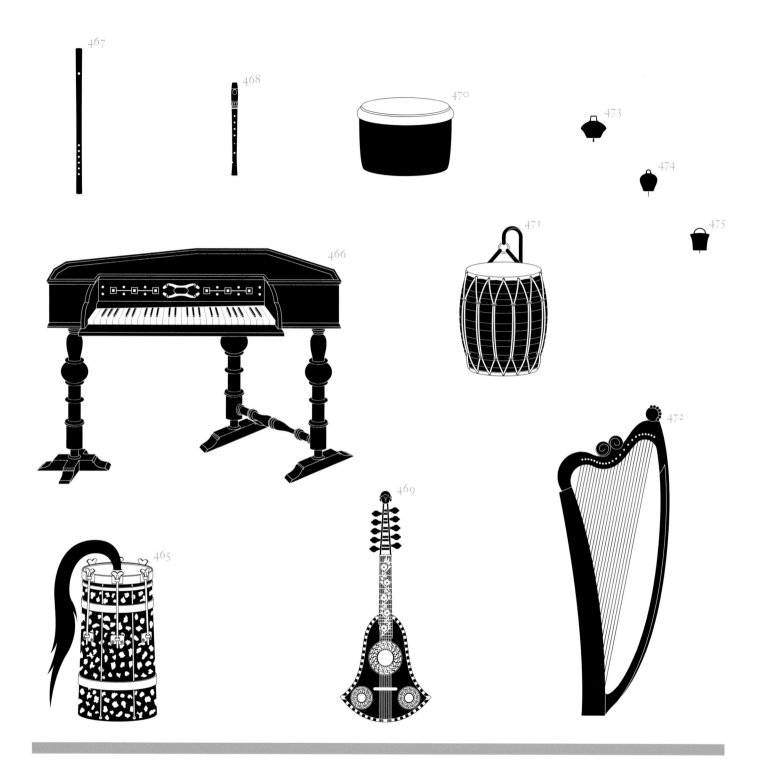

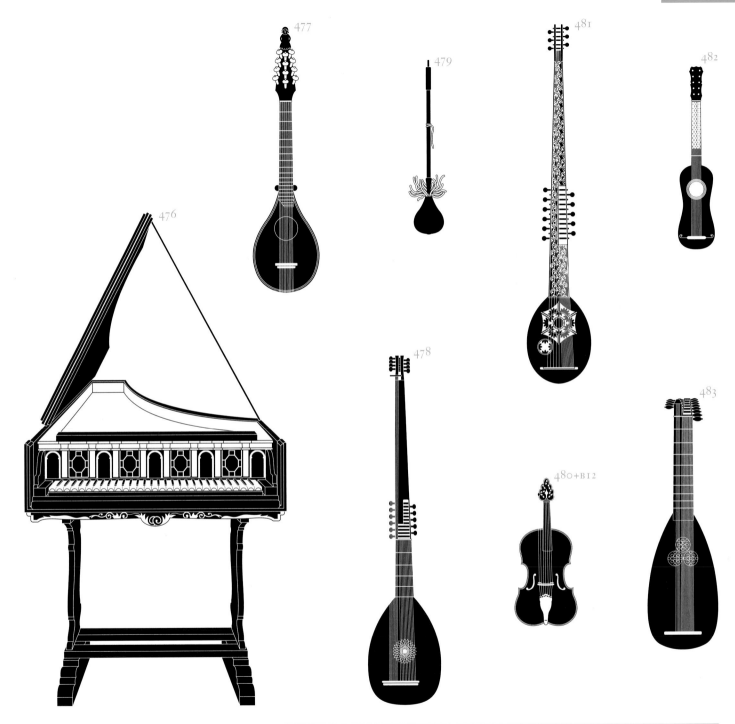

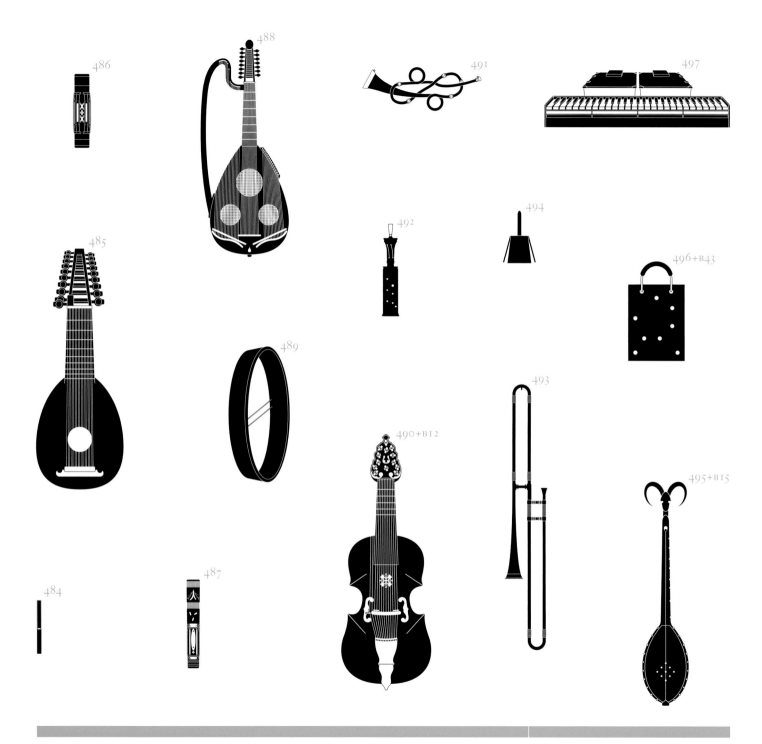

c 1600 ce

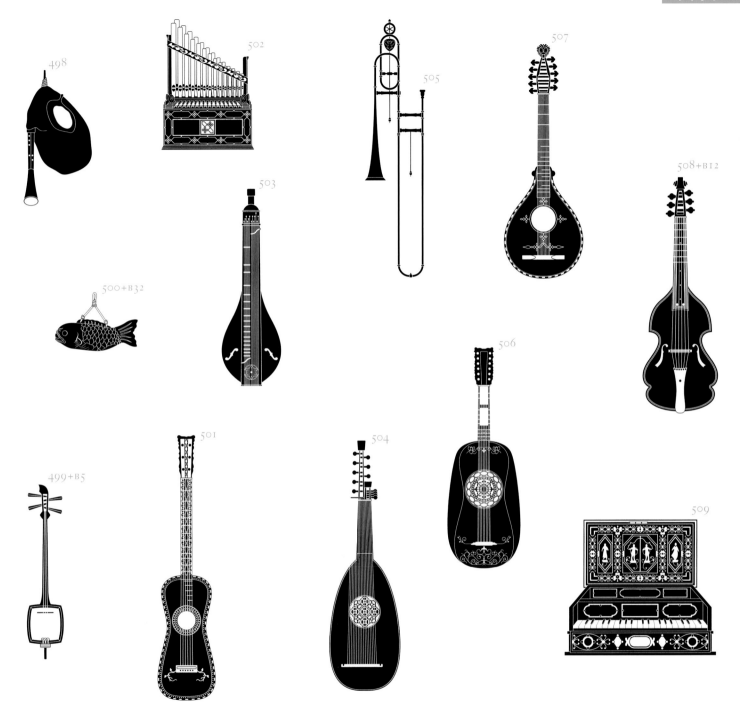

498

502

505

507

508+B12

503

500+B32

506

501

504

499+B5

509

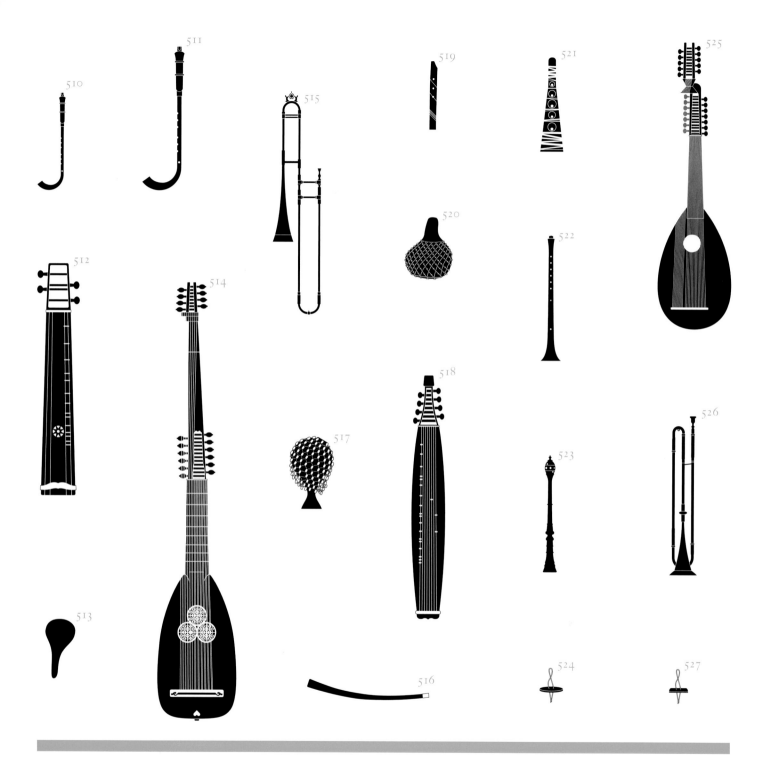

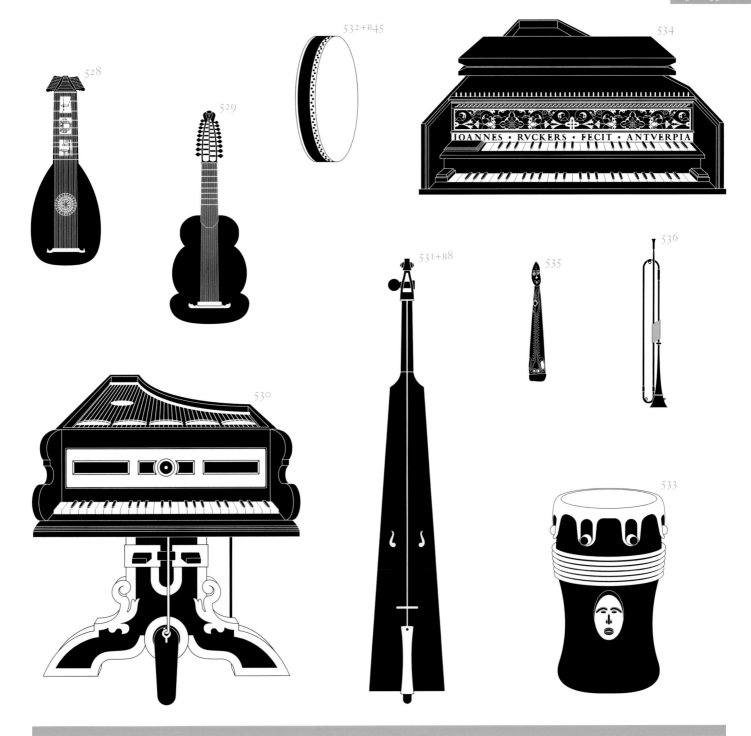

528

529

532+B45

534

IOANNES · RVCKERS · FECIT · ANTVERPIA

531+B8

535

536

530

533

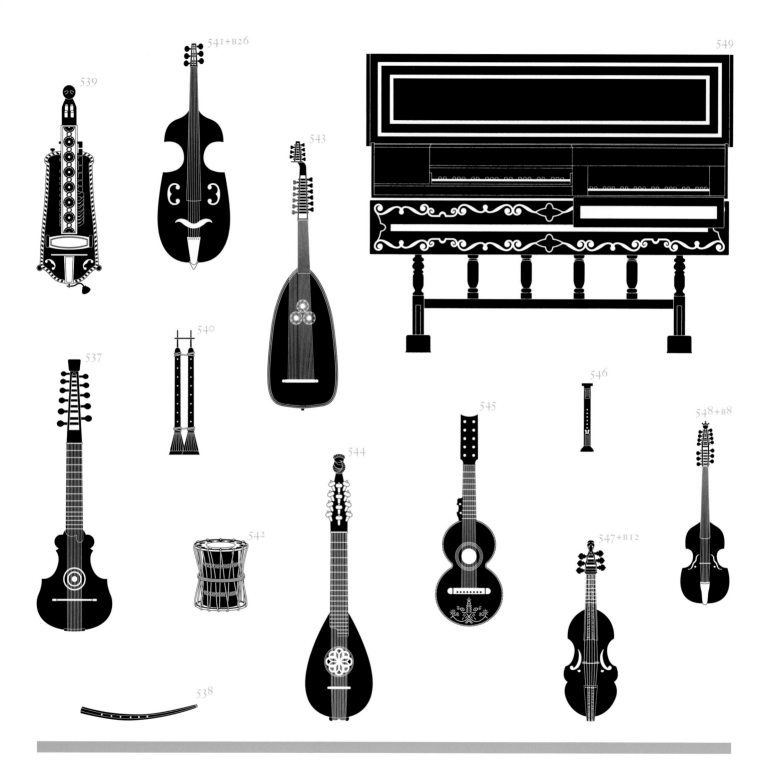

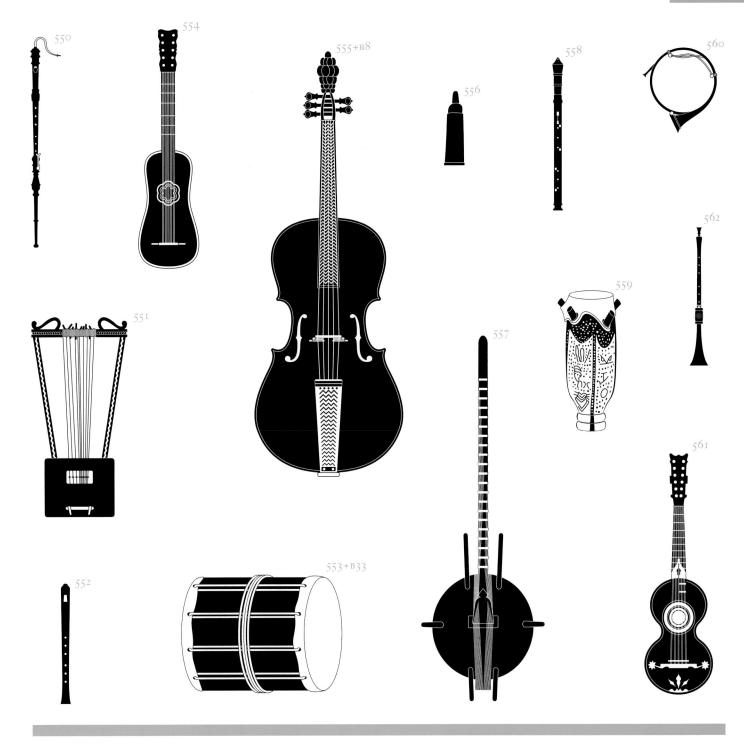

550

554

555+B8

556

558

560

551

559

562

557

552

553+B33

561

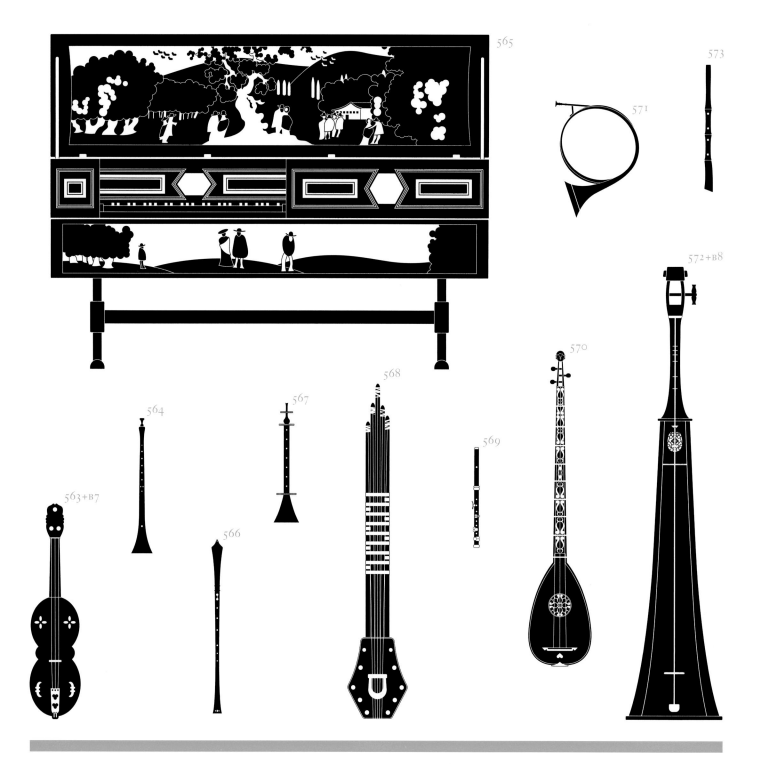

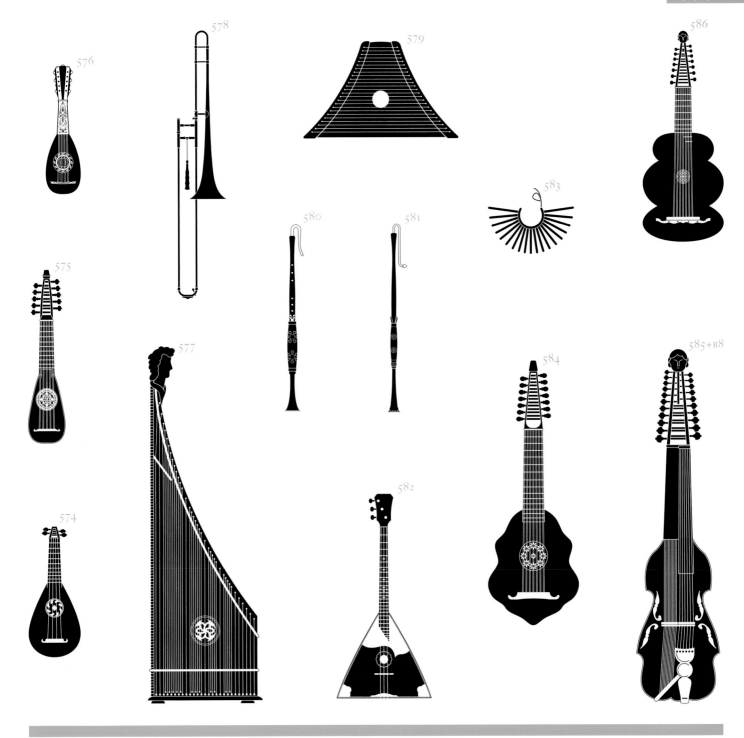

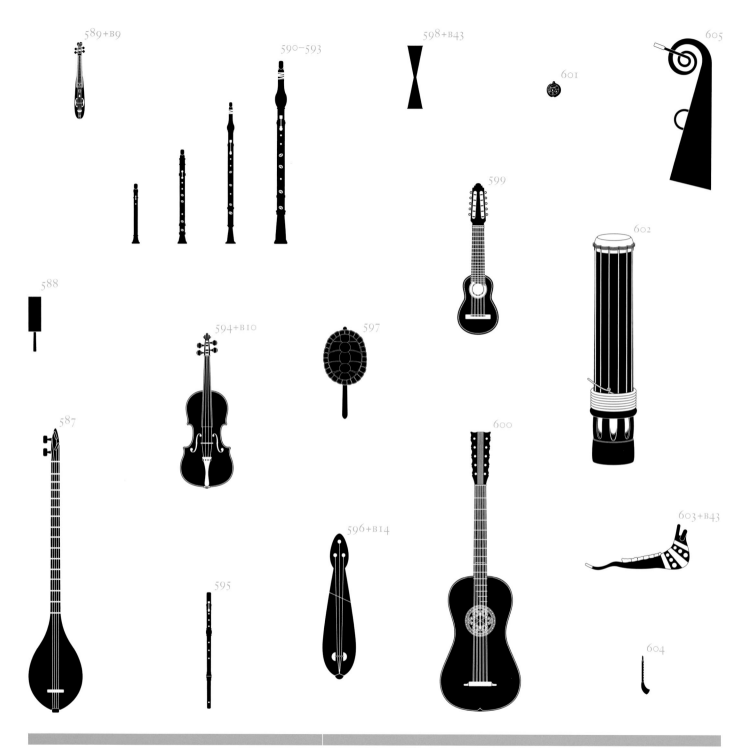

589+B9

590–593

598+B43

605

601

599

602

588

594+B10

597

587

600

603+B43

596+B14

595

604

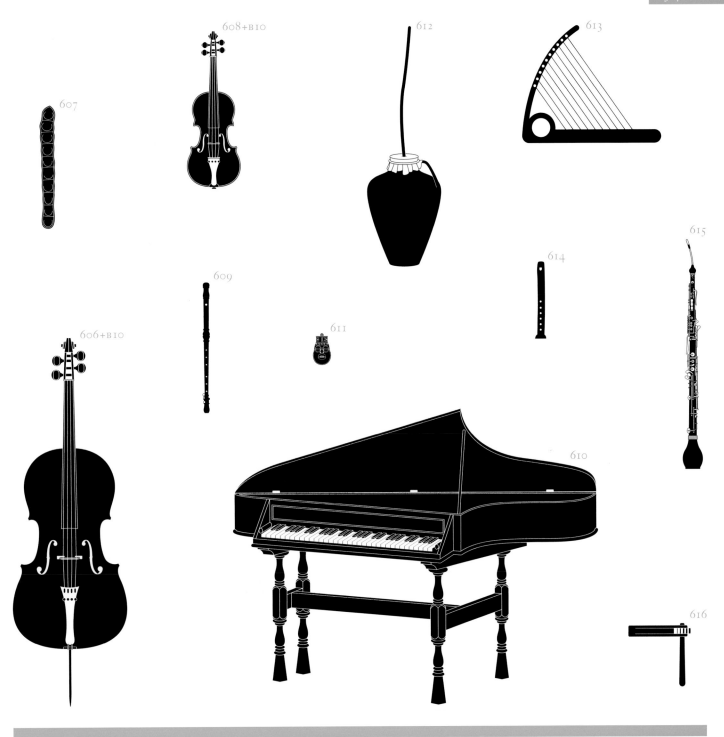

607

608+BIO

612

613

609

606+BIO

611

614

615

610

616

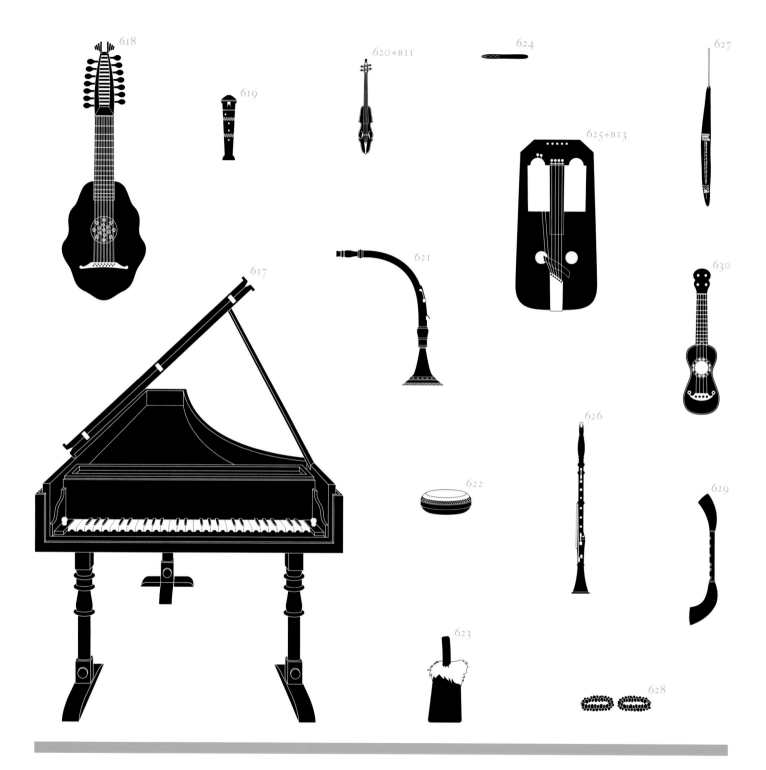

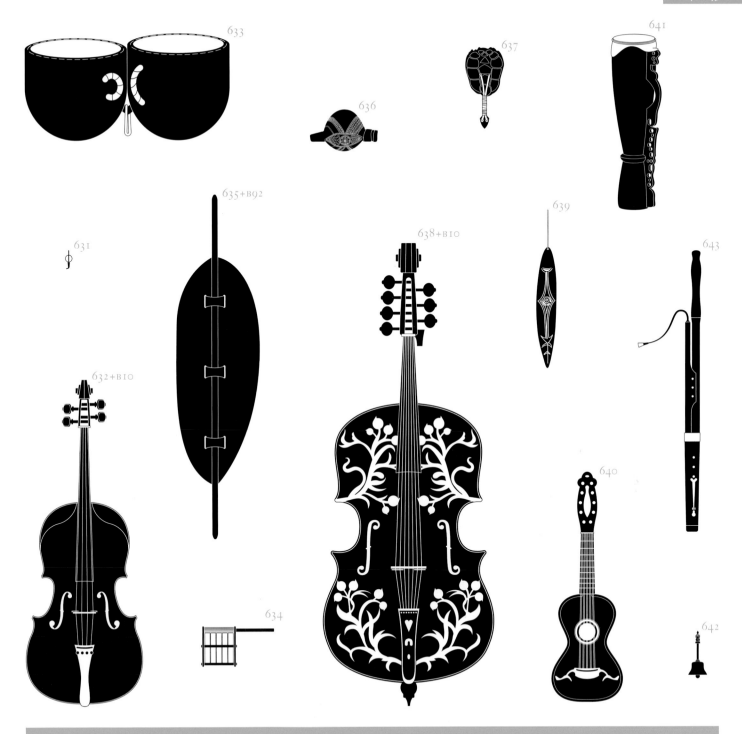

633

636

637

641

635+B92

631

639

638+B10

643

632+B10

640

634

642

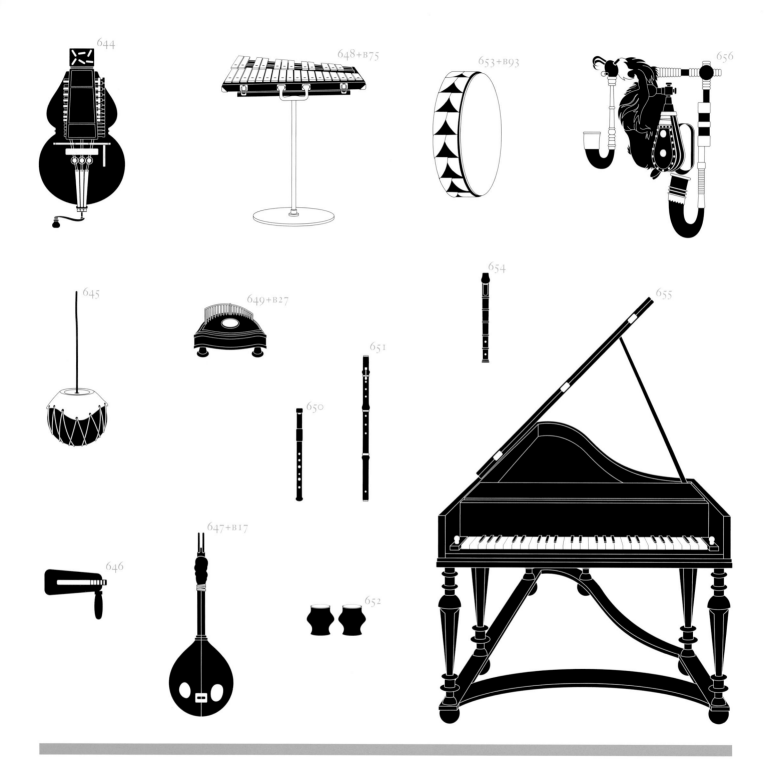

644

648+B75

653+B93

656

645

649+B27

651

654

655

650

646

647+B17

652

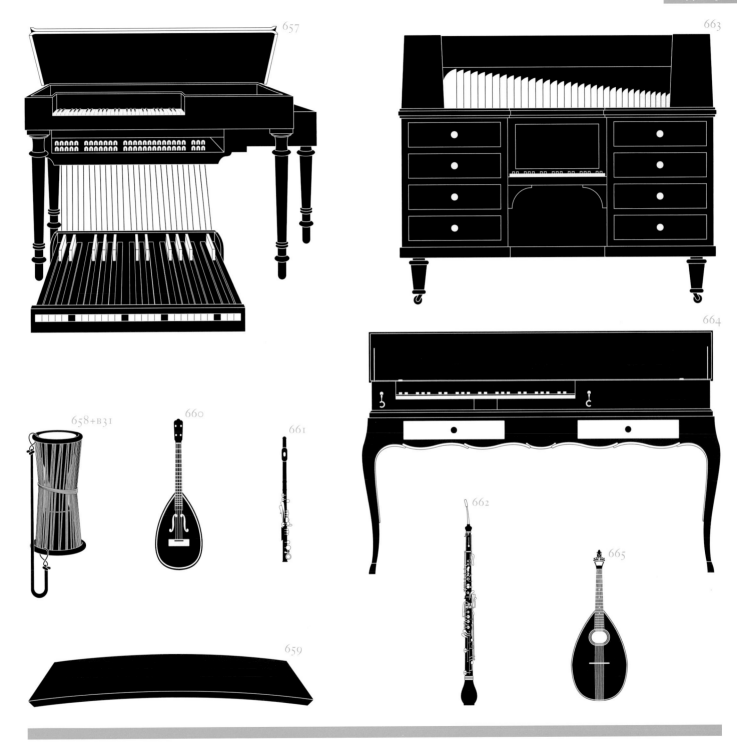

657

663

664

658+B31

660

661

662

659

665

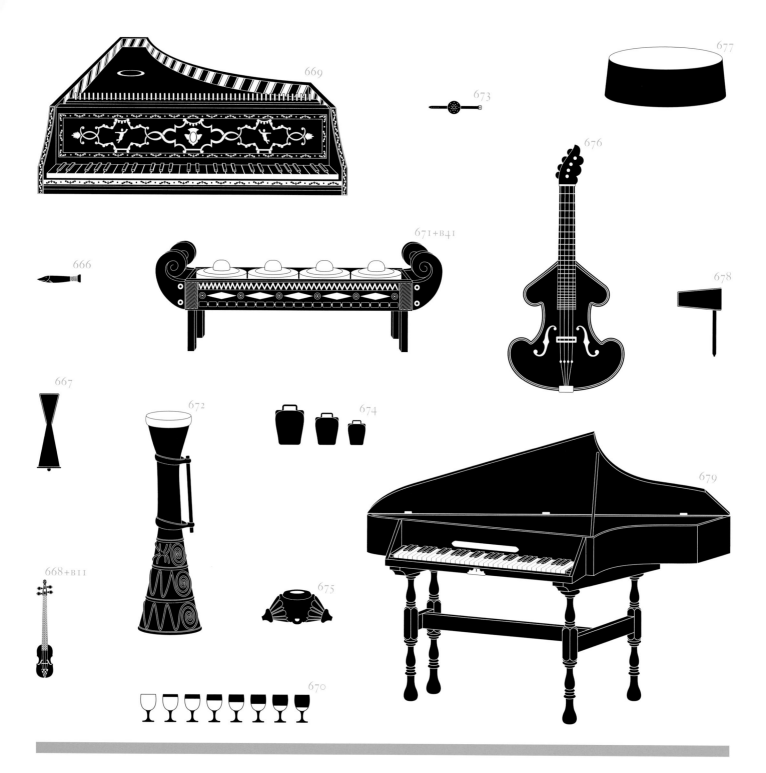

669

677

673

676

671+B41

666

678

667

672

674

668+B11

675

679

670

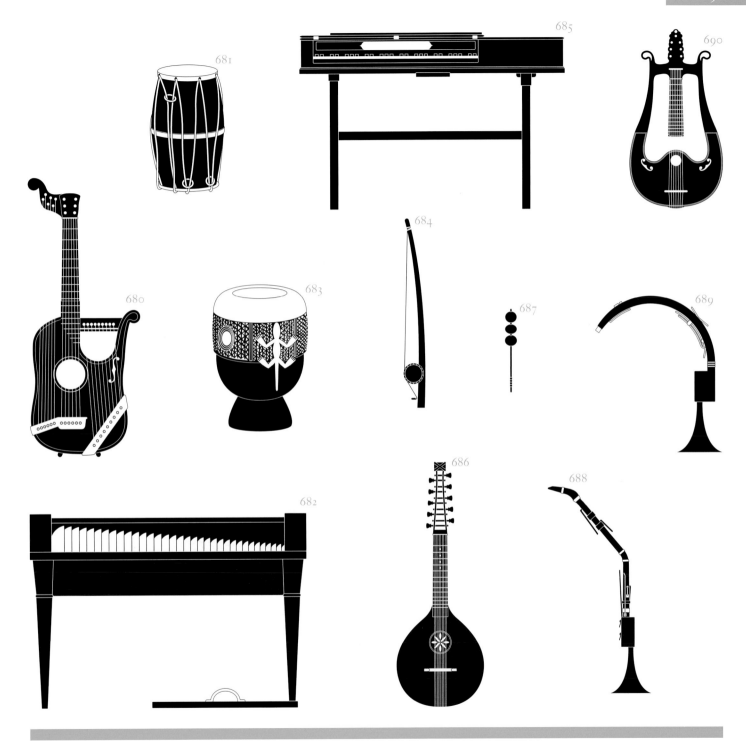

681

685

690

680

684

683

687

689

682

686

688

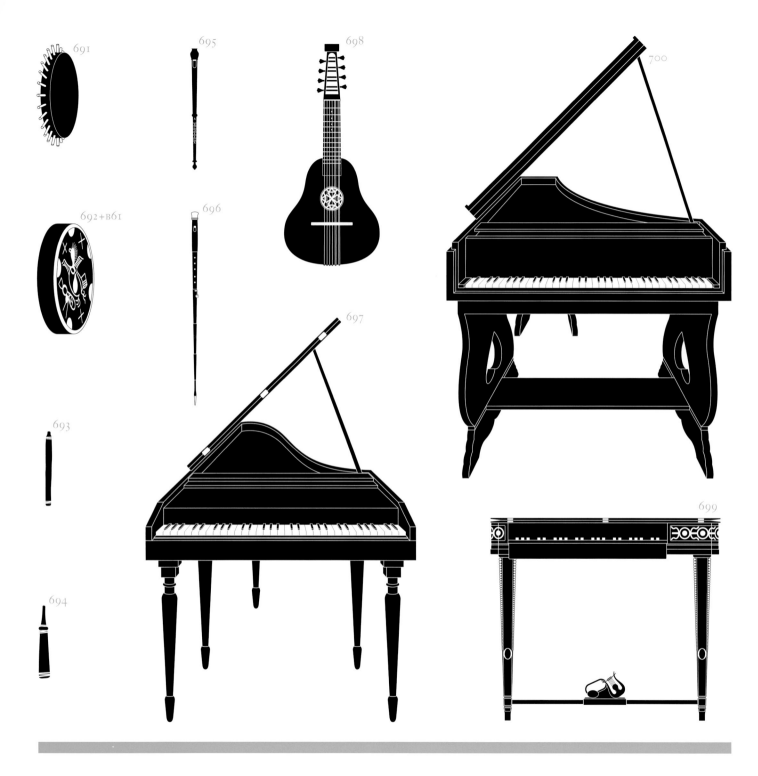

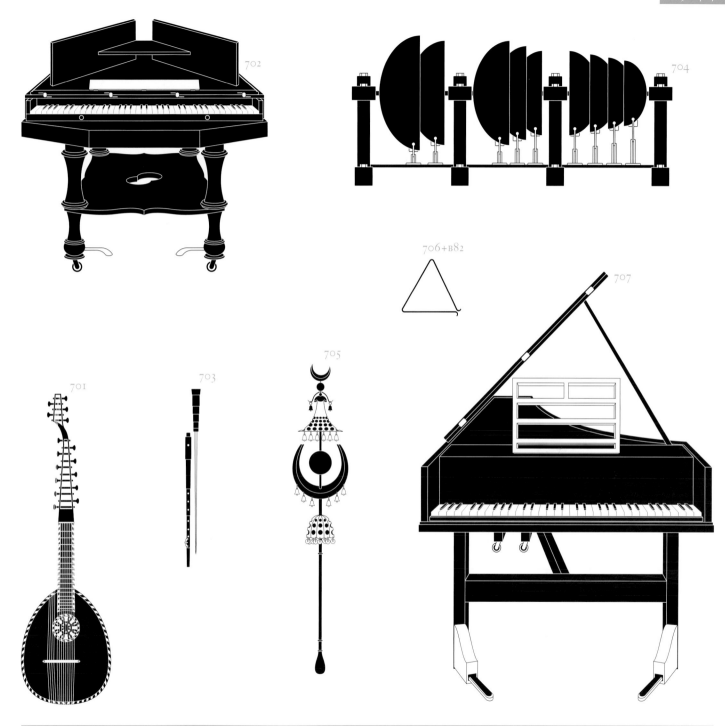

701 702 703 704 705 706+B82 707

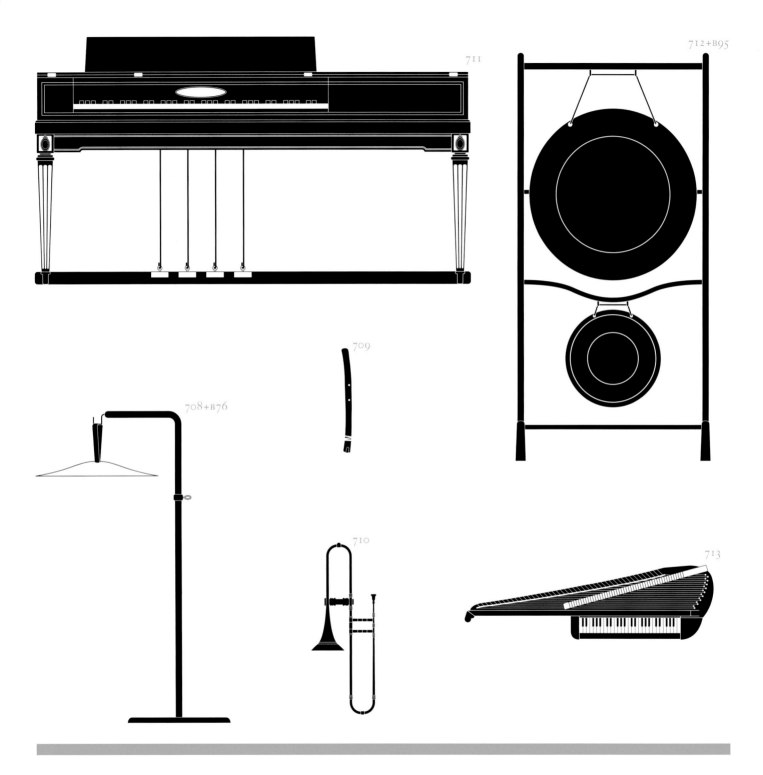

711

712+B95

709

708+B76

710

713

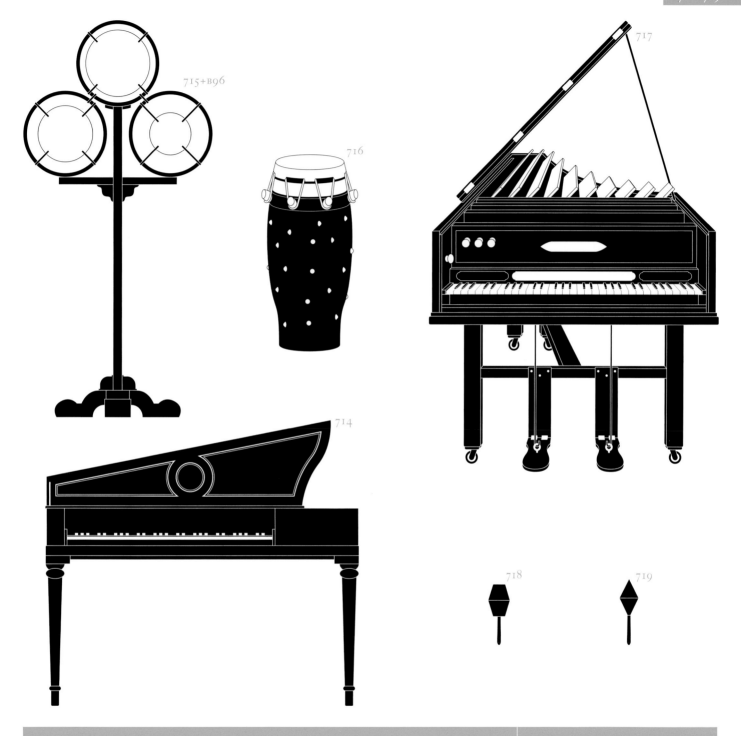

715+B96

716

717

714

718

719

c 1800 ce

720

721

722

723

724

725

726

727

728

729

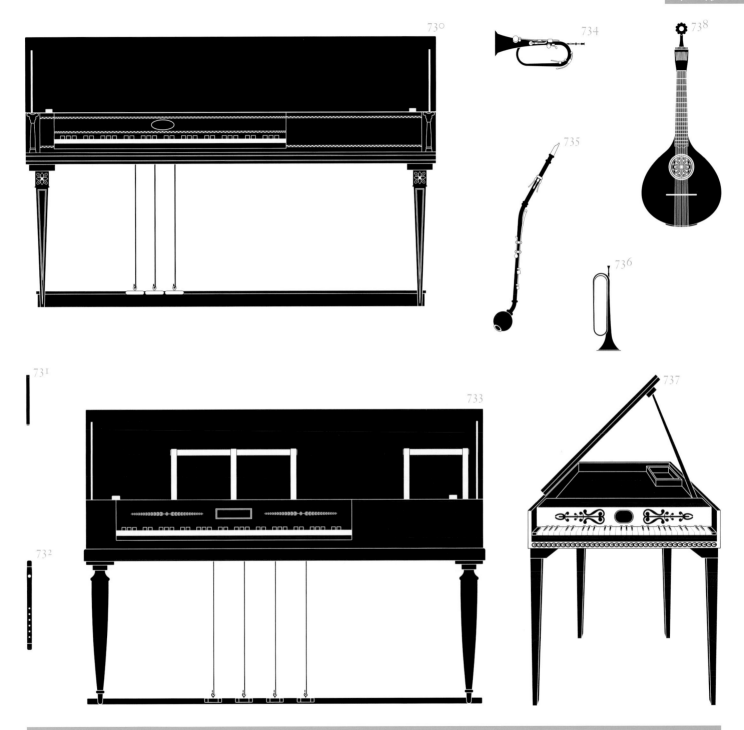

730

734

738

735

736

731

733

732

737

739

744

745

746

743

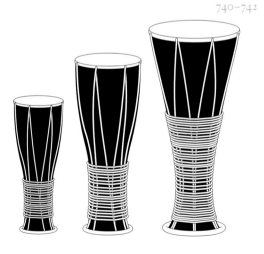

740–742

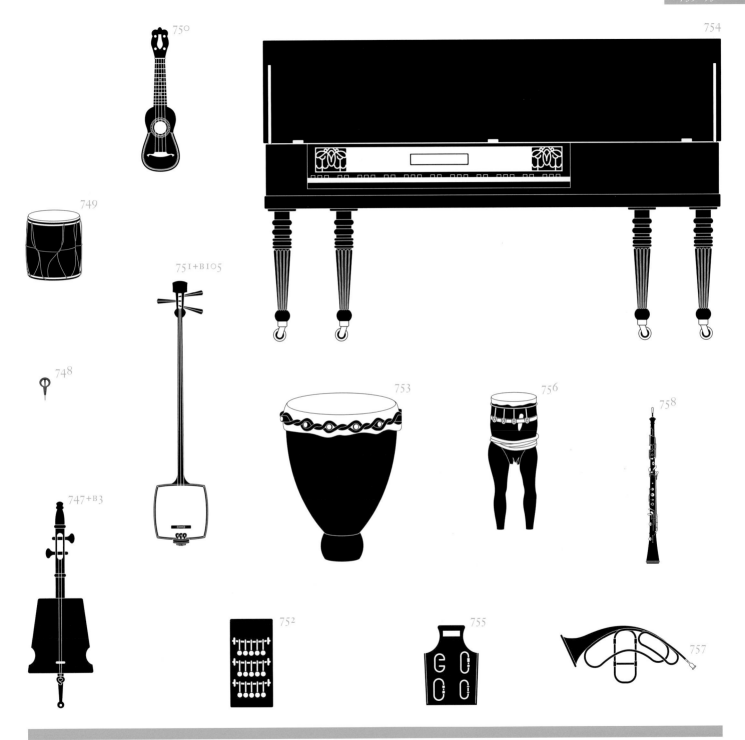

750

754

749

751+B105

748

753

756

758

747+B3

752

755

757

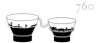

760

764

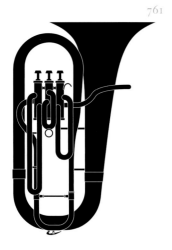

761

762

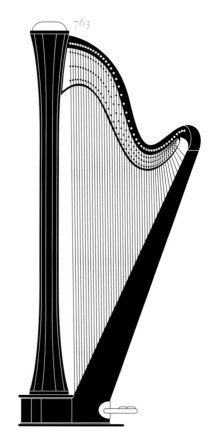

763

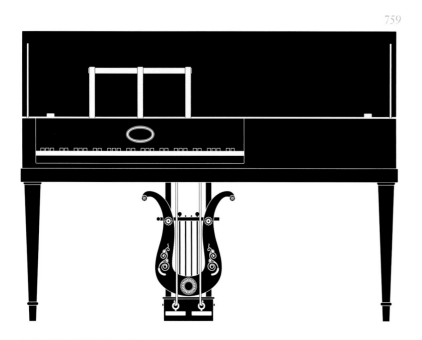

759

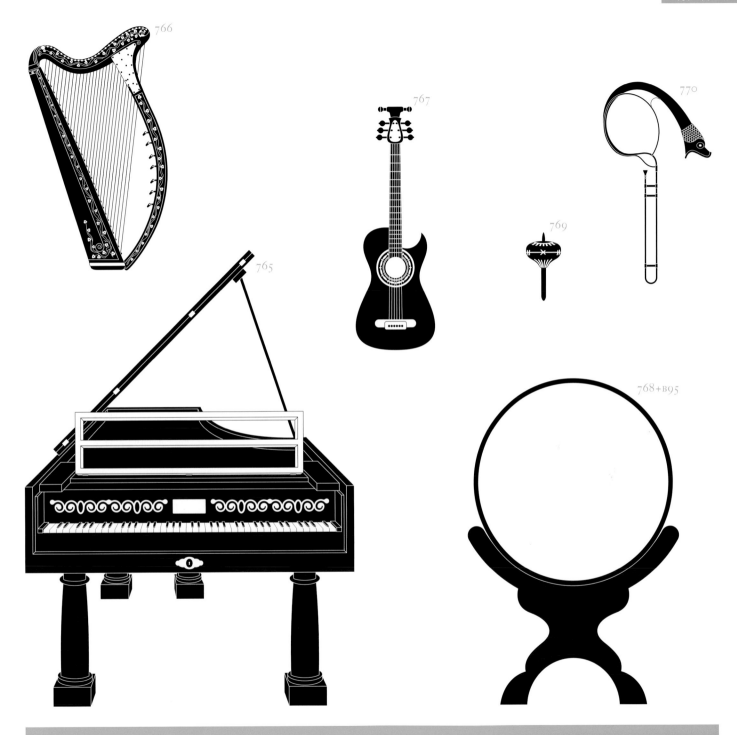

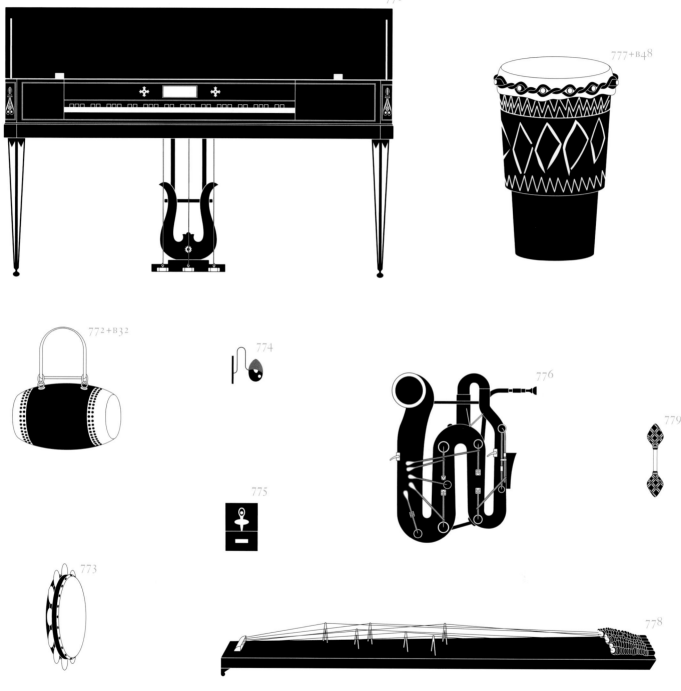

771

777+B48

772+B32

774

776

779

775

773

778

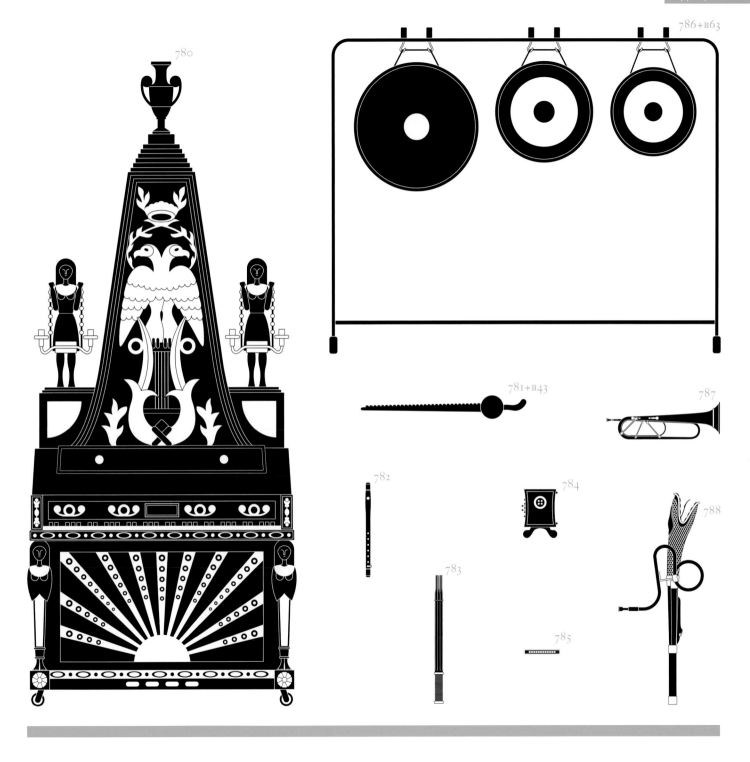

786+B63

780

781+B43

787

782

784

788

783

785

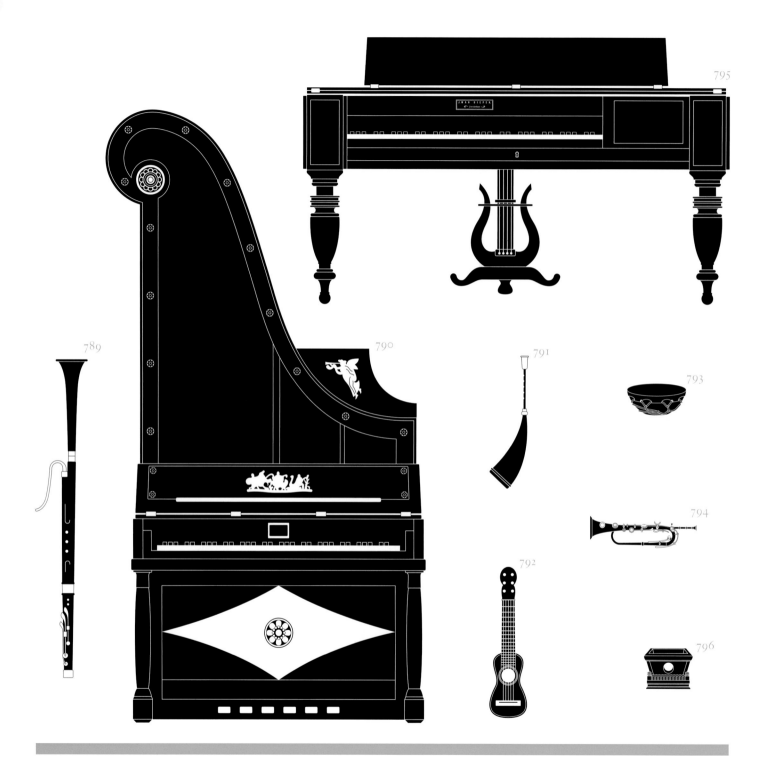

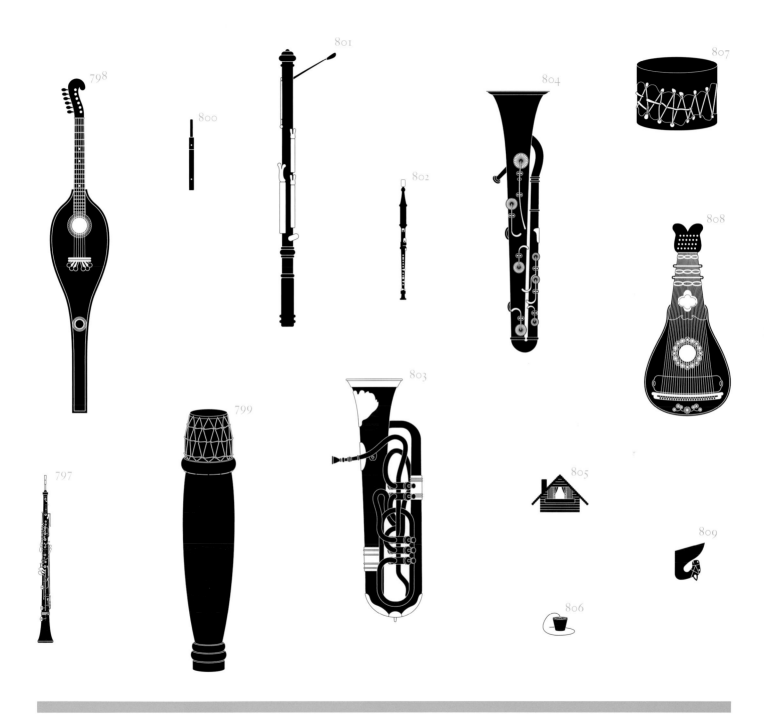

798

800

801

807

804

802

808

803

799

805

797

809

806

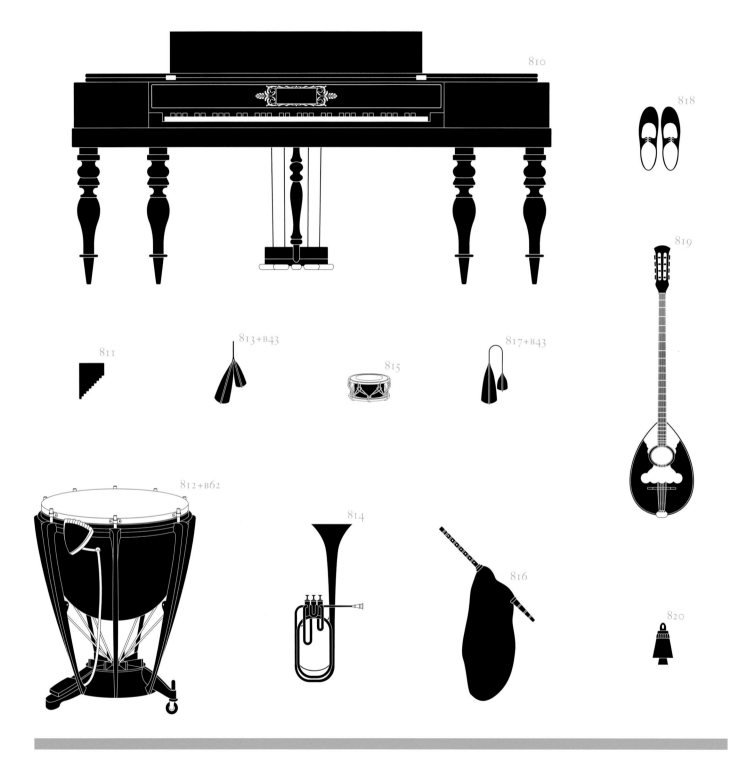

810

818

819

811

813+B43

815

817+B43

812+B62

814

816

820

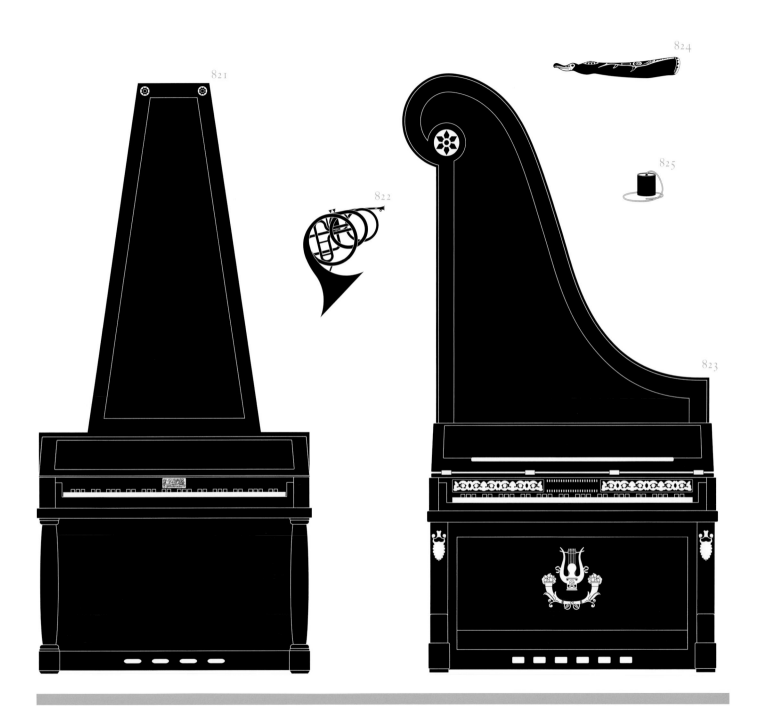

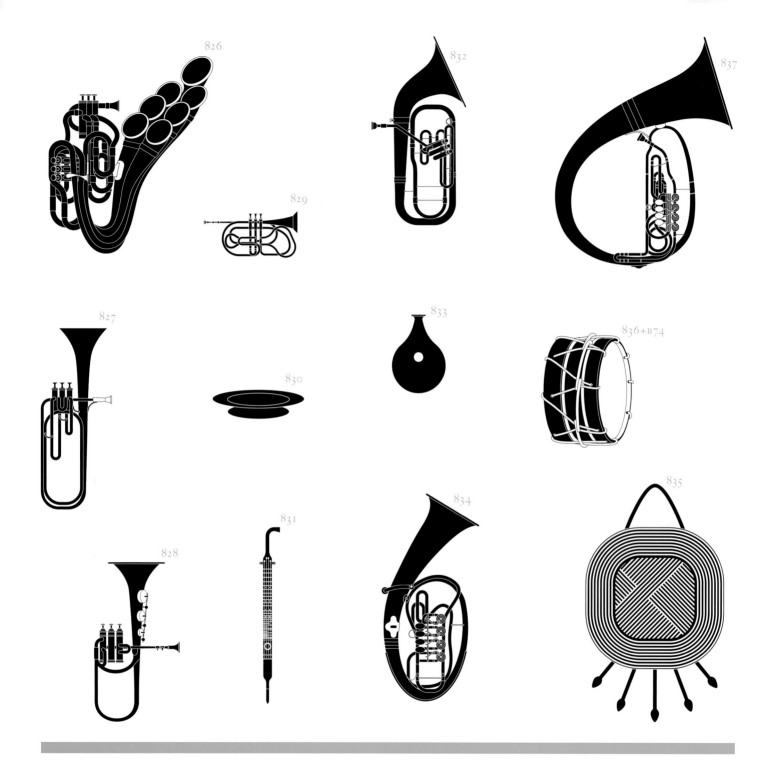

826

829

832

837

827

830

833

836+B74

831

834

835

828

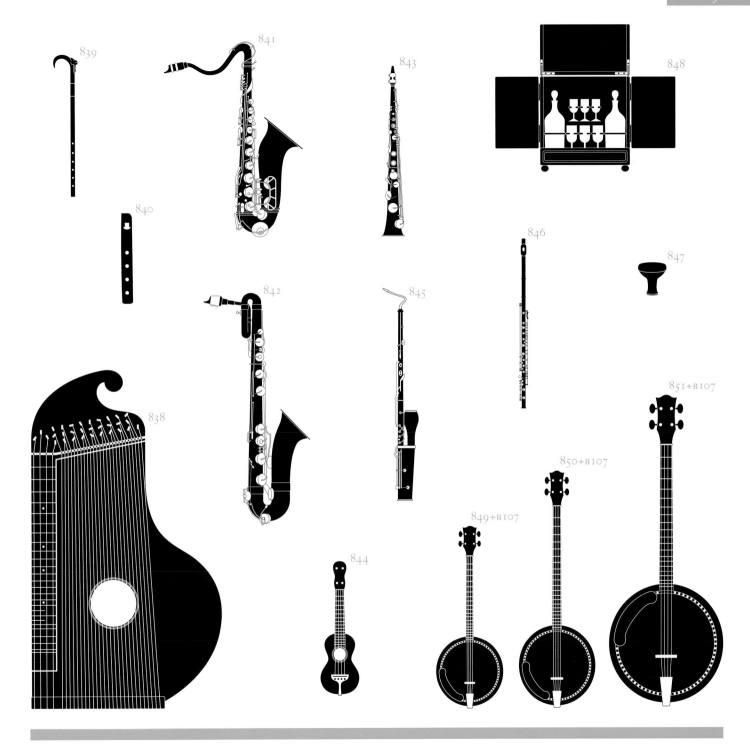

839

841

843

848

840

846

847

842

845

838

851+B107

850+B107

849+B107

844

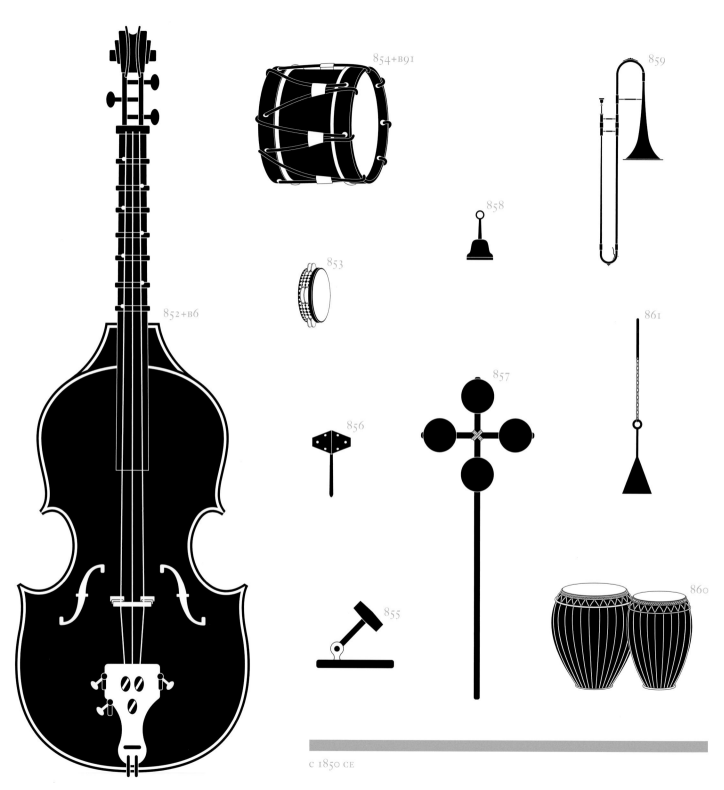

852+B6

854+B91

859

853

858

856

857

861

855

860

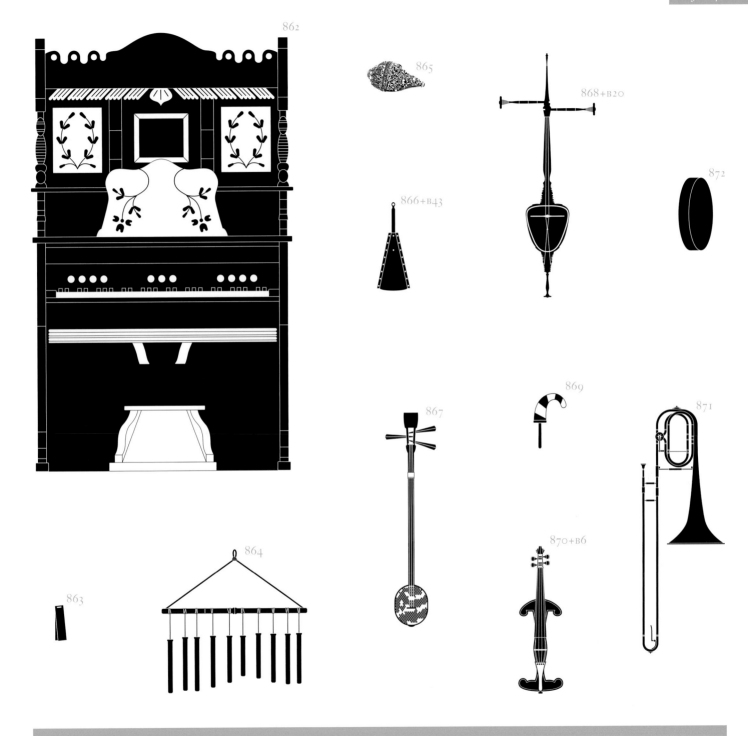

862

865

868+B20

866+B43

872

869

867

871

870+B6

864

863

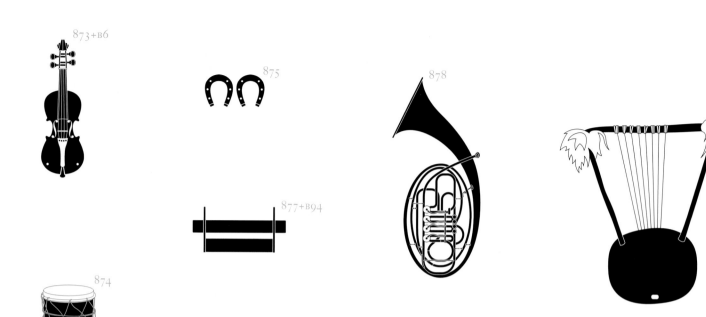

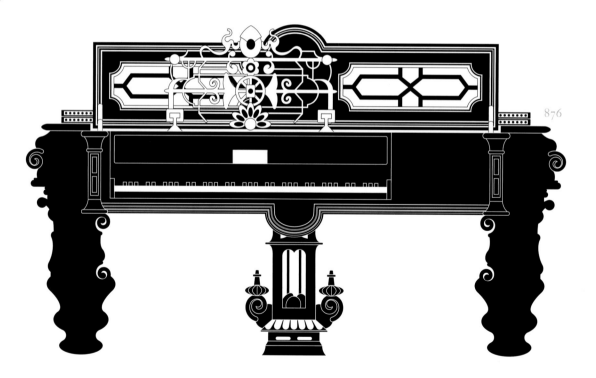

873+B6

875

878

879

877+B94

874

876

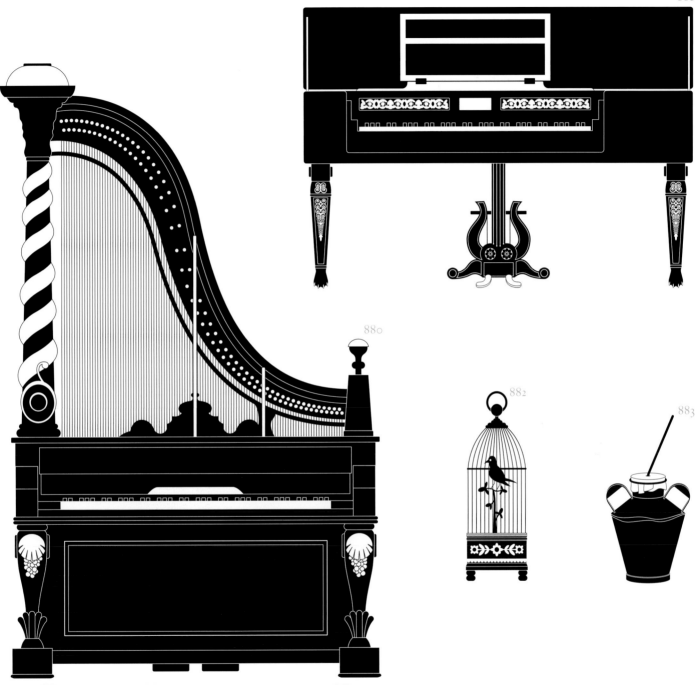

881

880

882

883

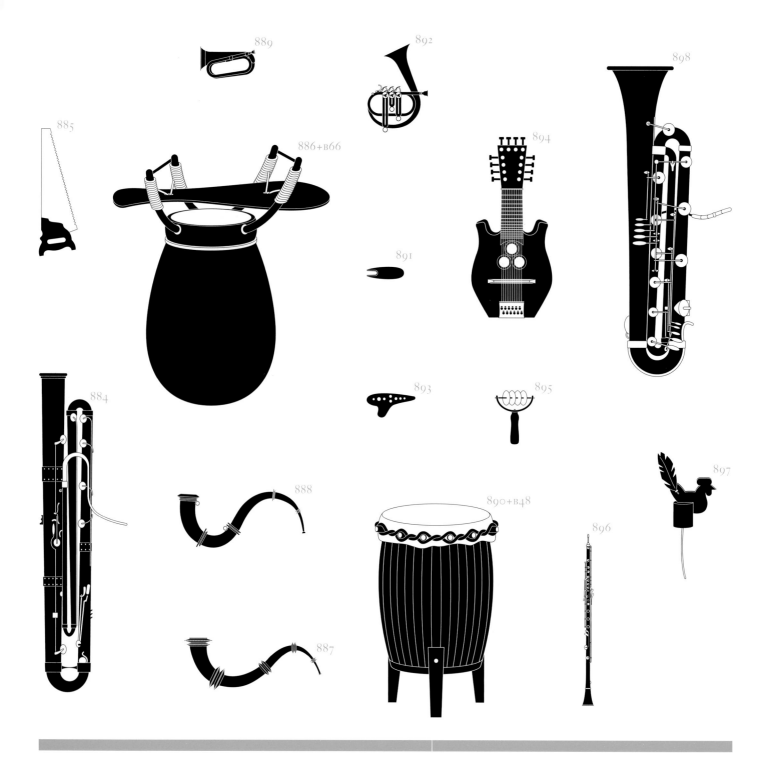

889

892

898

885

886+B66

894

891

884

893

895

897

888

890+B48

896

887

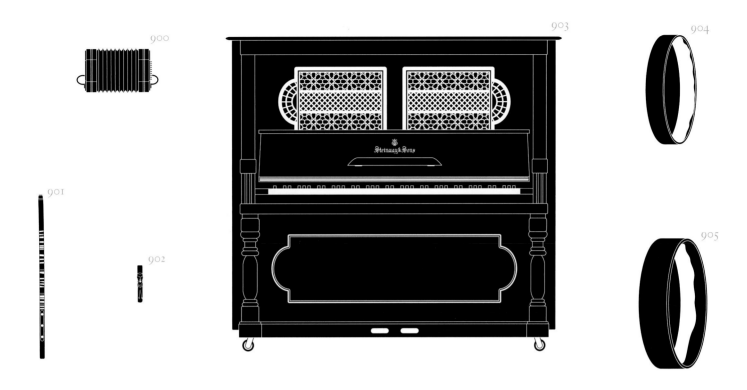

900

901

902

903

904

905

899+B79

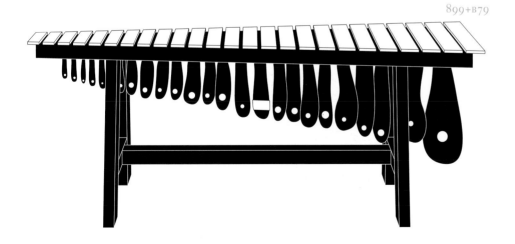

906

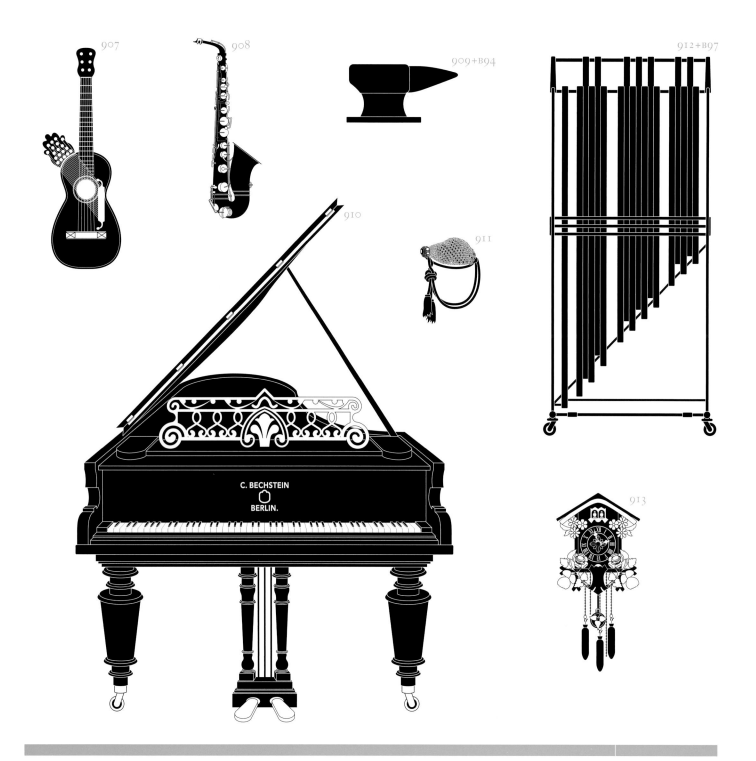

907

908

909+B94

912+B97

910

911

C. BECHSTEIN
BERLIN.

913

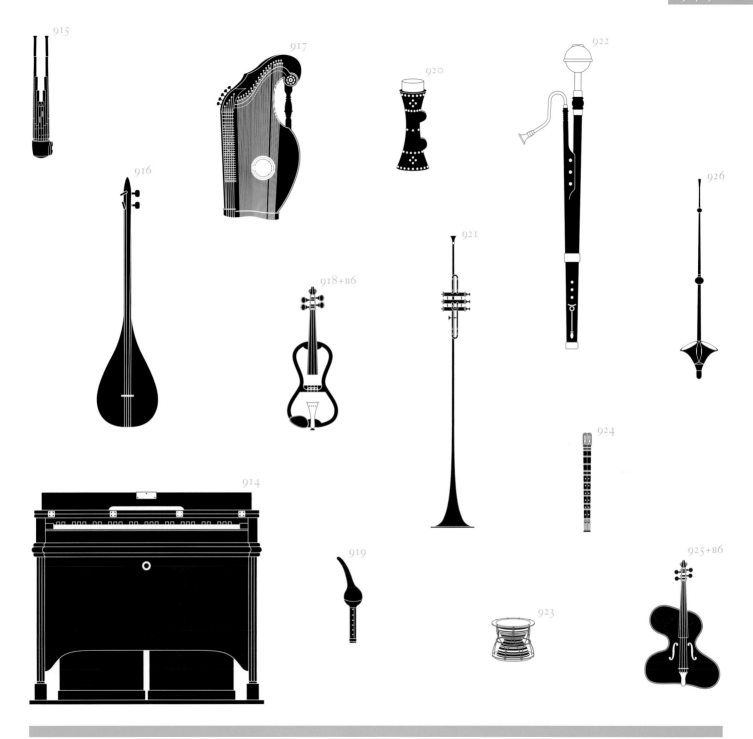

915

917

920

922

916

926

918+B6

921

914

924

919

923

925+B6

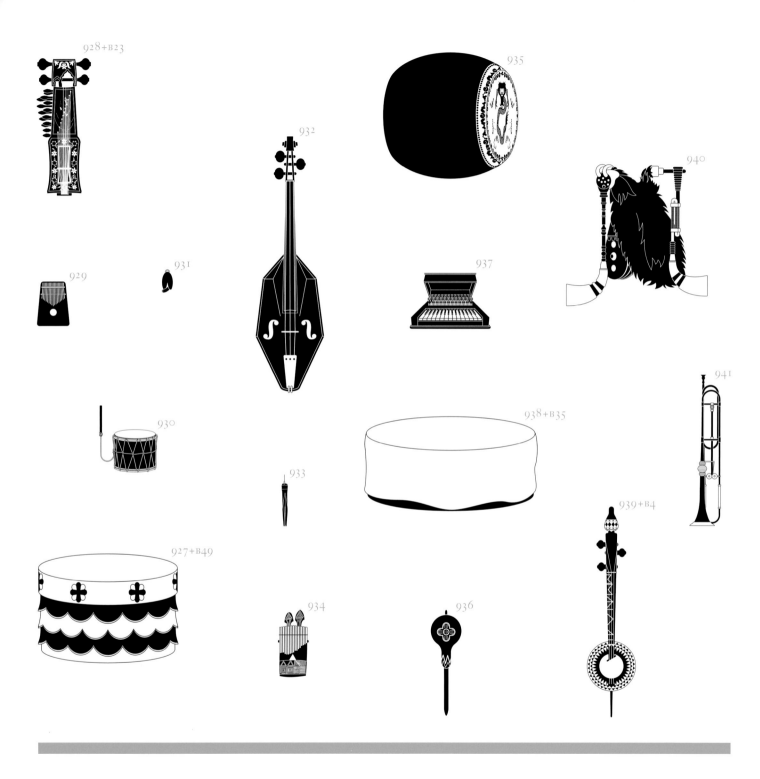

928+B23

935

929

931

932

940

937

930

933

938+B35

941

927+B49

934

936

939+B4

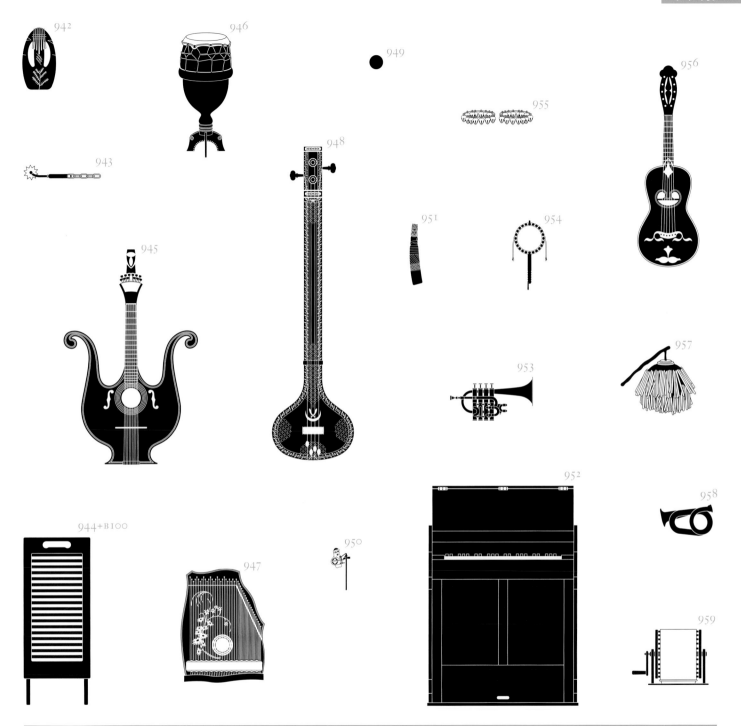

942

946

949

955

956

943

948

951 954

945

953 957

944+B100

950 952 958

947 959

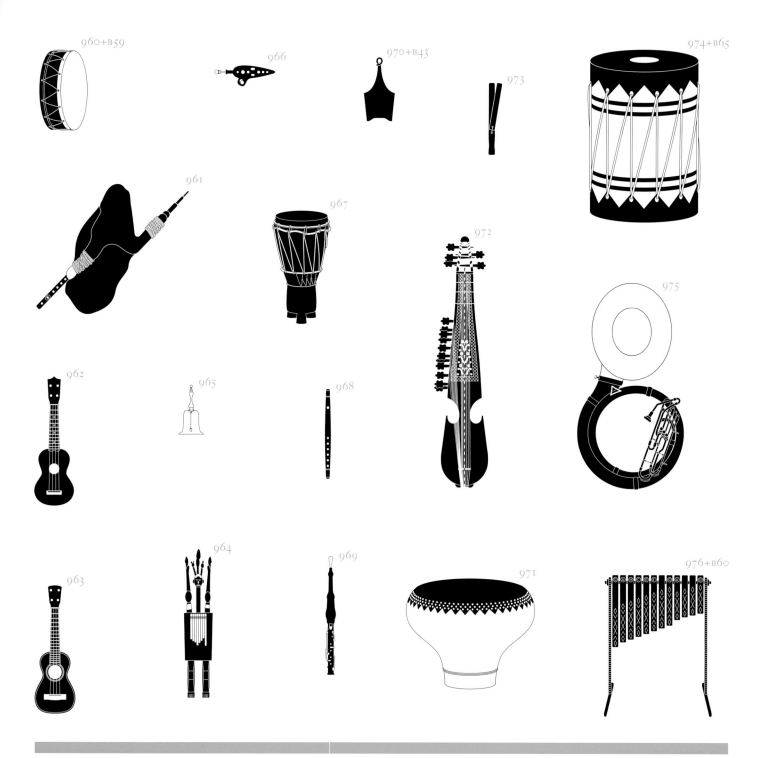

960+B59

966

970+B43

973

974+B65

961

967

972

975

962

965

968

964

969

971

976+B60

963

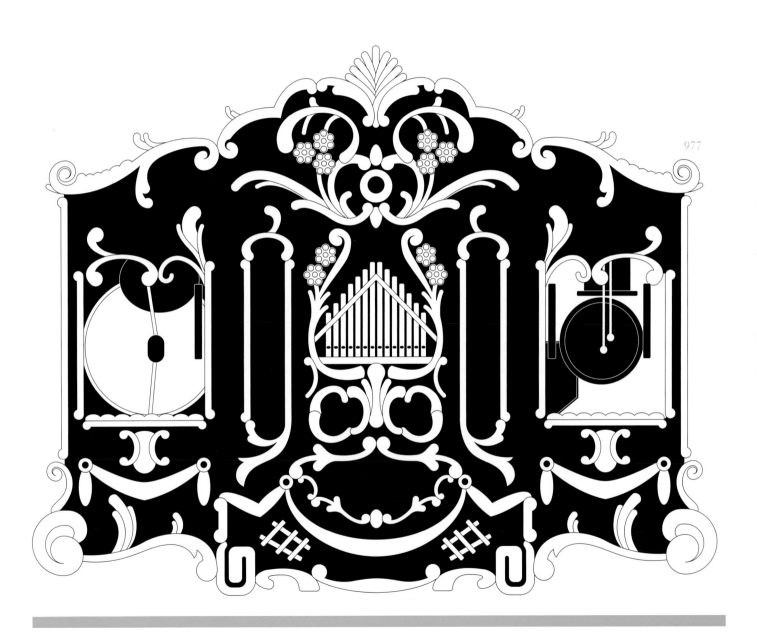

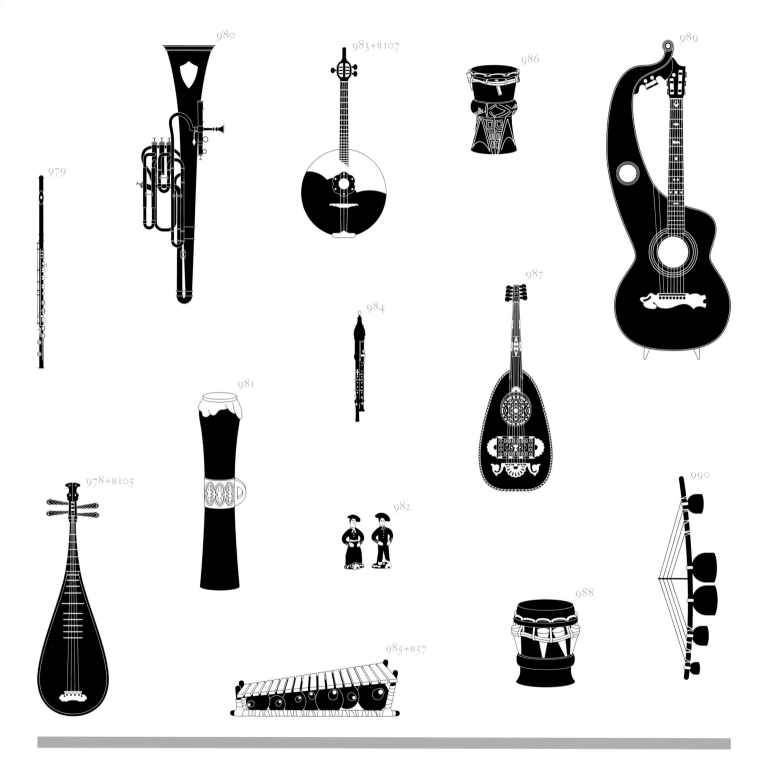

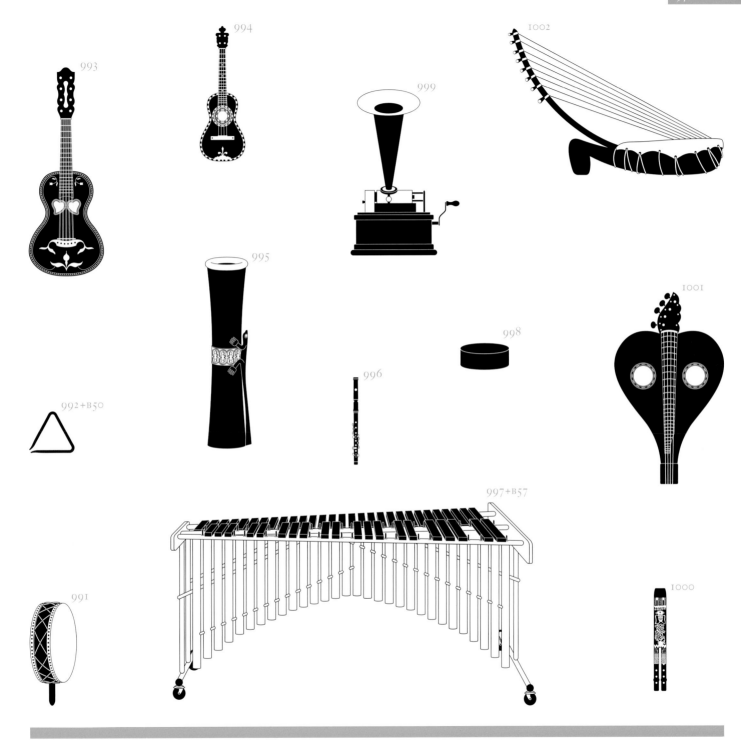

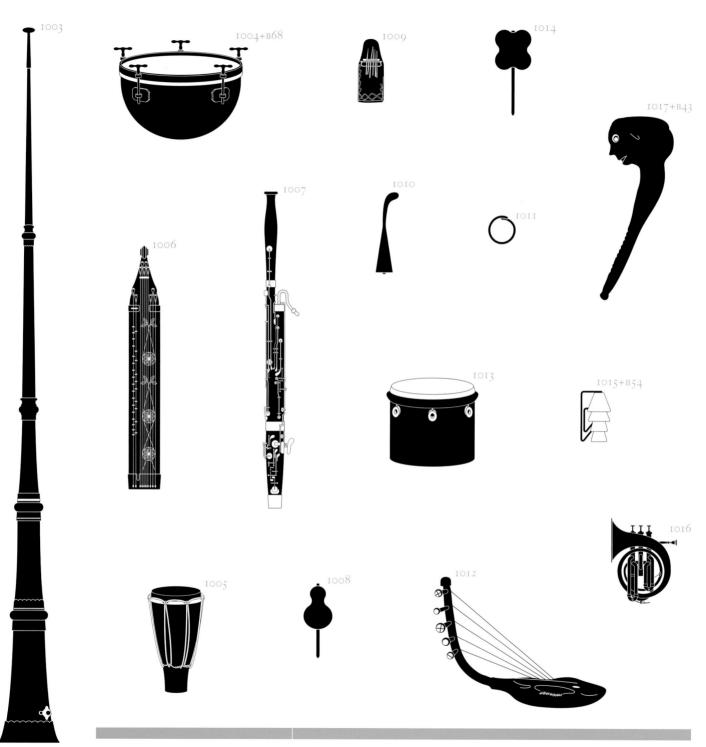

1003

1004+B68

1009

1014

1017+B43

1007

1010

1011

1006

1013

1015+B54

1016

1005

1008

1012

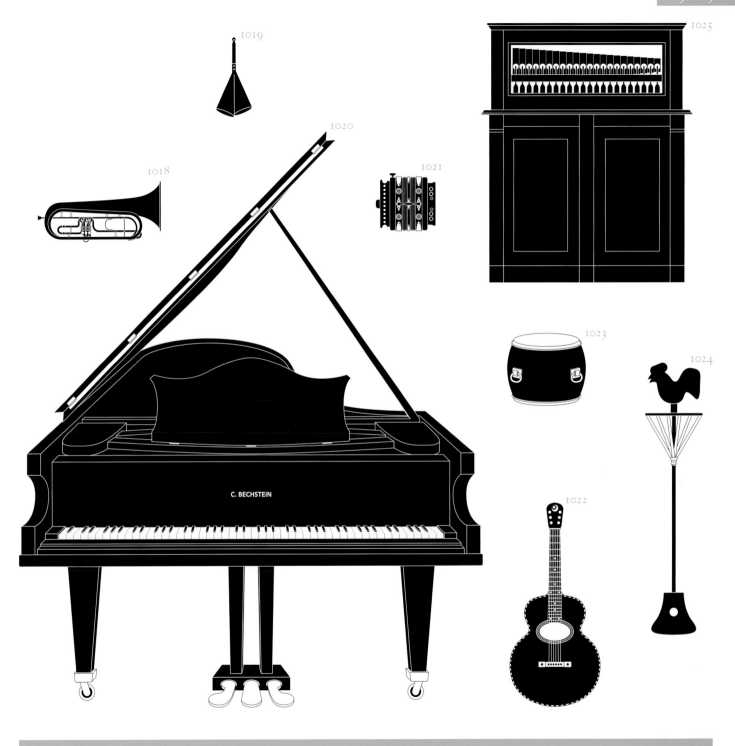

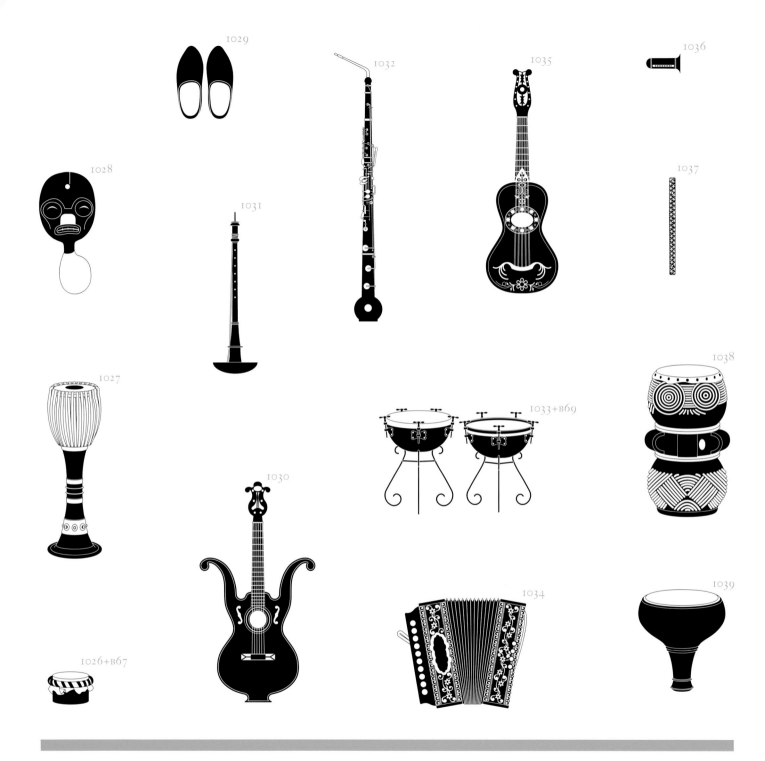

1029

1032

1035

1036

1028

1031

1037

1027

1033+B69

1038

1030

1026+B67

1034

1039

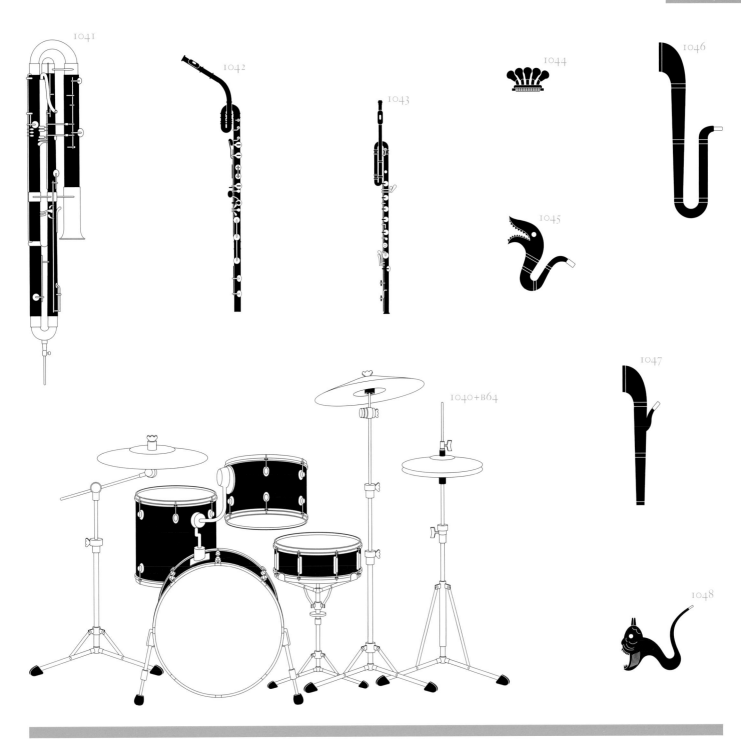

1041

1042

1043

1044

1045

1046

1040+B64

1047

1048

C 1910 CE

1051

1053

1055

1056

1052

1050

1054

1057

1049

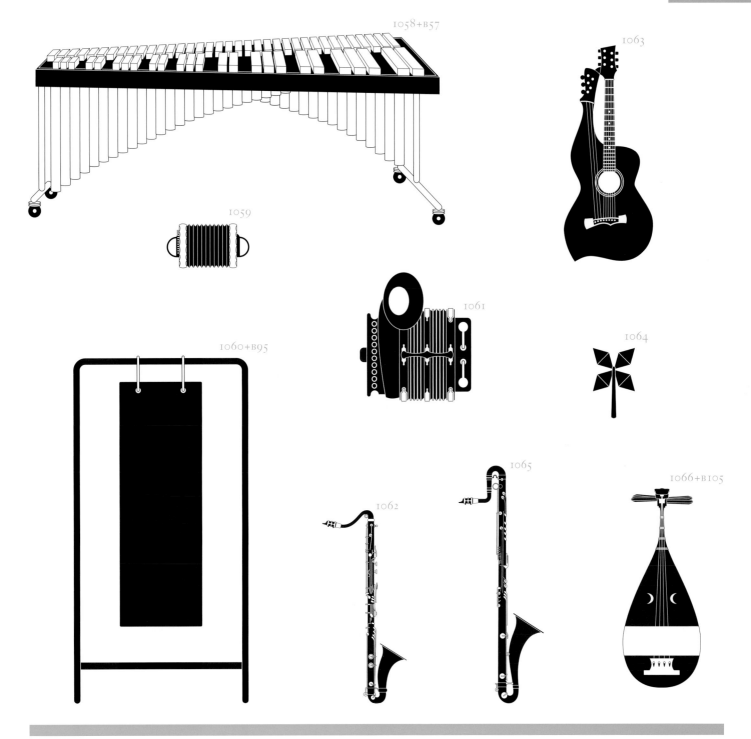

1058+B57

1059

1060+B95

1061

1062

1063

1064

1065

1066+B105

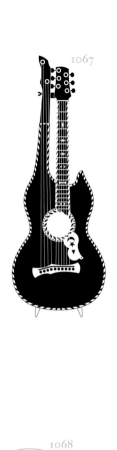

1067

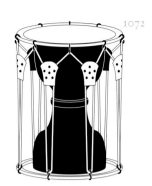

1072

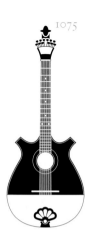

1075

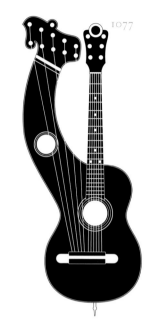

1077

1074+B70

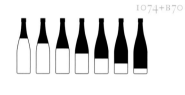

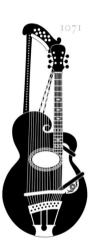

1071

1068

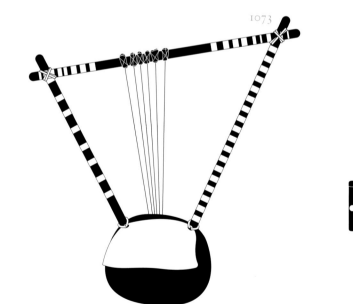

1073

1069

1070

1076

1078

1079+B57

1081

1082

1084

1080+B64

1083+B55

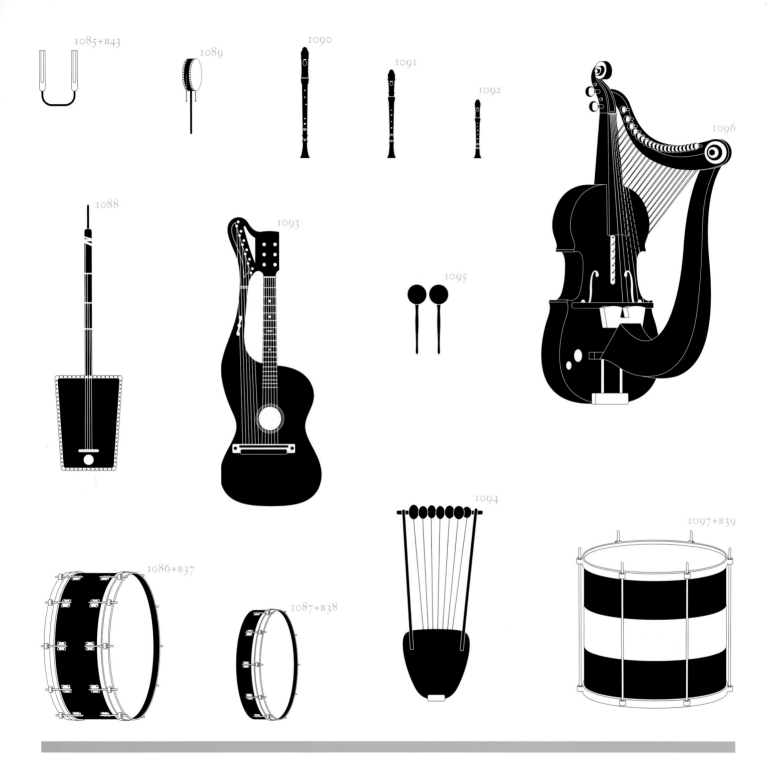

1085+B43

1089

1090

1091

1092

1096

1088

1093

1095

1094

1086+B37

1087+B38

1097+B39

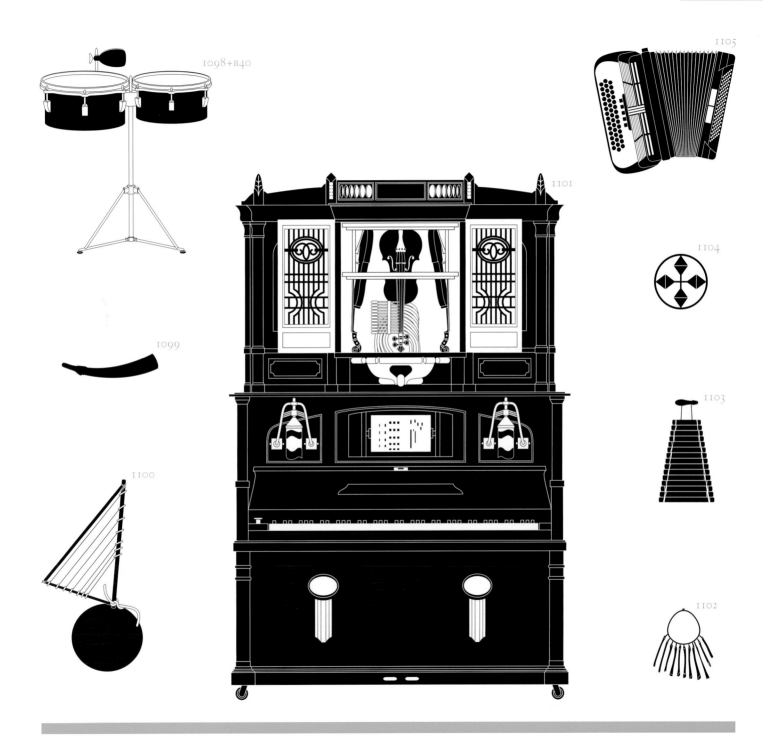

1098+B40

1105

1101

1104

1099

1103

1100

1102

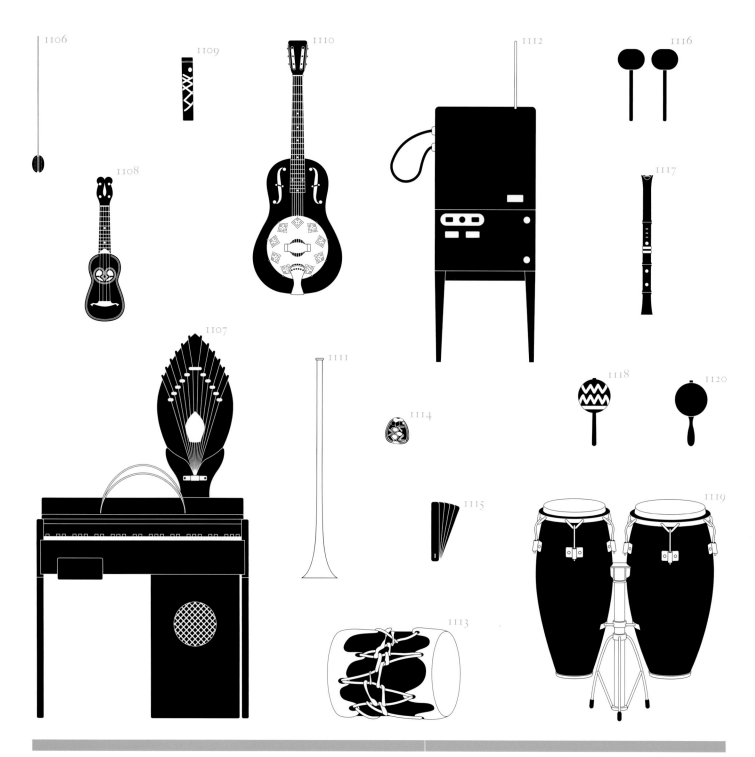

1106

1109

1110

1112

1116

1108

1117

1107

1111

1114

1118

1120

1115

1119

1113

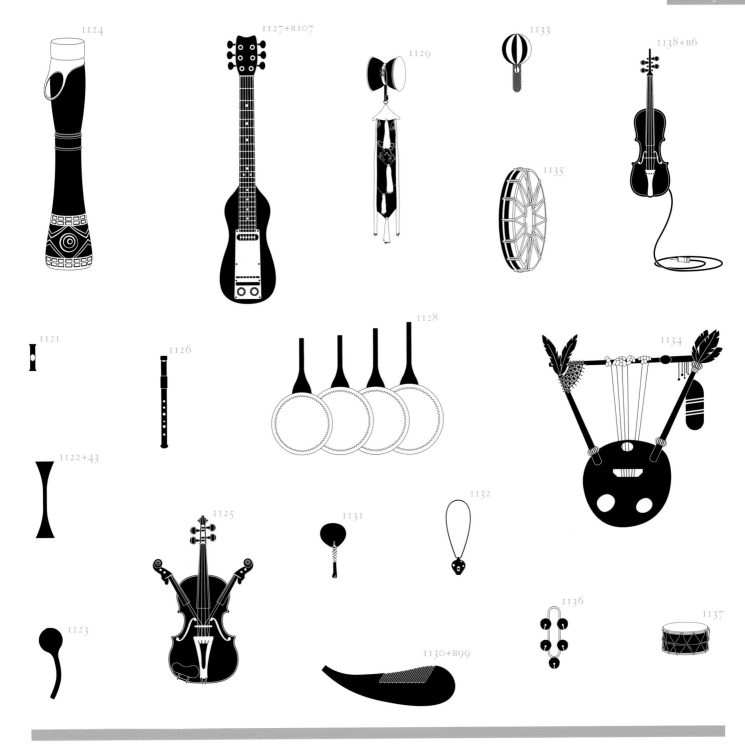

1124

1127+B107

1129

1133

1138+B6

1135

1121

1126

1128

1134

1122+43

1125

1131

1132

1123

1130+B99

1136

1137

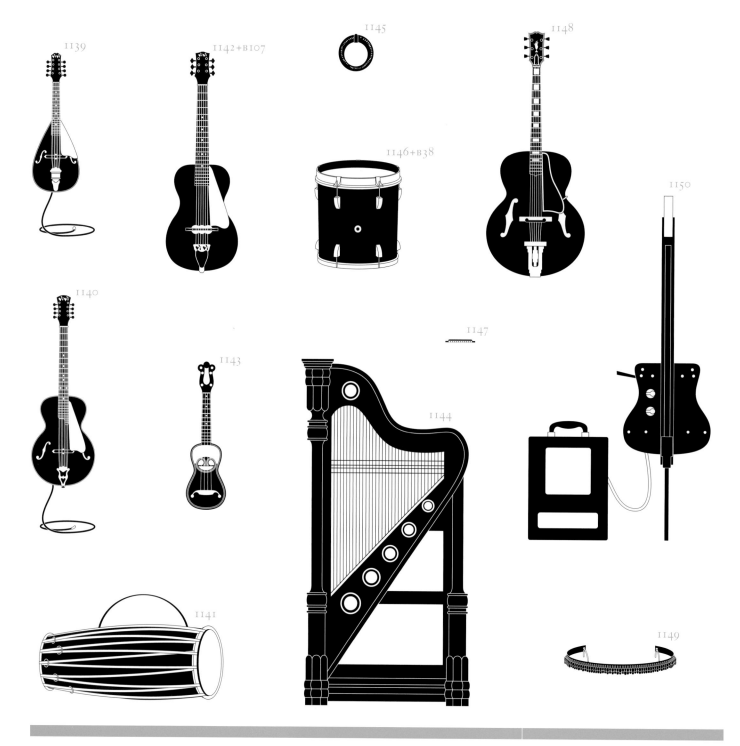

1139

1142+B107

1145

1148

1146+B38

1150

1140

1143

1144

1147

1149

1141

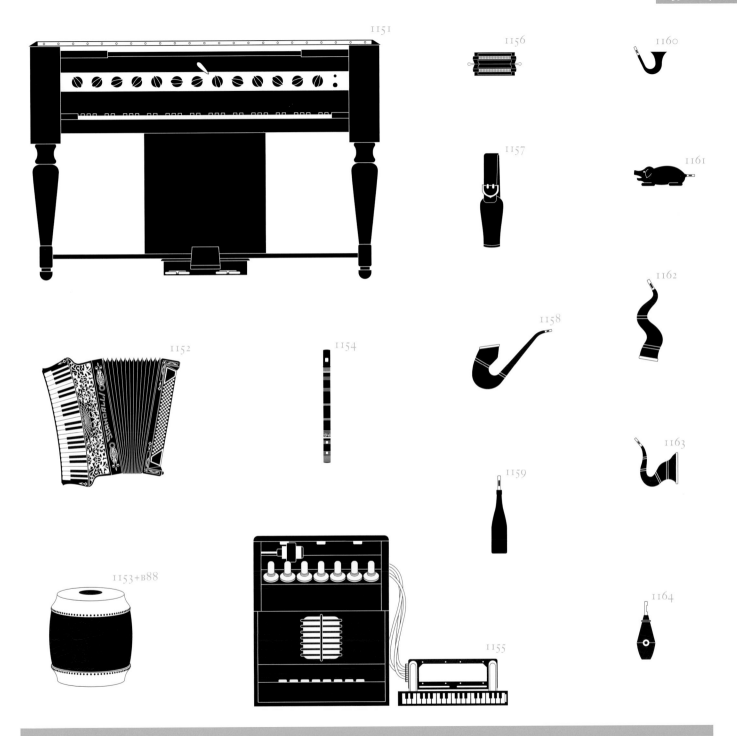

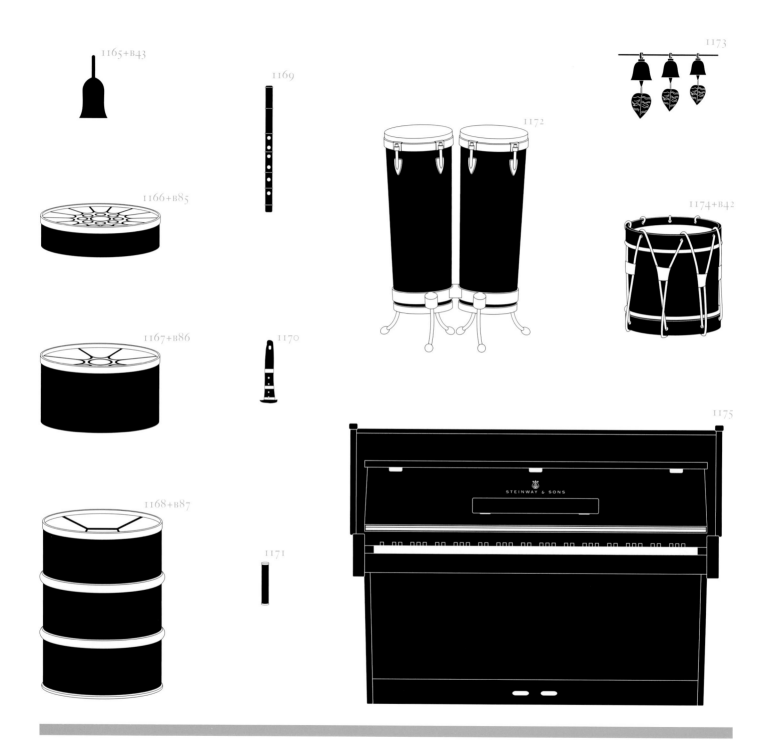

1165+B43

1169

1173

1166+B85

1172

1174+B42

1167+B86

1170

1168+B87

1171

1175

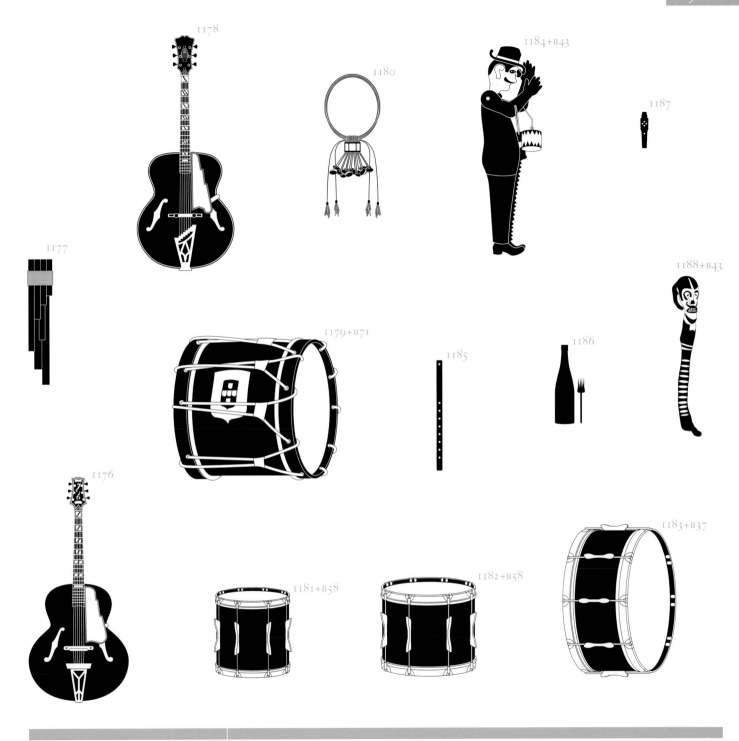

1178

1180

1184+B43

1187

1177

1188+B43

1179+B71

1185

1186

1176

1181+B58

1182+B58

1183+B37

C 1950 CE

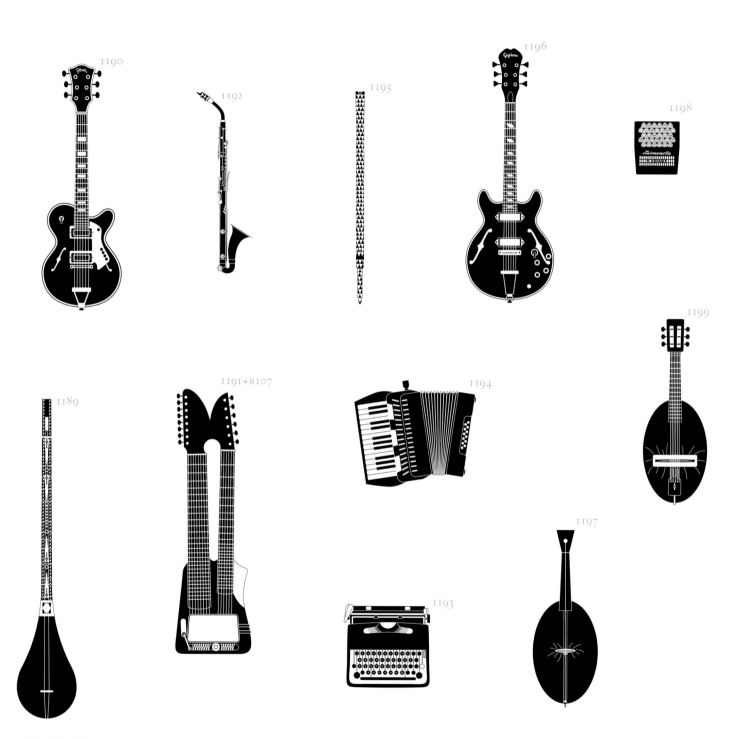

1190

1192

1195

1196

1198

1199

1189

1191+B107

1194

1197

1193

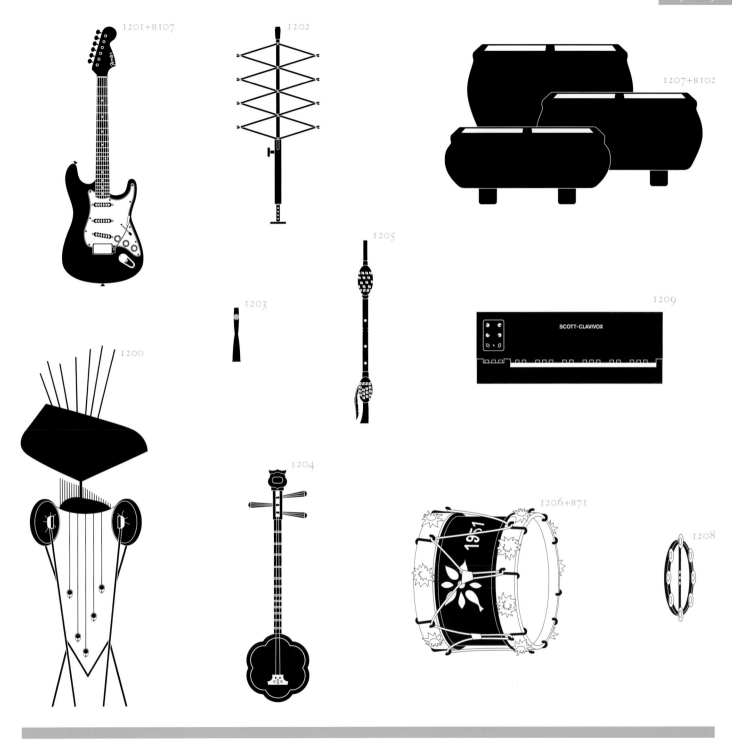

1201+B107

1202

1207+B102

1205

1203

1209

SCOTT-CLAVIVOX

1200

1204

1206+B71

1208

1951

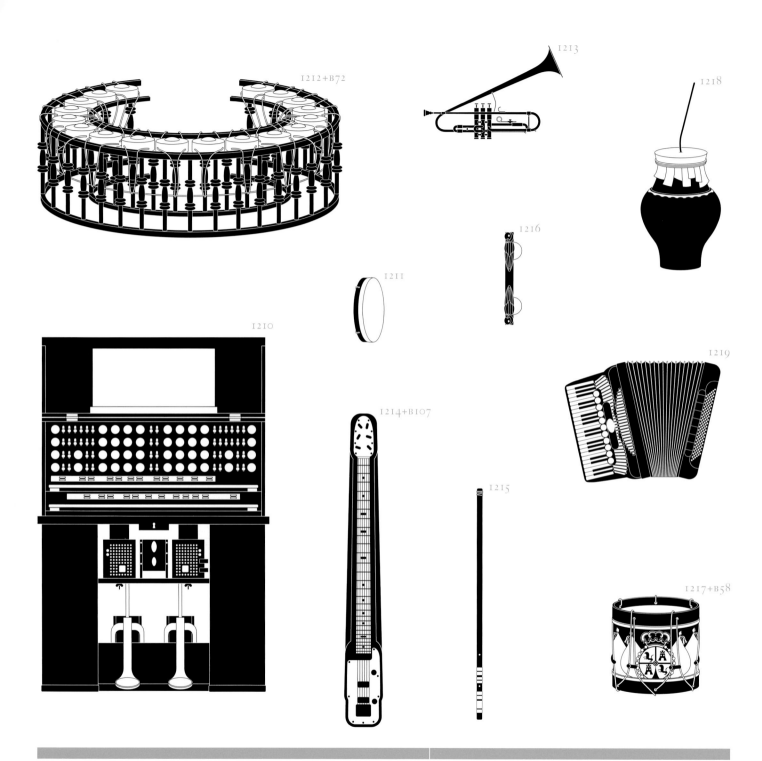

1212+B72

1213

1218

1216

1211

1210

1219

1214+B107

1215

1217+B58

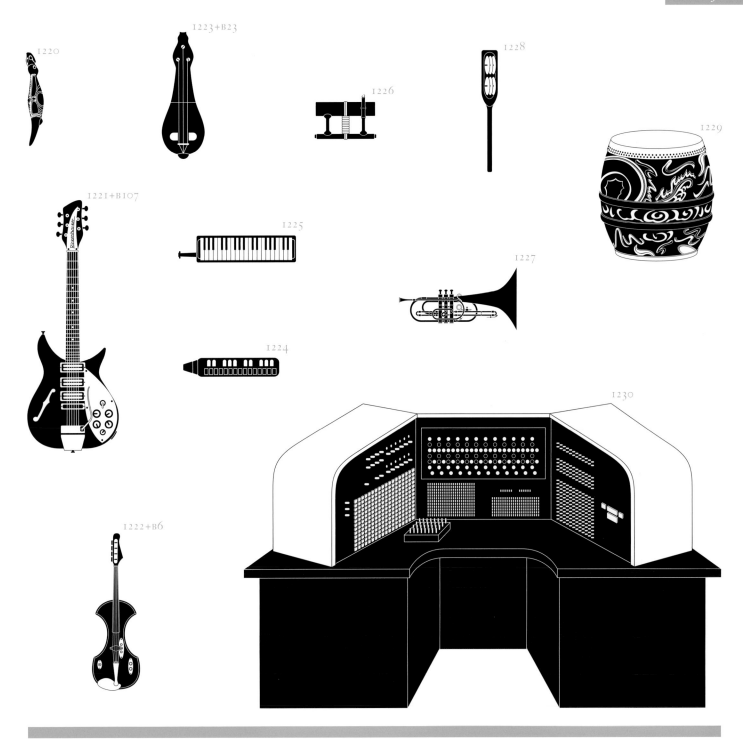

1220

1223+B23

1228

1226

1229

1221+B107

1225

1227

1224

1222+B6

1230

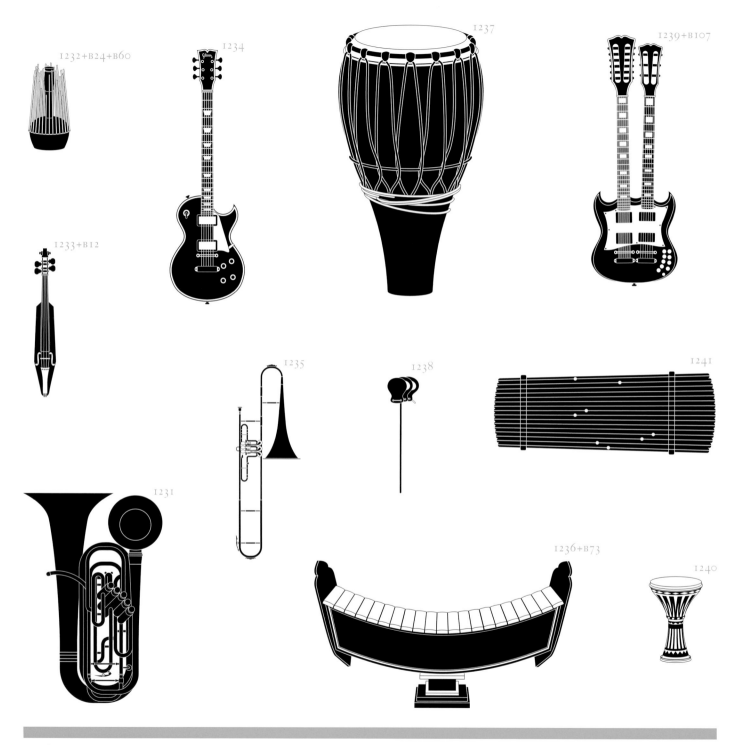

1232+B24+B60

1234

1237

1239+B107

1233+B12

1235

1238

1241

1231

1236+B73

1240

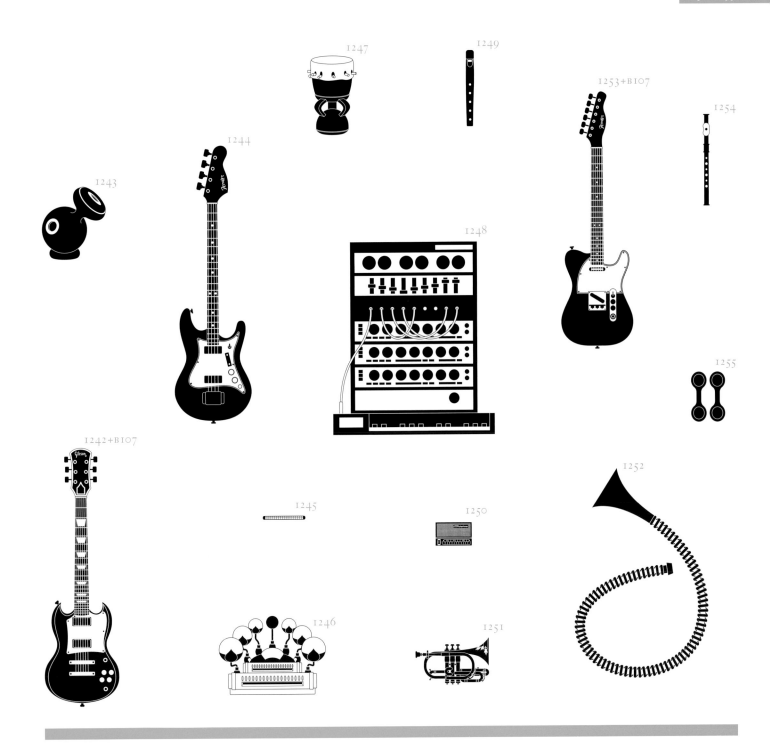

1247

1249

1253+B107

1244

1243

1254

1248

1255

1242+B107

1252

1245

1250

1246

1251

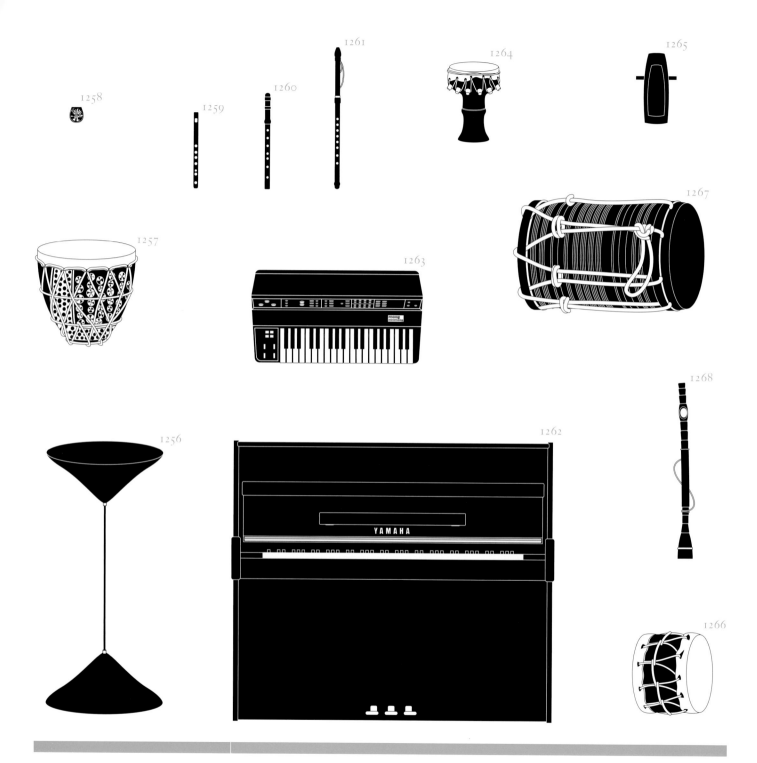

1258

1259

1260

1261

1264

1265

1257

1263

1267

1268

1256

1262

1266

C 1970 CE

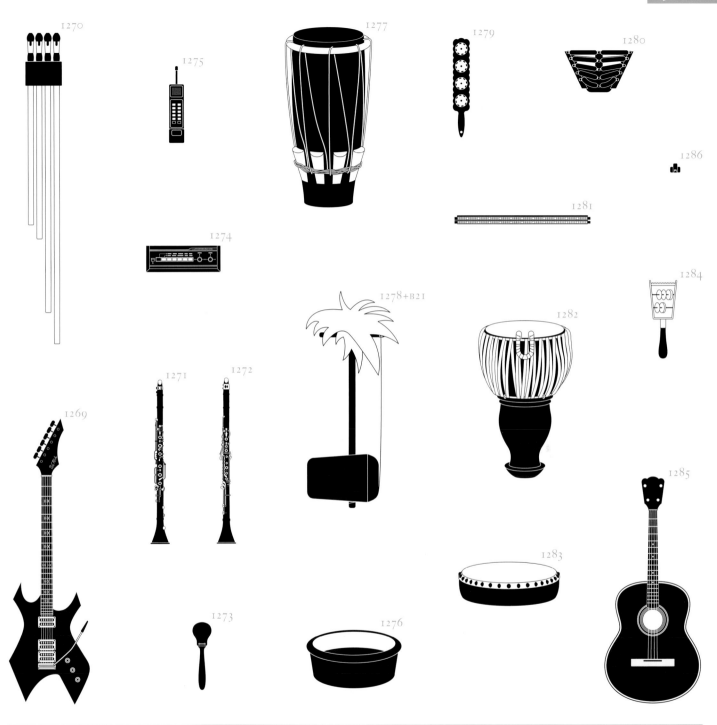

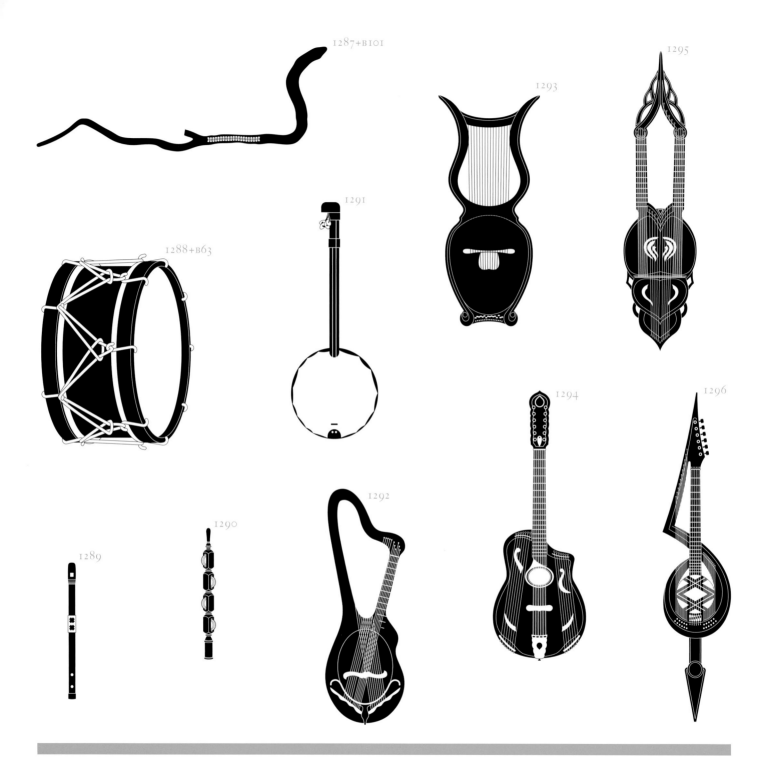

1287+B101

1295

1293

1288+B63

1291

1294

1296

1290

1289

1292

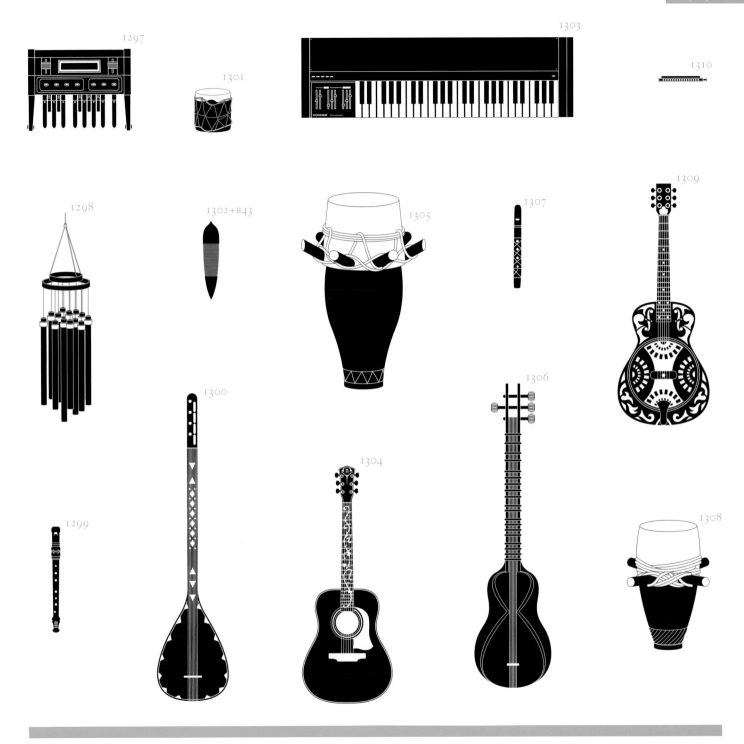

1297

1301

1303

1310

1298

1302+B43

1305

1307

1309

1300

1306

1299

1304

1308

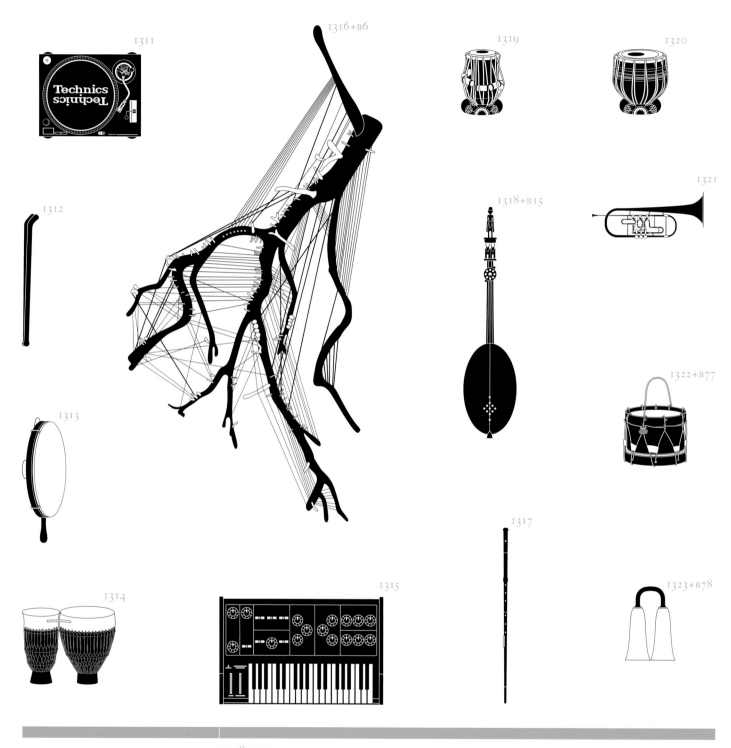

1311

1316+B6

1319

1320

1312

1318+B15

1321

1313

1322+B77

1317

1323+B78

1314

1315

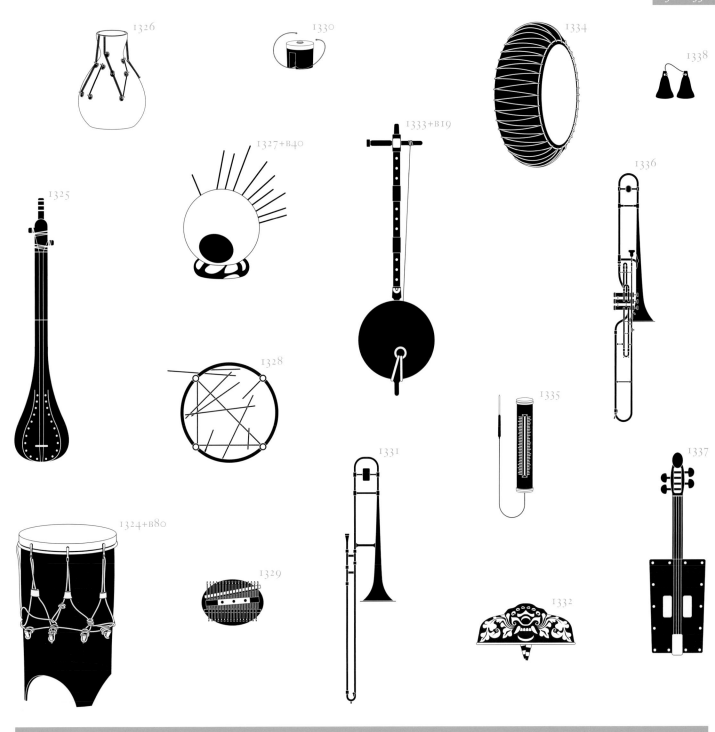

1326

1330

1334

1338

1327+B40

1333+B19

1336

1325

1328

1335

1324+B80

1331

1329

1332

1337

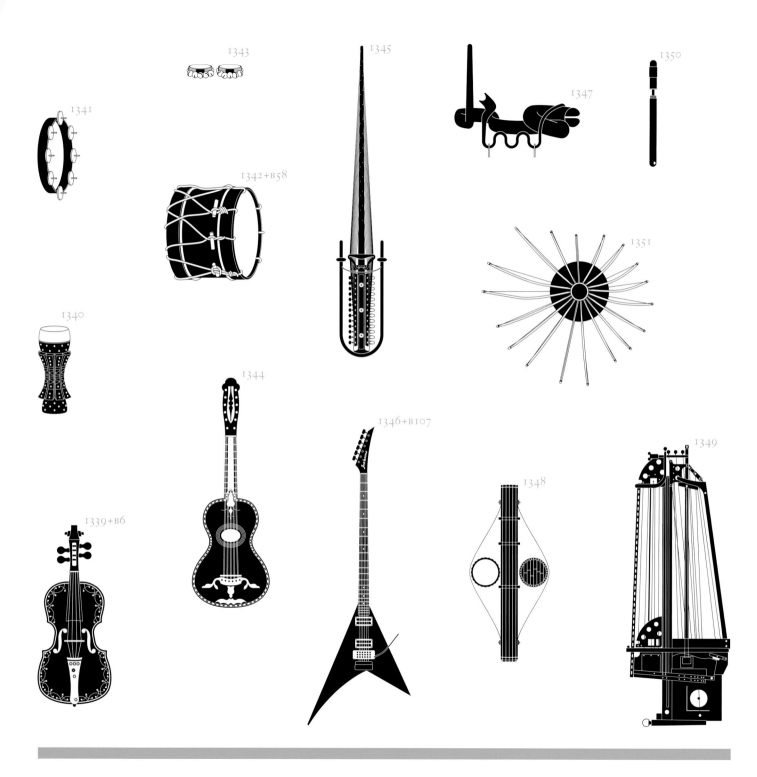

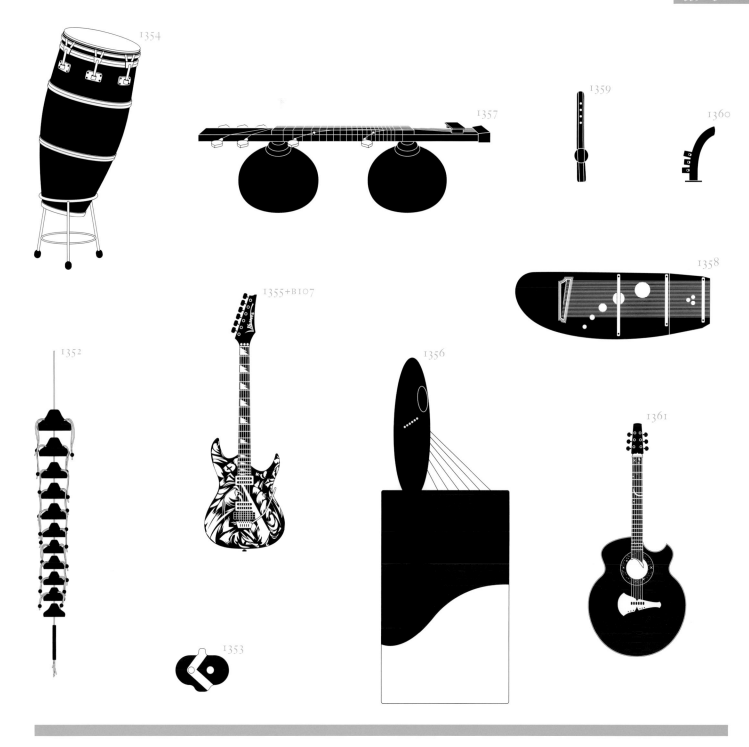

1354

1357

1359

1360

1355+B107

1358

1352

1356

1361

1353

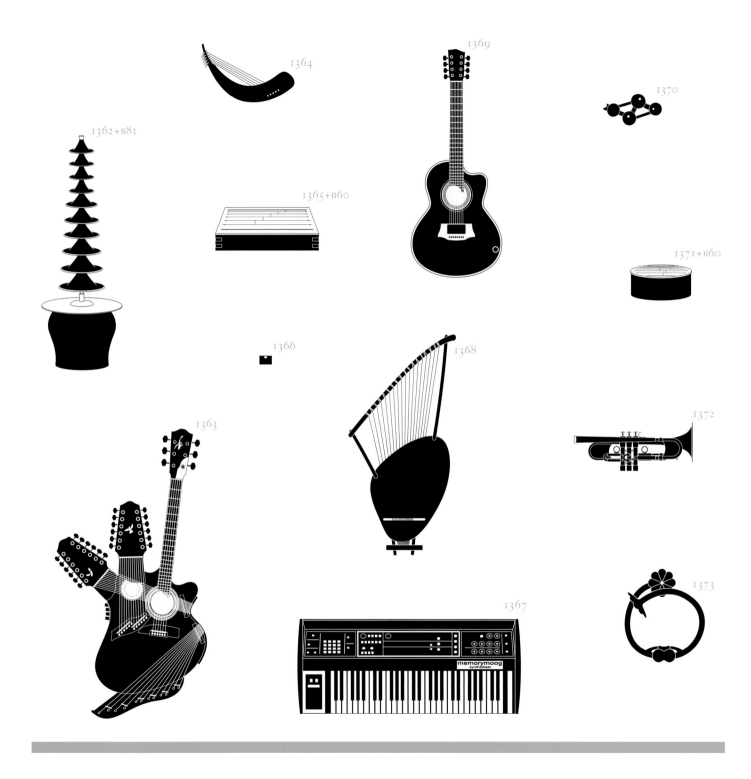

1364

1369

1370

1362+B81

1365+B60

1371+B60

1366

1368

1363

1372

1373

1367

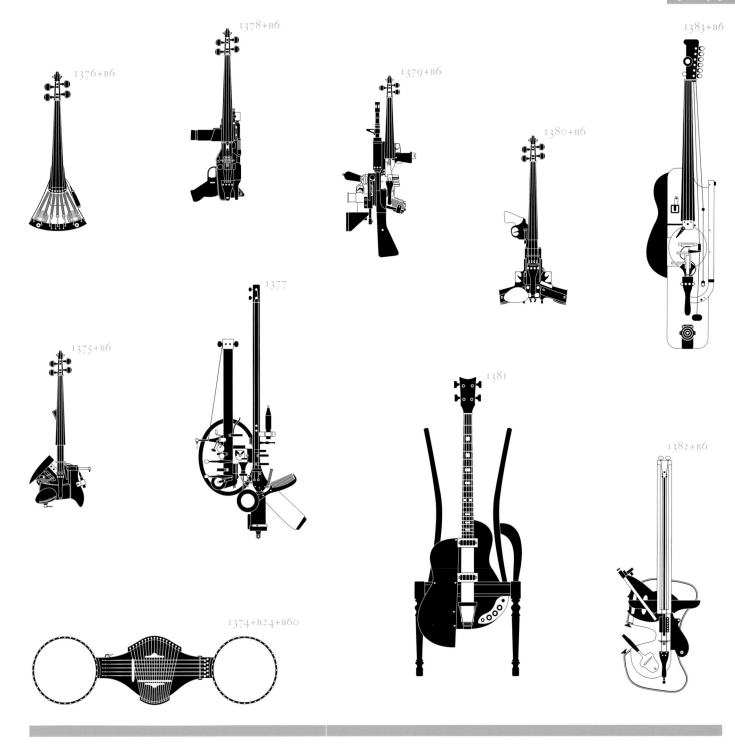

1376+B6

1378+B6

1379+B6

1380+B6

1383+B6

1377

1375+B6

1381

1382+B6

1374+B24+B60

C 1970 CE

1386

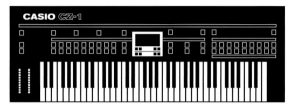

1391

1393

1392

1394

1385+B60

1387

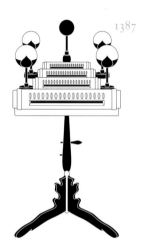

1389

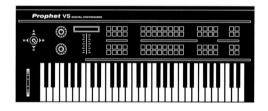

1384

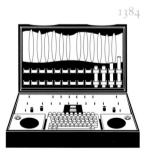

1388+B60

1390

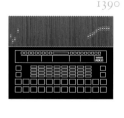

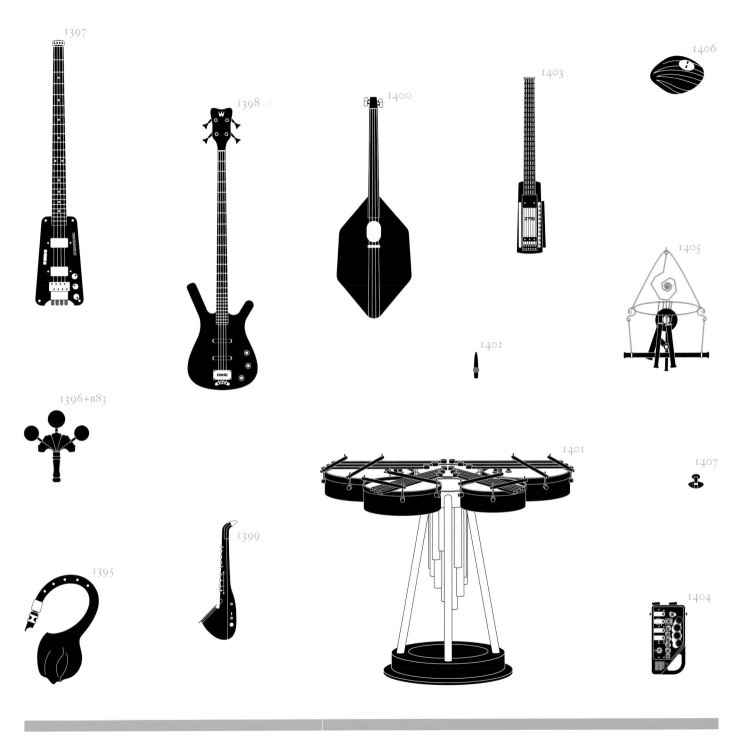

c 1990 CE

143

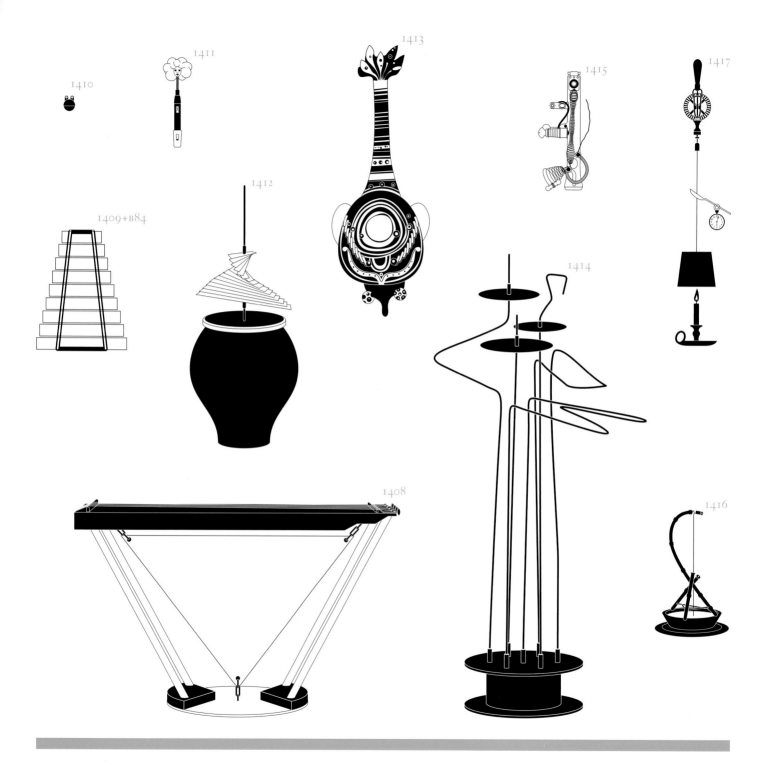

1410

1411

1413

1415

1417

1412

1409+B84

1414

1408

1416

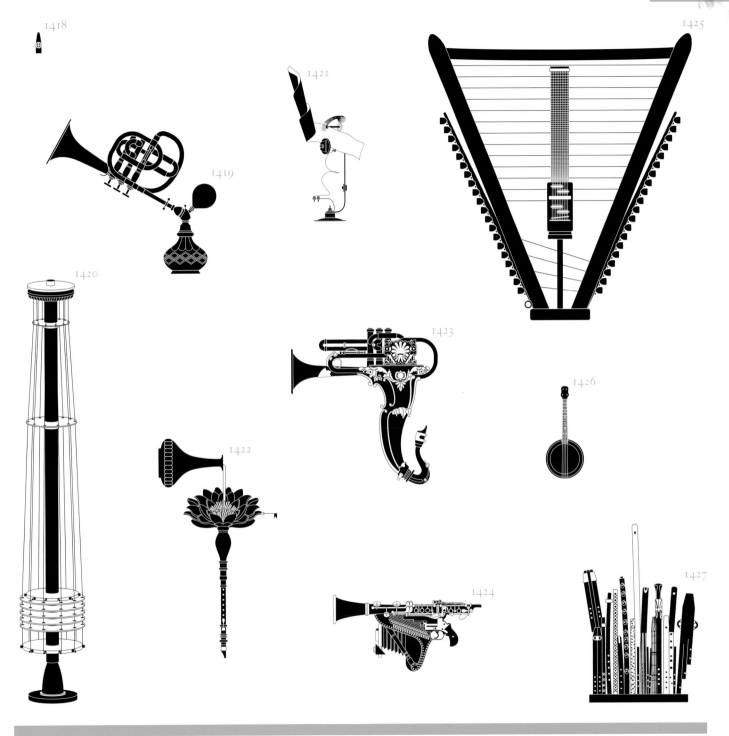

1428 1429

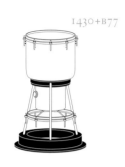

1430+B77

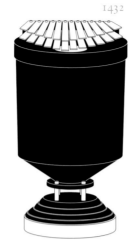

1432

1435+B60

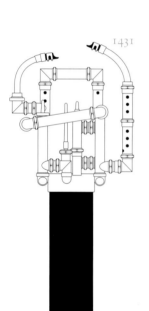

1431

1433+B24

1434

1436

1438

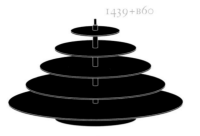

1439+B60

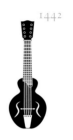

1442

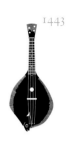

1443

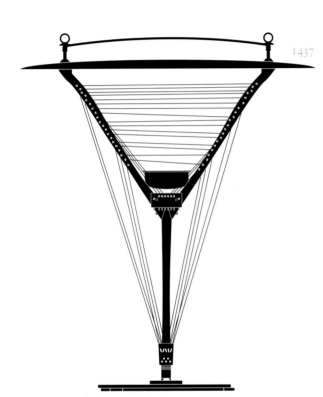

1437

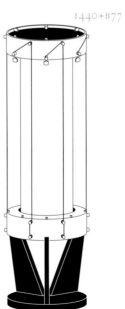

1440+B77

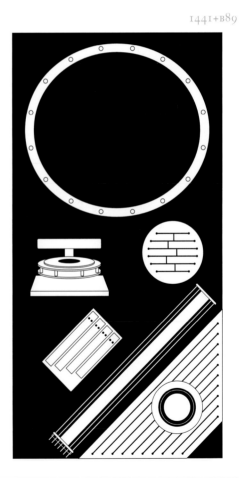

1441+B89

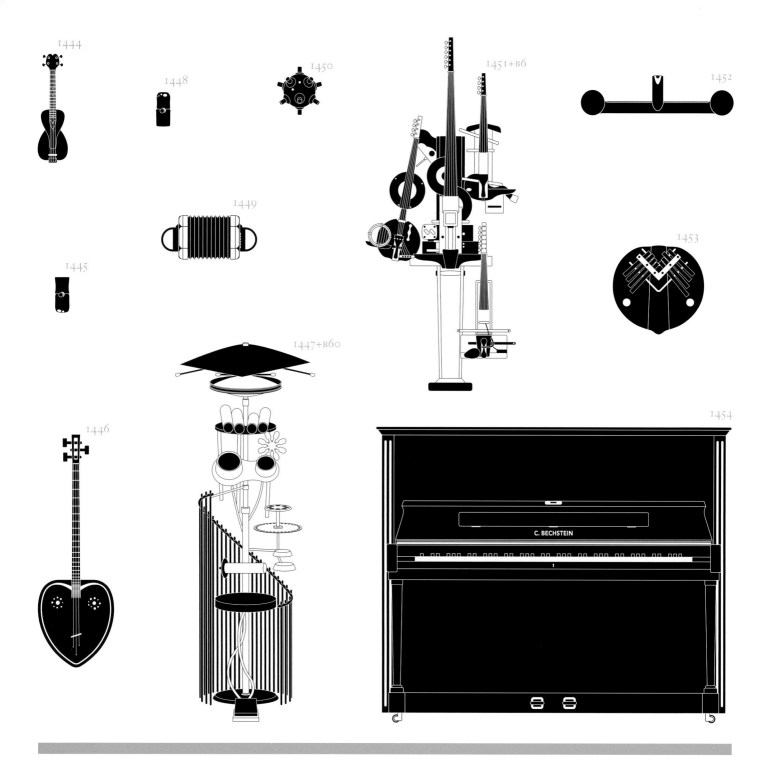

1444

1448

1450

1451+B6

1452

1449

1453

1445

1447+B60

1446

1454

C. BECHSTEIN

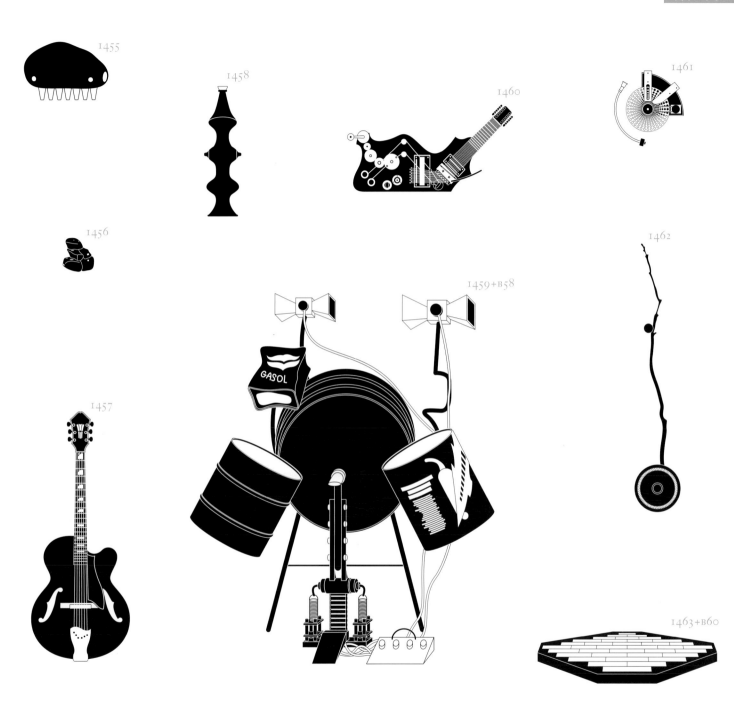

1455

1458

1460

1461

1456

1462

1459+B58

1457

1463+B60

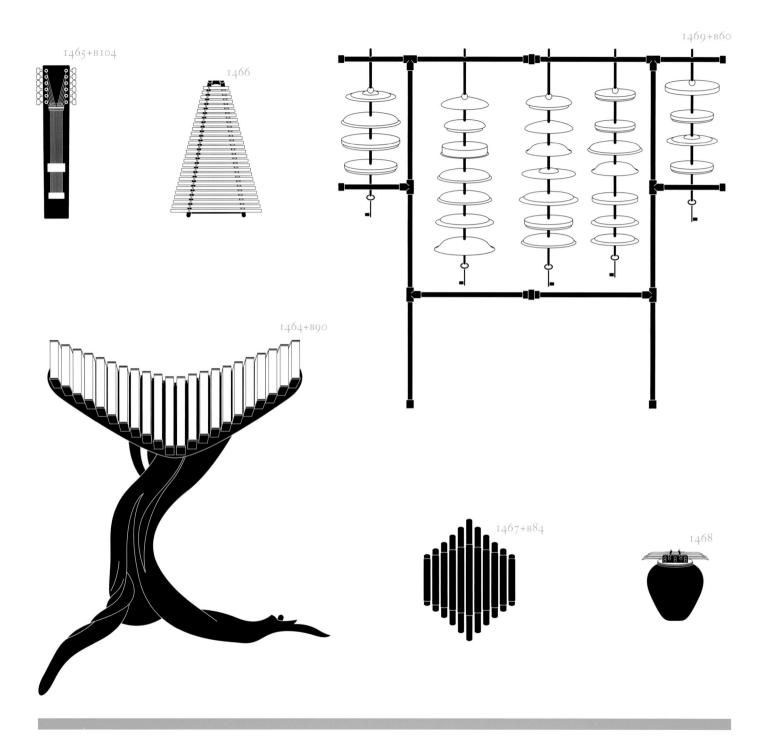

1465+B104

1466

1469+B60

1464+B90

1467+B84

1468

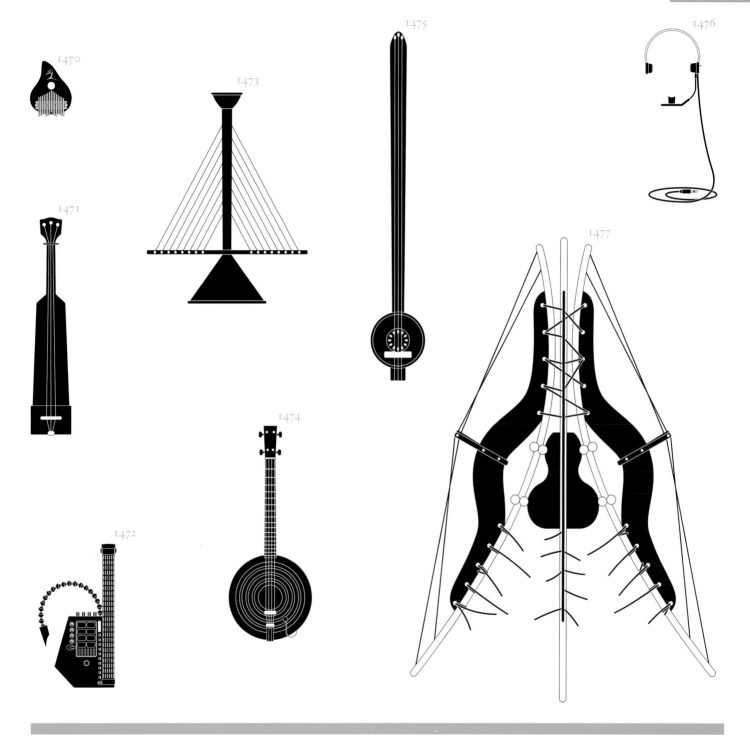

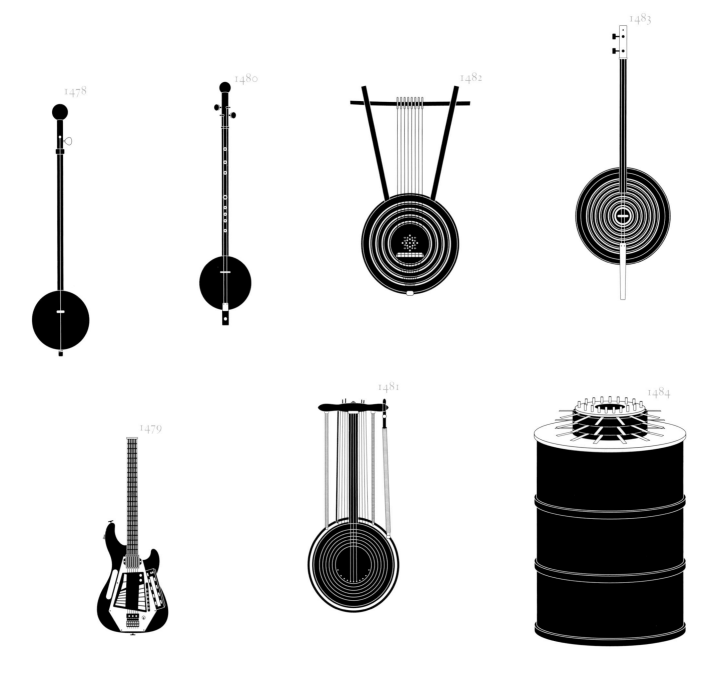

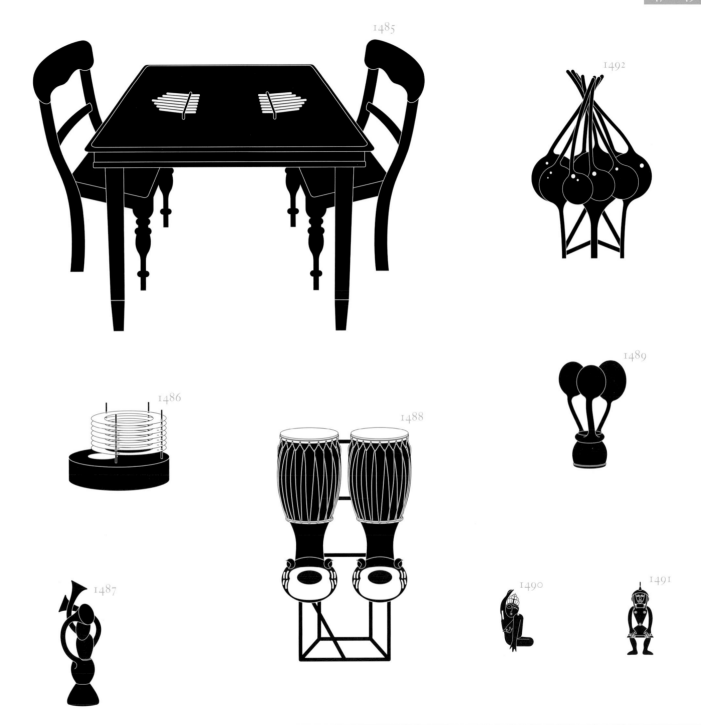

1485

1492

1486

1488

1489

1487

1490

1491

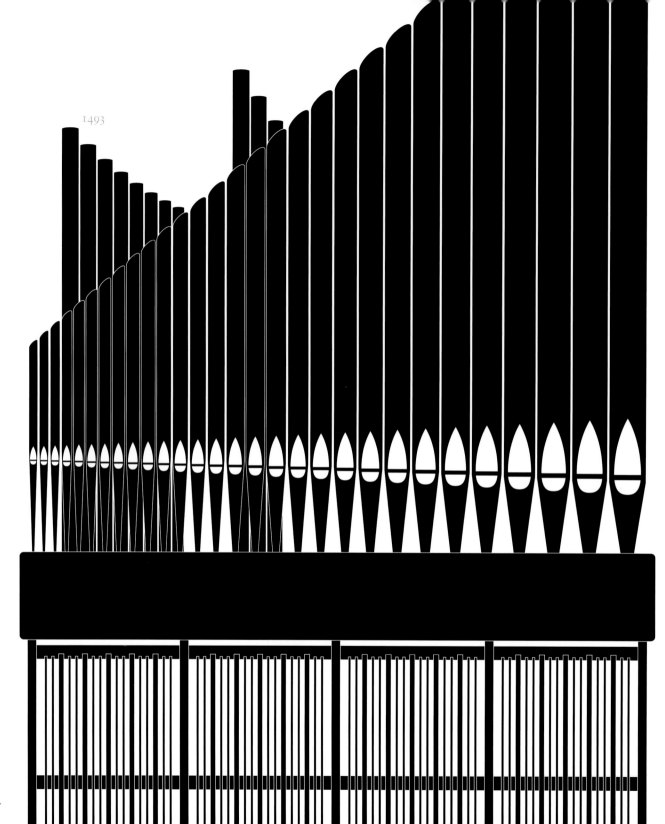

1493

154

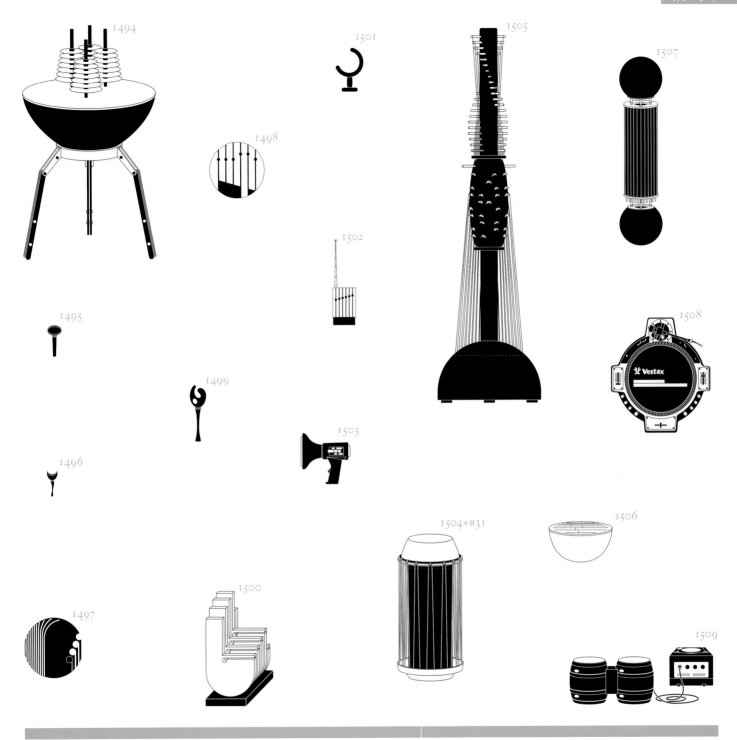

1494

1501

1505

1507

1498

1502

1508

1495

1499

1496

1503

1506

1497

1500

1504+B31

1509

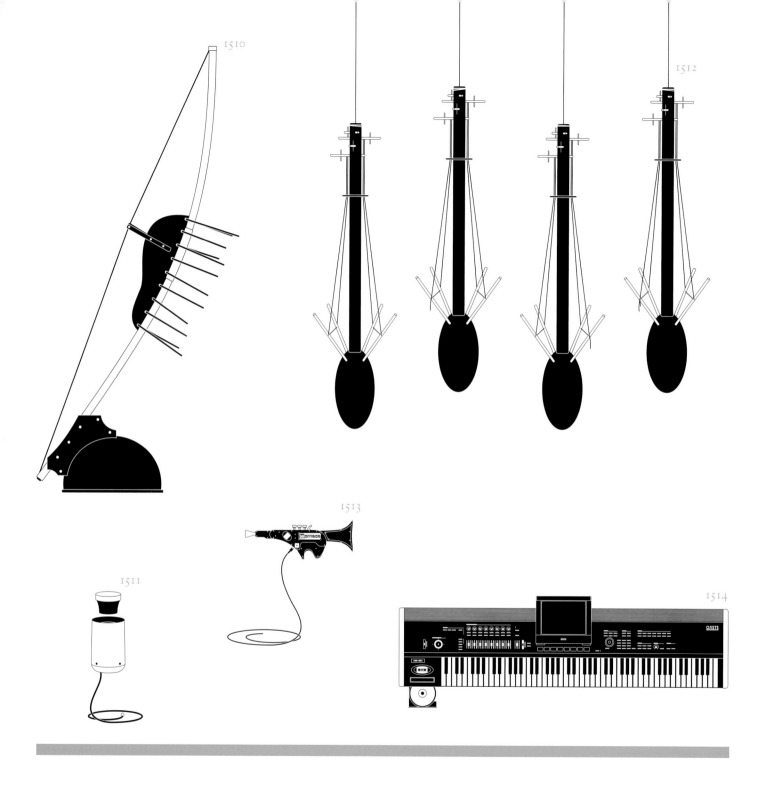

1510

1512

1513

1511

1514

1517

1515

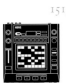

1516

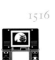

1518

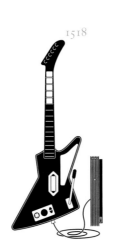

1519

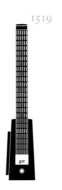

1520

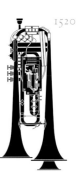

C 2007 CE

Oversized Musical Instruments – *scale* 1:42.5

Übergroße Musikinstrumente – *Maßstab* 1:42,5

Gros instruments de musique – *échelle* 1:42,5

Instrumêntos musicais sobredimensionados – *escala* 1:42,5

Instrumentos musicales grandes – *escala* 1:42,5

Strumenti musicali grandi – *scala* 1:42,5

Крупногабаритные Инструменты – *масштаб* 1:42,5

大きな楽器 – 縮小率 1:42.5

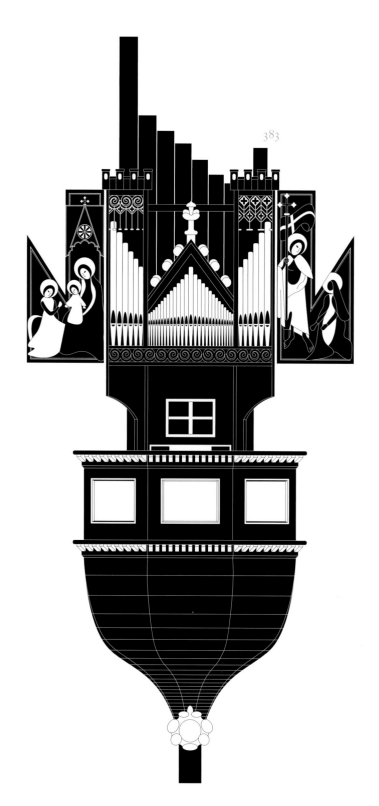

383

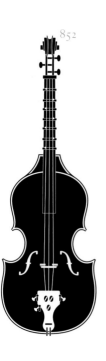

852

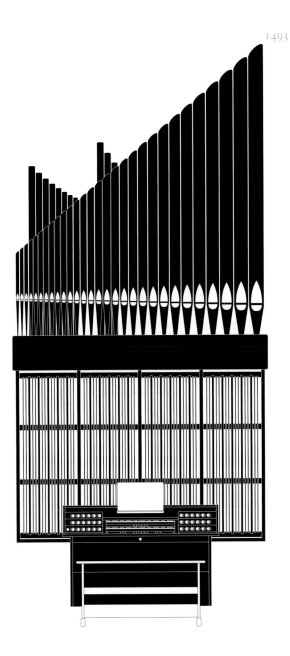

Bows, Beaters & Other Implements

Bögen, Schlegel und andere Hilfsmittel

Archets, baguettes et autres accessoires

Arcos, baquetas e outros elementos

Arcos, mazas y otros accesorios

Archi, bacchette e altri accessori

Смычки, палочки и другие приспособления

弓、バチ、その他の道具

Bows Arcos

Bögen Archi

Archets Смычки

Arcos ‎יֹ

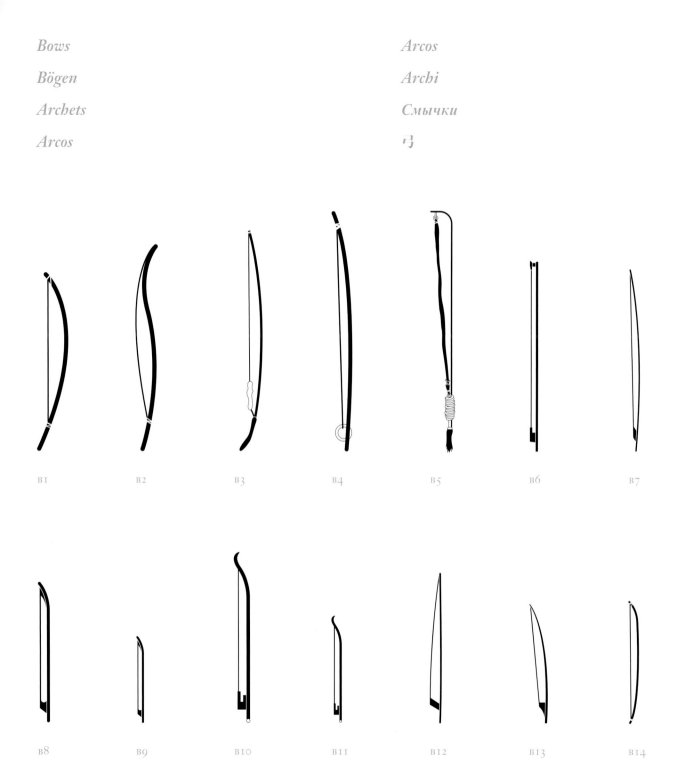

B1 B2 B3 B4 B5 B6 B7

B8 B9 B10 B11 B12 B13 B14

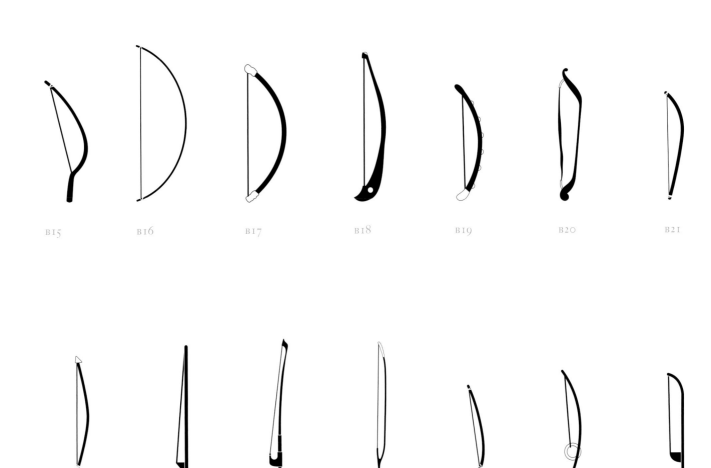

B15 B16 B17 B18 B19 B20 B21

B22 B23 B24 B25 B26 B27 B28

Beaters & Other Implements

Schlegel und andere Hilfsmittel

Baguettes et autres accessoires

Baquetas e outros elementos

Mazas y otros accesorios

Bacchette e altri accessori

Палочки и другие приспособления

バチ、その他の道具

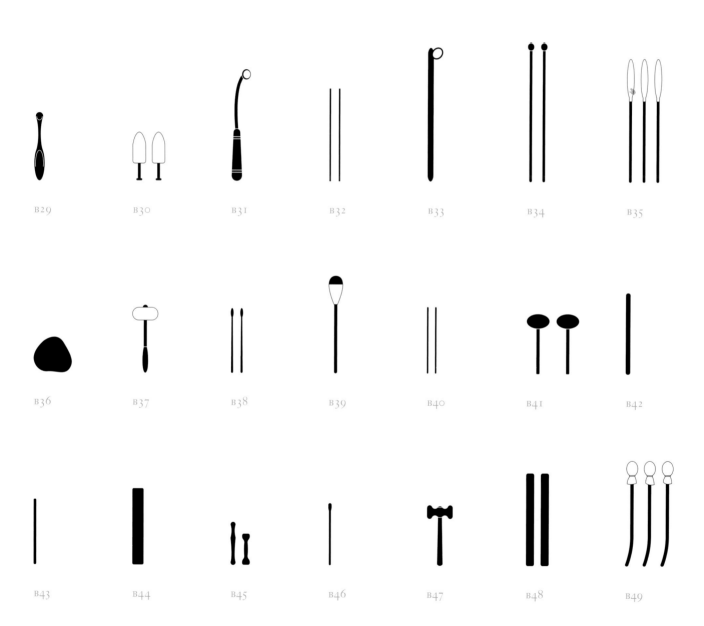

B29

B30

B31

B32

B33

B34

B35

B36

B37

B38

B39

B40

B41

B42

B43

B44

B45

B46

B47

B48

B49

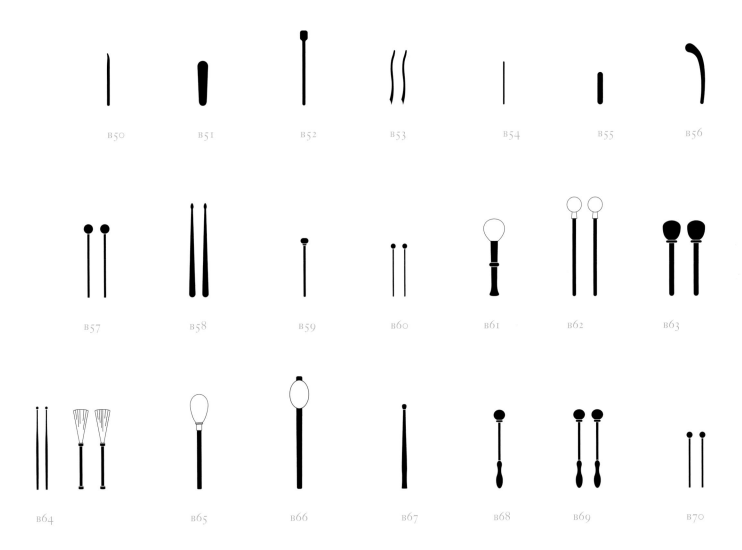

B50 B51 B52 B53 B54 B55 B56

B57 B58 B59 B60 B61 B62 B63

B64 B65 B66 B67 B68 B69 B70

Beaters & Other Implements

Schlegel und andere Hilfsmittel

Baguettes et autres accessoires

Baquetas e outros elementos

Mazas y otros accesorios

Bacchette e altri accessori

Палочки и другие приспособления

バチ、その他の道具

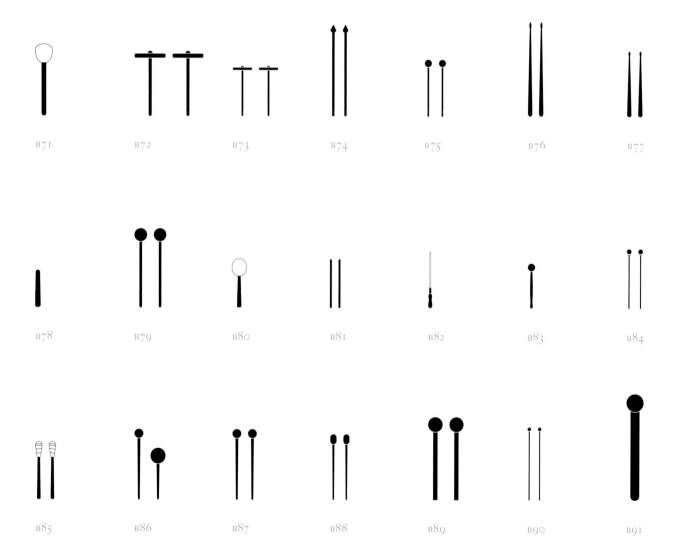

B71 B72 B73 B74 B75 B76 B77

B78 B79 B80 B81 B82 B83 B84

B85 B86 B87 B88 B89 B90 B91

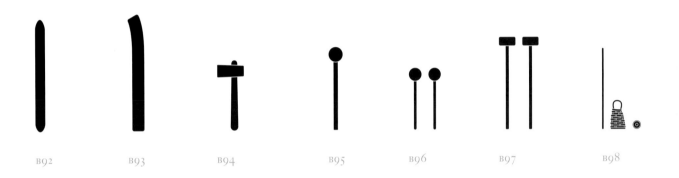

B92 B93 B94 B95 B96 B97 B98

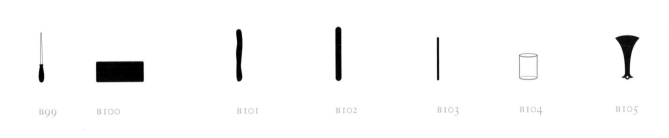

B99 B100 B101 B102 B103 B104 B105

B106 B107

Index

Index entry numbers correspond to the image numbers in this book and on the accompanying CD-ROM.

Each musical instrument has been classified as belonging to one of the following 7 groups:

AERO: **Aerophones** — produce sound primarily by vibrating air

MEMB: **Membranophones** — produce sound by vibrating a stretched membrane

IDIO: **Idiophones** — produce sound through vibrations in the body of the instrument itself

CHOR: **Chordophones** — produce sound by vibrating a stretched string or strings

MECH: **Mechanophones** — produce sound automatically from an arranged and repetitive mechanical programme

ELEC: **Electrophones** — produce sound by electrical means and/or have electric action or amplification

IMAG: **Imaginary** — have not been physically constructed but for which some form of documentation exists

The first four of these classification codes are based on the hierarchical classification devised by E.M. von Hornbostel and C. Sachs as published in *Zeitschrift für Ethnologie*, 1914.

Each index entry contains the following information, if the information is available:

No. — index entry number

GROUP — please refer to list above

DATE — approximate date when instrument was invented or designed

INSTRUMENT — general name of the instrument or type of instrument (in English in most cases)

NAME — name in original language and/or name given to a specific variation of the instrument

INSTRUMENT MAKER(s) — inventor and/or producer of the instrument

COUNTRY/REGION — country or region of origin or production

Register

Zahlen der Einträge im Register entsprechen den Zahlen der Bilder in diesem Buch und den Zahlen der Bilder auf der beiliegenden CD-ROM.

Jedes Musikinstrument wurde in eine der folgenden sieben Gruppen eingeteilt:

AERO: **Aerophone** — alle Instrumente mit schwingender Luft als Tonerzeuger

MEMB: **Membranophone** — Tonerreger sind straff gespannte Membranen

IDIO: **Idiophone** — alle Instrumente, die als Ganzes schwingend einen Ton erzeugen

CHOR: **Chordophone** — alle Instrumente, die zur Tonerzeugung schwingende Saiten verwenden

MECH: **Mechanophone** — automatische Tonerzeugung mittels eines arrangierten und sich wiederholenden mechanischen Programms

ELEC: **Elektrophone** — alle Instrumente, die Ton mithilfe elektrischer Tonerzeugung erzeugen und/oder elektrisch angetrieben oder verstärkt werden müssen

IMAG: **Imaginäre Instrumente** — alle Instrumente, die noch nicht tatsächlich konstruiert wurden, über die aber eine Art von Dokumentation existiert

Die ersten vier dieser Klassifikationsgruppen basieren auf der hierarchischen Systematik, die von E.M. von Hornbostel und C. Sachs entwickelt und erstmals 1914 in der *Zeitschrift für Ethnologie* veröffentlicht wurde.

Jeder Registereintrag umfasst die folgenden Informationen (falls vorhanden):

No. — (Nummer) Zahl des Eintrags im Register

GROUP — (Gruppe) vgl. die obenstehende Liste

DATE — (Datum) das ungefähre Entstehungs– oder Entwicklungsdatum des Instruments

INSTRUMENT — Name des Instruments oder Typ des Instruments (meist in englischer Sprache)

NAME — Name des Instruments in der Originalsprache und/oder Name einer bestimmten Variation des Instruments

INSTRUMENT MAKER(s) — Erfinder und/oder Produzent des Instruments

COUNTRY/REGION — Ursprungsland oder –region der Instrumentenproduktion

Index

Le numéro de l'inscription dans l'index correspond au numéro de l'image dans ce livre et sur le CD-ROM d'accompagnement.

Chaque instrument de musique a été classé dans l'un des sept groupes suivants :

AERO: **Aérophones** — ils produisent un son principalement par vibration de l'air

MEMB: **Membranophones** — ils produisent un son par vibration d'une membrane tendue

IDIO: **Idiophones** — ils produisent un son par vibration de leur propre corps

CHOR: **Cordophones** — ils produisent un son par vibration d'une ou plusieurs cordes

MECH: **Mécanophones** — ils produisent un son automatiquement par un programme mécanique réglé et répétitif

ELEC: **Electrophones** — ils produisent un son par des moyens électriques, par une action électrique ou par amplification électrique

IMAG: **Imaginaire** — ils n'ont jamais été fabriqués, mais une forme de documentation existe à leur sujet

Les quatre premiers codes de classification sont basés sur une classification hiérarchique conçue par E.M. Von Hornbostel et C. Sachs et publiée dans *Zeitschrift für Ethnologie*, 1914.

Chaque inscription dans l'index contient l'information suivante, si elle est disponible :

No. — numéro de l'inscription dans l'index

GROUP — veuillez vous référer à la liste ci-dessus

DATE — date approximative de l'invention ou de la conception de l'instrument

INSTRUMENT — nom général de l'instrument ou du type d'instrument (en anglais dans la plupart des cas)

NAME — nom dans la langue d'origine ou nom donné à une variante particulière de l'instrument

INSTRUMENT MAKER(s) — inventeur ou fabricant de l'instrument

COUNTRY/REGION — pays ou région d'origine ou de fabrication

Índice

Os números de entrada no índice correspondem aos números das imagens deste livro e do CD-ROM que acompanha a obra.

Cada instrumento musical foi classificado, por sistema vibratório, em função dos 7 grupos que se seguem:

AERO: **Aerofones** — o elemento vibratório é o ar

MEMB: **Membranofones** — o elemento vibratório é uma membrana tensionada

IDIO: **Idiofones** — o elemento vibratório é o corpo do próprio instrumento

CHOR: **Cordofones** — o elemento vibratório é uma ou várias cordas tensionadas

MECH: **Automatofones** — o elemento vibratório é um programa mecânico repetitivo, pré-definido

ELEC: **Electrofones** — o elemento vibratório é um meio eléctrico e/ou tem uma acção eléctrica ou amplificação

IMAG: **Imaginários** — não foram construídos, mas existe algum tipo de documentação acerca deles.

Os quatro primeiros códigos desta classificação baseiam-se na classificação hierárquica concebida por E.M. von Hornbostel e C. Sachs publicada na *Zeitschrift für Ethnologie* em 1914.

Cada entrada de índice contém a seguinte informação, caso esteja disponível:

No. — número de entrada do índice

GROUP — consultar a lista supra

DATE — data aproximada da invenção ou concepção do instrumento

INSTRUMENT — nome genérico do instrumento ou tipo de instrumento (em inglês na maioria dos casos)

NAME — nome no idioma original e/ou nome atribuído a uma variação específica do instrumento

INSTRUMENT MAKER(s) — inventor e/ou fabricante do instrumento

COUNTRY/REGION — país ou região de origem ou de fabrico

Índice

Los números de las entradas del índice corresponden a los números de las imágenes de este libro y del CD-ROM adjunto.

Cada instrumento musical se ha clasificado dentro de uno de estos siete grupos:

AERO: **Aerófonos** — generan el sonido por la vibración del aire

MEMB: **Membranófonos** — generan el sonido por la vibración de una membrana tensa

IDIO: **Idiófonos** — generan el sonido por las vibraciones en el cuerpo del propio instrumento

CHOR: **Cordófonos** — generan el sonido por la vibración de una o varias cuerdas tensadas

MECH: **Mecanófonos** — generan el sonido automáticamente a partir de un programa mecánico arreglado y repetitivo

ELEC: **Electrófonos** — generan el sonido por medios eléctricos y/o presentan una acción eléctrica o amplificación

IMAG: **Imaginarios** — no se han construido físicamente pero están documentados de algún modo

Los cuatro primeros códigos de la lista siguiente se corresponden con la clasificación jerárquica de E.M. von Hornbostel y C. Sachs publicada en la revista *Zeitschrift für Ethnologie* en 1914.

Las entradas del índice incluyen la siguiente información, si procede:

No. — número de entrada del índice

GROUP — grupo al que pertenece el instrumento (véase la lista superior)

DATE — fecha aproximada en la que se inventó o diseñó el instrumento

INSTRUMENT — nombre genérico del instrumento o del tipo de instrumento (en inglés en general)

NAME — nombre en el idioma original y/o nombre dado a una variación específica del instrumento

INSTRUMENT MAKER(s) — inventor y/o fabricante del instrumento

COUNTRY/REGION — país o región de origen o fabricación del instrumento

Indice

I numeri delle voci dell'indice corrispondono ai numeri delle immagini contenute nel libro e nel CD-ROM.

Gli strumenti musicali sono stati classificati e suddivisi nei seguenti 7 gruppi:

AERO: **Aerofoni** — il suono è dato principalmente dalle vibrazioni dell'aria

MEMB: **Membranofoni** — il suono è dato dalle vibrazioni di una membrana tesa

IDIO: **Idiofoni** — il corpo vibrante coincide con il corpo dello strumento stesso

CHOR: **Cordofoni** — il suono è dato dalle vibrazioni di una o più corde

MECH: **Meccanici** — il suono è prodotto automaticamente da un sistema meccanico in modo prestabilito e ripetitivo

ELEC: **Elettrofoni** — utilizzano l'elettricità per generare i suoni e/o dispongono di un amplificatore

IMAG: **Immaginari** — mai costruiti fisicamente ma esiste documentazione al riguardo

Le prime quattro voci sono basate sulla classificazione gerarchica elaborata da E.M. von Hornbostel e C. Sachs e pubblicata su *Zeitschrift für Ethnologie*, 1914.

Le voci dell'indice contengono le seguenti informazioni, se disponibili:

No. — numero della voce nell'indice

GROUP — secondo l'elenco precedente

DATE — data approssimativa dell'invenzione o della creazione dello strumento

INSTRUMENT — nome generico dello strumento o tipo di strumento (in inglese nella maggior parte dei casi)

NAME — nome nella lingua originale e/o nome dato a una specifica variante dello strumento

INSTRUMENT MAKER(s) — inventore e/o fabbricante dello strumento

COUNTRY/REGION — paese o località d'origine o fabbricazione

Указатель

Записи указателя пронумерованы в соответствии с номерами рисунков в книге и на прилагающемся компакт-диске.

Классификация распределяет каждый музыкальный инструмент в одну из следующих групп:
AERO: **Аэрофоны** — звук производится прежде всего вибрацией воздуха
MEMB: **Мембрамофоны** — звук производится благодаря вибрации натянутой перепонки
IDIO: **Идиофоны** — звук производится посредством вибраций корпуса самого инструмента
CHOR: **Хордофоны** — звук производится вибрацией одной или нескольких натянутых струн
MECH: **Механофоны** — звук производится автоматически благодаря заготовленной и повторяющейся программе
ELEC: **Электрофоны** — производят звук электрическими средствами и/или имеют электрическое действие или усиление
IMAG: **Воображаемые** — не были физически воплощены, но тем или иным способом документально зафиксированы

Первые четыре классификационных обозначения основываются на иерархической классификации, разработанной Е.М. вон Хорнбостелем и К. Саксом в издании журнала *Zeitschrift für Ethnologie* 1914 – ого года.

Каждая запись указателя содержит следующую информацию, если таковая имеется:
No. — номер записи в указателе
Group — смотрите в списке выше
Date — приблизительная дата изобретения или конструкции инструмента
Instrument — общее название инструмента или типа инструмента (в основном на английском)
Name — название на исходном языке и/или название, данное особой разновидности инструмента
Instrument Maker(s) — изобретатель и/или производитель инструмента
Country/Region — страна или область происхождения или производства

インデックス

インデックスの番号は、本書のイラスト番号、及び附録CD-ROMのイラスト番号に対応しています。

楽器は、以下の7つのカテゴリーに分類されています。
AERO: 管楽器 — 空気の振動で音が出る楽器
MEMB: 膜鳴楽器 — 伸びた膜の振動で音が出る楽器
IDIO: 体鳴楽器 — 楽器自体の振動で音が出る楽器
CHOR: 弦楽器 — 弦の振動で音が出る楽器
MECH: 機械楽器 — プログラムされた機械から自動的に音が反復して出る楽器
ELEC: 電子楽器 — 電気によって、あるいは電気的な動きまたは増幅によって音が出る楽器
IMAG: 想像上の楽器 — 実際に製作はされなかったものの、デザインが存在している楽器

この分類カテゴリーのうち、最初の4カテゴリーは、1914年に出版された "Zeitschrift für Ethnologie" (著者：E.M. von Hornbostel、C. Sachs) の階層的分類に基づいています。

インデックスに含まれている情報は以下のとおりです (ただし、すべてが含まれているとは限らず、以下の一部のみ含んでいる場合もあります)。
No. — インデックス番号
Group — カテゴリー (上記のリストをご参照ください)
Date — 楽器の発明あるいはデザイン時期
Instrument — 楽器の名前、あるいは楽器のタイプ (多くの場合、英語表記)
Name — 原語での楽器の名前、あるいはその亜流の楽器名前
Instrument Maker(s) — 楽器の発明者、あるいは製作者
Country/Region — 楽器が発明された国、あるいは地域

35 CHOR; c 2nd millennia BCE; **Musical Bow**; –; –; Kenya

36 IDIO; c 2nd millennia BCE; **Slit Drum**; –; –; Kongo (Congo)

37 AERO; c 2nd millennia BCE; **Panpipe**; *Syrinx*; –; Ancient Greece

38 MEMB; c 2nd millennia BCE; **Globlet drum**; –; –; Bohemia

39 MEMB; c 2–1st millennia BCE; **Hourglass Drum**; *Damru (or Dhamarukha)*; –; India

40 CHOR; c 18th c. BCE; **Aeolian Harp**; *Kinnor (or Quinor)*; –; Mari (Iraq)

41 AERO; 18–5th c. BCE; **Trumpet**; *Lur*; –; Denmark

42 AERO; 17–11th c. BCE; **Double Clarinet**; *Pūngī (or Tiktiri)*; –; India

43 IDIO; 16–11th c. BCE; **Clappers**; –; –; Ancient Egypt

44 IDIO; 16–11th c. BCE; **Rattle**; –; –; Iran

45 IDIO; 16–11th c. BCE; **Clappers**; –; –; Ancient Egypt

46 CHOR; 1550–1292 BCE; **Lute**; –; –; Ancient Egypt

47 IDIO; 16–11th c. BCE; **Clappers**; –; –; Ancient Egypt

48 IDIO; 16–11th c. BCE; **Sliding Rattle**; *Naos Sistrum (or Sesheshet)*; –; Ancient Egypt

49 IDIO; 16–11th c. BCE; **Sliding Rattle**; *Naos Sistrum (or Sesheshet)*; –; Ancient Egypt

50 CHOR; 1550–1292 BCE; **Lyre**; –; –; Ancient Egypt

51 CHOR; 1550–1292 BCE; **Harp**; –; –; Ancient Egypt

52 CHOR; 1550–1292 BCE; **Lute**; –; –; Ancient Egypt

53 CHOR; 1550–1292 BCE; **Lyre**; –; –; Ancient Egypt

54 AERO; c 15th c. BCE; **Flute**; –; –; North America

55 IDIO; c 15th c. BCE; **Bell**; –; –; Gabon

56 MEMB; c 15th c. BCE; **Drum**; *Bendré*; Moaga People; Burkina Faso

57 AERO; c 15–10th c. BCE; **Gourd Clarinet**; *Bumpe*; –; Burkina Faso

58 MEMB; c 14th c. BCE; **Drum**; *Tof*; –; –;

59 AERO; c 14th c. BCE; **Trumpet**; *The Trumpet of Tutankhamun*; –; Ancient Egypt

60 AERO; 1400–1200 BCE; **Mouth Organ**; *He (or Yu)*; –; China

61 AERO; c 13th c. BCE; **Vessel Flute**; –; –; China

62 AERO; 1292–1152 BCE; **Double Clarinet**; –; –; Ancient Egypt

63 AERO; 1292–1152 BCE; **Double Clarinet**; –; –; Ancient Egypt

64 IDIO; c 1150 BCE; **Bell**; –; –; Ancient Greece

65 AERO; 1122–256 BCE; **Trumpet**; *Cha Xiao*; –; China

66 AERO; c 1st millennia BCE; **Mouth Organ**; *Khaen Gao*; –; Laos

67 IDIO; c 1st millennia BCE; **Clapper**; –; –; Nigeria

68 AERO; c 1st millennia BCE; **Drone Pipe**; *Didjeridu (or Didgeridoo)*; –; Australia

69 IDIO; c 1st millennia BCE; **Water Drum**; *Assakhalebo*; –; Middle/West Sahara

70 IDIO; c 1st millennia BCE; **Finger Cymbals**; *Zills*; –; Balkan Peninsula

71 AERO; c 1st millennia BCE; **Nose-blown Flute**; –; –; Fiji

72 IDIO; c 1st millennia BCE; **Gourd Rattle**; –; –; Nigeria

73 IDIO; c 1st millennia BCE; **Gourd Rattle**; –; –; Nigeria

74 IDIO; c 1st millennia BCE; **Gourd Rattle**; –; –; Nigeria

75 AERO; c 1st millennia BCE; **Flute**; –; –; Colombia

76 MEMB; c 1st millennia BCE; **Frame Drum**;
 Kilaut (or Cauyuq); Inuit People; Canada

77 AERO; c 1st millennia BCE; **Mouth Organ**; –;
 Dyak People; Borneo

78 AERO; 10–6th c. BCE; **Oboe**; *Duduk (or Duduki)*;
 –; Armenia

79 IDIO; c 9–6th c. BCE; **Bell**; –; –; China

80 IDIO; c 9–4th c. BCE; **Cymbals**; –; –; Ancient Rome

81 AERO; c 9–4th c. BCE; **Shawm**; *Tibia (or Fistula)*; –;
 Ancient Rome

82 AERO; c 9–4th c. BCE; **Trumpet**; *Lituus*; –; Ancient Rome

83 CHOR; c 8th c. BCE; **Aeolian Harp**;
 King David's Kinnor (or Quinor); –; Europe

84 IDIO; c 8th c. BCE; **Rattle**; –; –; Silesia (Poland)

85 CHOR; c 8th c. BCE; **Lyre**; –; –; Ancient Greece

86 IDIO; c 8th c. BCE; **Bell**; –; –; Assyria (Iraq)

87 IDIO; c 8th c. BCE; **Bell**; –; –; Assyria (Iraq)

88 MEMB; c 8th c. BCE; **Double Skin Drum**;
 Daouli (or Toubano); –; Ancient Greece +B56

89 AERO; c 8th c. BCE; **Side-blown Trumpet**; –;
 Bororo Indians; Brazil and Bolivia

90 AERO; c 8–7th c. BCE; **Trumpet**; *Salpinx*; –; Ancient Greece

91 IDIO; 8–5th c. BCE; **Slapsticks**; *Crotala*; –; Switzerland

92 AERO; c 7th c. BCE; **Mouth Organ**; *Sheng*; –; China

93 AERO; c 6th c. BCE; **Mouth Organ**; *Sheng*; –; China

94 AERO; c 6th c. BCE; **Double Reed**; *Zamr (or Mizmar)*;
 –; Oman

95 AERO; *before* 5th c. BCE; **Vessel Flute**; –; Carché Culture;
 Ecuador

96 IDIO; c 5th c. BCE; **Rattle**; –; –; Ireland

97 IDIO; c 5th c. BCE; **Rattle**; –; –; Ireland

98 CHOR; c 5th c. BCE; **Lyre**; *Kithara*; –; Ancient Greece

99 MEMB; c 5th c. BCE; **Drum**; *Daouli*; –; Ancient Greece +B56

100 MEMB; c 5th c. BCE; **Hanging Drum**; *Tsuri-daiko*; –; Japan

101 MEMB; c 5th c. BCE; **Barrel Drum**; *O-daiko*; –; Japan +B48

102 IDIO; c 5th c. BCE; **Cymbals**; *Zilli Masa*; –; Ancient Greece

103 CHOR; c 5th c. BCE; **Chordophone (Musical Bow)**; –; –;
 Central Africa

104 CHOR; c 5th c. BCE; **Lyre**; –; –; Ancient Greece

105 AERO; c 5th c. BCE; **Trumpet**; *Lituus*; –; Ancient Rome

106 MEMB; c 5th c. BCE; **Kettle Drum**; –; –; India +B44

107 AERO; 433 BCE; **Panpipe**; *Paixiao*; –; China

108 CHOR; c 5th c. BCE; **Trough Zither**; –; –; Africa

109 CHOR; c 5th c. BCE; **Trough Zither**; –; –; Africa

110 IDIO; *after* 380 BCE; **Temple Bell**; – ;–; Ethiopia

111 AERO; c 4th c. BCE; **Shawm**;
 Aulos (Monaulos & Plagiaulos); –; Ancient Greece

112 IDIO; c 6th c. BCE; **Cymbals**; *Zilli Masa*; –; Ancient Egypt

113 MEMB; c 3rd c. BCE; **Goblet Drum**; *Bernburg Drum*; –; Bohemia

114 CHOR; c 3rd c. BCE; **Lyre**: –; –; Ancient Greece

115 AERO; 300–250 BCE; **Duct Flute**; –; Colima Culture; Mexico

116 AERO; 4–3th c. BCE; **Vessel Flute**; –; Guanacaste–Nicoya Culture; Costa Rica

117 CHOR; c 2nd c. BCE; **Wind Harp**; *Aeolian Harp*; –; Ancient Greece

118 IDIO; c 2nd c. BCE; **Bell**; –; –; Ancient Egypt

119 AERO; c 2nd c. BCE; **Panpipe**; –; –; Peru

120 IDIO; c 2nd c. BCE; **Sliding Rattle**; *Angklung*; –; Indonesia (Java)

121 AERO; c 2nd c. BCE; **Bagpipe**; *Gaida*; –; Macedonia

122 IDIO; c 2nd c. BCE; **Bell**; –; –; Ancient Egypt

123 IDIO; c 2nd c. BCE; **Zither**; *Se*; –; China

124 AERO; c mid 2nd c. BCE; **Ocarina**; *Hun*; –; Gojoseon (Korea)

125 AERO; c 2nd c. BCE; **Whistle**; –; –; Europe

126 CHOR; c mid 2nd c. BCE; **Stick Zither**; *Tzeze*; –; Uganda

127 AERO; c 1st c. BCE; **Hydraulic Organ**; *Hydraulis*; –; Ancient Rome (Pompeii)

128 AERO; c 1st c. BCE; **Flute**; –; Hopewell Culture; North America

129 MEMB; c 1st c. BCE; **Friction drum**; –; –; Bohemia

130 CHOR; 63–14 BCE; **Lyre**; –; –; Ancient Rome

131 CHOR; 0–4th c. CE; **Cradle Zither**; *Nanga*; –; Uganda

132 AERO; c 1st c. CE; **Panpipe**; –; Hopewell Culture; North America

133 IDIO; c 79 CE; **Cymbals**; –; –; Ancient Rome (Pompeii)

134 AERO; c 79 CE; **Trumpet**; *Cornu*; –; Ancient Rome (Pompeii)

135 AERO; c 2nd c. CE; **Panpipe**; –; Hopewell Culture; North America

136 IDIO; c 2nd c. CE; **Sliding Rattle**; *Sistrum*; –; Ethiopia

137 IDIO; 2–7th c. CE; **Basketwork Rattle**; –; –; Latin America

138 IDIO; 2–7th c. CE; **Rattle**; –; –; Peru

139 AERO; *after* 150 CE; **Double Flute**; –; –; Honduras

140 MEMB; *before* 3rd c. CE; **Frame Drum**; *Kanjeera (or Kanjira)*; –; India

141 CHOR; 3–6th c. CE; **Rebec**; –; –; Europe +B1

142 CHOR; 3–6th c. CE; **Gigue**; –; –; Europe +B1

143 CHOR; 3–6th c. CE; **Rebec**; –; –; Europe +B1

144 AERO; c 3rd c. CE; **End–blown Flute**; –; Nazca Culture; Peru

145 MEMB; c. 230 CE; **Drum**; –; Gamelan Orchestra; Indonesia (Bali)

146 CHOR; 3–6th c. CE; **Gigue**; –; –; Europe +B1

147 IDIO; 3–5th c. CE; **Vessel Rattle**; –; Moche Culture; Peru

148 CHOR; 3–6th c. CE; **Gigue**; –; –; Europe +B1

149 CHOR; 3–6th c. CE; **Fiddle**; –; –; Europe +B1

150 CHOR; 3–6th c. CE; **Vielle**; –; –; Europe +B2

151 MEMB; *mid* 3–10*th* c. CE; **Drum**; –; Mayan Civilisation;
 Maya area

152 AERO; *mid* 3–10*th* c. CE; **Flute**; –; Mayan Civilisation;
 Maya area (Ecuador)

153 AERO; c 4*th* c. CE; **Double Whistle Flute**; –; –;
 Latin America

154 MEMB; c 4*th* c. CE; **Goblet Drum**; –; –; Ghana

155 IDIO; c 4*th* c. CE; **Wind Bell**; –; –; Korea

156 CHOR; c 4*th* c. CE; **Lyre**; *Krar*; –; Ethiopia

157 AERO; *mid* 3–10*th* c. CE; **Flute**; –; Mayan Civilisation;
 Maya area (Ecuador)

158 AERO; 4–9*th* c. CE; **Nose–blown Flute**; –; –; Tahiti

159 AERO; 4–6*th* c. CE; **Shawm**; *Suona (or Sona)*; –; China

160 CHOR; c 4*th* c. CE; **Lute**; *Komuz*; –; Kyrgyzstan

161 AERO; 4–8*th* c. CE; **Transverse Flute**; –; –; Mexico

162 AERO; 4–9*th* c. CE; **Flute**; –; –; Tahiti

163 AERO; c 5*th* c. CE; **Flute**; –; Mayan Civilisation; Maya area

164 AERO; *mid* 3–10*th* c. CE; **Flute**; –; Mayan Civilisation;
 Maya area (Costa Rica)

165 AERO; 5–16*th* c. CE; **Bagpipe**; *Gajde (or Gadjarka)*; –;
 Serbia & Montenegro

166 IDIO; 5–16*th* c. CE; **Shepherd's Bell**; –; –; Switzerland

167 IDIO; 5–16*th* c. CE; **Coins**; –; –; Europe

168 IDIO; 5–16*th* c. CE; **Clapper**; –; –; Switzerland

169 CHOR; 5–16*th* c. CE; **Lyre**; *Hiiukannel (or Rootsikannel)*;
 –; Estonia +B14

170 CHOR; 5–16*th* c. CE; **Dulcimer**; *Hackbrett*; –;
 Germany +B53

171 AERO; 5–16*th* c. CE; **Shepherd's Flute**; *Hosszú Furugla*;
 –; Hungary

172 AERO; c 5*th* c. CE; **Triple Flute**; –; –; Mexico

173 IDIO; 5–16*th* c. CE; **Bell**; *Cabman's Bell*; –; Europe

174 AERO; c 5*th* c. CE; **Trumpet**; –; –; Peru

175 CHOR; c 5*th* c. CE; –; *Harpe de Menestrel*;
 Manuscrit du Miroir Historial; France

176 IDIO; c 5*th* c. CE; **Gong**; –; –; Ethiopia +B51

177 CHOR; 5–16*th* c. CE; **Zither**; –; –; France

178 CHOR; 5–16*th* c. CE; **Fiddle**; –; –; Europe

179 AERO; c 5*th* c. CE; **Flute**; –; Mayan Civilisation; Maya area

180 AERO; c 5*th* c. CE; **Clarinet**; –; –; Latin America

181 AERO; c 5*th* c. CE; **Flute**; –; Mayan Civilisation; Maya area

182 CHOR; 5–7*th* c. CE; –; *Harpe Sculpee*; –; France

183 AERO; *before* 6*th* c. CE; **Bagpipe**; *Magyar Duda*;
 –; Hungary

184 IDIO; *before* 6*th* c. CE; **Cog Rattle**; *Ratchet*; –;
 Czech Republic

185 CHOR; c 6*th* c. CE; **Lyre**; *Rotta*; –; West Europe

186 AERO; 5–16*th* c. CE; **Hornpipe**; –; –; Finland

187 IDIO; 5–16*th* c. CE; **Crystallophone**;
 Jaltarang (or Jal-yantra); –; India +B40

188 IDIO; 5–16th c. CE; **Clapper**; –; –; Switzerland

189 IDIO; 5–16th c. CE; **Clapper Bell**; *Cowbell*; –; Europe

190 AERO; c 6th c. CE; **Trumpet**; –; –; Mexico

191 AERO; c 6th c. CE; **Flute**; *Tai Hei Shakuhachi*; –; Japan

192 CHOR; c 6th c. CE; **Lyre**; *Kissar (or Gytarah Barbaryeh)*; –; Sudan

193 IDIO; c 6th c. CE; **Rattle**; –; –; Mexico

194 AERO; c 6th c. CE; **Trumpet**; –; –; Latin America

195 CHOR; 5–16th c. CE; **Rebec**; –; –; Europe +B14

196 AERO; c 6th c. CE; **Trumpet**; –; –; Latin America

197 CHOR; 5–16th c. CE; **Zither**; *Fidla*; –; Iceland

198 AERO; c 6th c. CE; **Trumpet**; –; –; Latin America

199 AERO; c 6th c. CE; **Trumpet**; –; –; Peru

200 IDIO; c 6th c. CE; **Rattle**; –; –; Mexico

201 AERO; *mid* 3–10th c. CE; **Flute**; –; Mayan Civilisation; Maya area (Peru)

202 CHOR; c 6th c. CE; **Fiddle**; *Goge (or Goje)*; –; West Africa +B22

203 IDIO; *before* c 7th c. CE; **Klepalo**; *Semantron*; –; Greece +B52

204 AERO; *before* c 7th c. CE; **Flute**; –; –; Mexico

205 AERO; c 6th c. CE; **Flute**; –; Mayan Civilisation; Maya area

206 AERO; 6–8th c. CE; **Double Transverse Flute**; –; –; Mexico

207 CHOR; 5–16th c. CE; **Harp**; –; –; Europe

208 CHOR; 5–16th c. CE; **Lyre**; *Lirica*; –; Serbia and Croatia +B23

209 MEMB; 6–8th c. CE; **Hourglass Drum**; *Kalangu (or Kalungu)*; Hausa People; Nigeria +B31

210 IDIO; *before* 7th c. CE; **Klepalo**; *Semantron*; –; Greece +B47

211 IDIO; 5–16th c. CE; **Jew's Harp**; *Scaccia Pensieri*; –; Italy

212 CHOR; 5–16th c. CE; **Spike Fiddle**; –; –; Morocco +B4

213 AERO; c 7th c. CE; **Polyphonic Flute**; –; –; Mexico

214 CHOR; c 7th c. CE; **Lute**; –; –; Egypt

215 AERO; c 7th c. CE; **Flute**; –; –; Mexico

216 MEMB; c 7th c. CE; **Tambourine**; *Terbang*; –; Indonesia (Java)

217 AERO; c 7th c. CE; **Polyphonic Flute**; –; –; Mexico

218 CHOR; 5–16th c. CE; **Harp**; –; –; Europe

219 AERO; c 7th c. CE; **Flute**; –; –; Peru

220 CHOR; c 7th c. CE; **Lyre**; *Rotta*; –; West Europe

221 MEMB; *after* c 7th c. CE; **Double–headed Drum**; *Ghinang*; –; Vietnam

222 MEMB; *before* 632 CE; **Frame Drum**; *Daff (or Daf)*; –; Iran

223 MEMB; *before* 670 CE; **Goblet Drum**; *Darbukka (or Derbuga)*; –; Morocco

224 IDIO; 5–16th c. CE; **Spoons**; –; –; Europe

225 CHOR; 5–16th c. CE; **Zither**; –; –; Hungary

226 AERO; c 8th c. CE; **End–blown Flute**; *Kaval (or Caval)*; –; Bulgaria

227 AERO; c 8th c. CE; **End–blown Flute**; –; –; Morocco

228 AERO; c 8th c. CE; **Panpipe**; *Paixiao*; –; Japan

229 IDIO; 5–16th C. CE; **Bells**; –; –; Russia

230 IDIO; C 8th C. CE; **Jew's Harp**; *Vargan*; –; Russia

231 MEMB; C 8th C. CE; **Barrel Drum**; *Kakko*; –; Japan +B34

232 MEMB; C 8th C. CE; **Long Drum**; *Ngalabi*; –; Nigeria

233 CHOR; C 8th C. CE; **Fiddle**; *Gusle*; –; Croatia +B15

234 MEMB; 750–1076 CE; **Talking Drum**; *Tama*; –;
 Ancient Ghana +B31

235 CHOR; 5–16th C. CE; **Lyre**; *Tallharpa*; –; Estonia +B14

236 CHOR; C 9th C. CE; **Short–necked Plucked Lute**; *Ud*;
 –; Middle East

237 MEMB; C 9th C. CE; **Double–headed Drum**; *Sampho*;
 –; Cambodia

238 AERO; C 9th C. CE; **Double Flute**;
 Dvojachka (or Dvoyacky); –; Slovakia

239 IDIO; 5–16th C. CE; **Clapper**; –; –; Switzerland

240 CHOR; C 9th C. CE; **Lute**; *Alaúde*; –; Portugal

241 IDIO; C 9th C. CE; **Vessel Drum**; *Udu*; Igbo People; Nigeria

242 CHOR; C 9th C. CE; **Lyre**; *Lyre du Nord*; –; France

243 AERO; C 9th C. CE; **Panpipe**; –; –; Czech Republic

244 CHOR; 5–16th C. CE; **Viol**; *Vihuela*; –; England +B2

245 AERO; 802–1431 CE; **Oboe**; *Sralai (or Sralay)*;
 –; Cambodia

246 AERO; C 9th C. CE; **Trumpet**; *Alphorn*; –; Switzerland

247 CHOR; 823–961 CE; **Fiddle**; *Cretan Lira*; –; Greece +B1

248 CHOR; 9–11th C. CE; **Lyre**; –; –; Sweden

249 AERO; *after 896* CE; **Trumpet**; –; –; Hungary

250 AERO; 9–14th C. CE; **Flute**; *Nguru*; Maori People;
 New Zealand

251 AERO; 9–14th C. CE; **Trumpet**; –; Maori People;
 New Zealand

252 AERO; 9–14th C. CE; **Trumpet (or Bugle)**; *Putorino*;
 Maori People; New Zealand

253 IDIO; 5–16th C. CE; **Spur**; –; –; Europe

254 AERO; 5–16th C. CE; **Flute with Pitch–adjusting Slide**;
 –; –; Europe

255 CHOR; C 10th C. CE; **Chordophone**; –;
 Apocalipse do Escorial; Iberian Peninsula

256 CHOR; C 10th C. CE; **Lyre**; –; –; Europe

257 CHOR; C 10th C. CE; **Fiddle**; *Rebab (or Rabab)*; –;
 North West Africa

258 CHOR; C 10th C. CE; **Lyre**; *Rotta*; –; West Europe

259 AERO; *after 918* CE; **Trumpet**; *Nallari (or Hojok)*;
 –; Korea

260 CHOR; *after 10th* C. CE; **Hybrid Lute (or Box Zither)**;
 Bandoura (or Bandura); –; Ukraine

261 CHOR; *after 10th* C. CE; **Fiddle**; *Kamancheh (or Kemance)*;
 –; Balkan Peninsula +B16

262 CHOR; *after 10th* C. CE; **Fiddle**;
 Gadulka (or Ganilika or kopanka); –; Bulgaria +B16

263 AERO; *after 10th* C. CE; **Horn–shaped Trumpet**;
 –; –; Hungary

264 CHOR; *after 10th* C. CE; **Lute**; *Guzla (or Gusla)*; –;
 Bulgaria +B15

265 CHOR; *after* 10*th* c. CE; **Lute**; *Outi (or Uti)*; –; Greece

266 CHOR; *after* 10*th* c. CE; **Lute**; *Outi (or Uti)*; –; Greece

267 CHOR; *after* 10*th* c. CE; **Rebec**; –; –; France +B14

268 CHOR; *after* 10*th* c. CE; **Rebec**; –; –; Europe +B14

269 AERO; 5–16*th* c. CE; **Clarinet with Horn Bell**; –; –; Scotland

270 CHOR; 5–16*th* c. CE; **Rebec**; *Husle (or Husla)*; –; Serbia +B14

271 AERO; c 11*th* c. CE; **Bullroarer**; –; Thule People; Canada

272 AERO; c 11*th* c. CE; **Bullroarer**; –; Thule People; Canada

273 MEMB; c 11*th* c. CE; **Bass Drum**; *Lodër (or Tupan)*; –; Bulgaria

274 AERO; c 11*th* c. CE; **Flute**; –; –; Peru

275 AERO; c 11*th* c. CE; **Flute**; –; –; Peru

276 CHOR; c 11*th* c. CE; **Plucked Bowed Lyre**; *Crwth*; –; Wales +B18

277 AERO; c 11*th* c. CE; **Single Hornpipe with Mouth Horn**; *Pibgorn (or Pibcorn)*; –; Wales

278 MEMB; c 11*th* c. CE; **Side Drum**; *Tabor*; –; France +B46

279 AERO; c 11*th* c. CE; **Bladder Pipe**; –; –; Europe

280 AERO; c 11*th* c. CE; **End–blown Flute**; –; Chancay Culture; Peru

281 CHOR; c 11*th* c. CE; **Bow Lute**; *Pluriarc*; –; South Africa

282 IDIO; 5–16*th* c. CE; **Frame Rattle**; –; –; Switzerland

283 AERO; c 11*th* c. CE; **Bagpipe**; *Mezoued (or Zukra)*; –; Tunisia

284 AERO; c 11*th* c. CE; **End–blown Horn**; *Oliphant*; –; Italy

285 CHOR; c 11*th* c. CE; **Zither**; *Kantele (or Soittu)*; –; Finland

286 AERO; c 11*th* c. CE; **Nose Flute**; *Ohe Hanu Ihu*; –; Hawaii

287 AERO; c 11*th* c. CE; **Panpipe**; *Skuduciai*; –; Lithuania

288 AERO; c 11*th* c. CE; **Bagpipe**; *Mezoued (or Zukra)*; –; Arabia

289 AERO; c 11*th* c. CE; **Fanfare Trumpet**; –; –; Europe

290 AERO; c 11*th* c. CE; **Double Flute**; –; Motzi People; Romania

291 CHOR; c 1047 CE; **Chordophone**; –; –; Spain (Códice da Biblioteca Nacional de Madrid)

292 AERO; 11–14*th* c. CE; **Bagpipe**; *Gaita de Foles*; –; Portugal

293 IDIO; 11–16*th* c. CE; **Suspension Rattle**; –; Chancay Culture; Peru

294 CHOR; early 12*th* c. CE; **Pear–shaped Lute**; *Pipa*; –; China +B105

295 IDIO; 5–16*th* c. CE; **Cymbals**; –; –; Europe

296 MEMB; c 12*th* c. CE; **Kettle Drum**; *Naqqara (or Naker)*; –; Egypt

297 IDIO; c 12*th* c. CE; **Time–beating Gourd**; –; –; Ghana

298 MEMB; c 12*th* c. CE; **Friction Drum**; –; –; Zambia

299 AERO; c 12*th* c. CE; **Transverse Flute**; –; –; Bolivia

300 MEMB; c 12*th* c. CE; **Drum**; *Djembe (or Jembe)*; –; Mali

301 IDIO; 1100–1476 CE; **Vessel Rattle**; –; Chimù Culture; Peru

302 AERO; 11–14*th* c. CE; **Bagpipe**; *Gaita de Foles*; –; Portugal

303 MEMB; c 12th c. CE; **Cylindrical Drum**; ***Djun Djun (or Dunun)***; –; West Africa

304 CHOR; c 12th c. CE; **Lyre**; –; –; Italy +B7

305 CHOR; c 12th c. CE; **Hurdy Gurdy**; ***Organistrum***; –; Spain

306 AERO; c 12th c. CE; **Flute**; –; –; Cuba

307 IDIO; c 12th c. CE; **Bell**; –; –; Liberia

308 IDIO; c 12th c. CE; **Lithophone**; ***Seixo***; –; Portugal

309 IDIO; 1185–1333 CE; **Rattle**; ***Binzasara (or Kokiriko)***; –; Japan

310 CHOR; 12–18th c. CE; **Irish Harp**; –; –; Ireland

311 AERO; 11–14th c. CE; **Bagpipe**; ***Gaita de Foles***; –; Portugal

312 IDIO; c 13th c. CE; **Church Bell**; –; –; England

313 AERO; 1206–1405 CE; **Oboe**; ***Gangling***; –; Mongolia

314 AERO; c 13th c. CE; **Flute**; –; –; Peru

315 AERO; c 13th c. CE; **Flute**; –; –; Peru

316 MEMB; c 13th c. CE; **Drum**; ***Tuur***; –; Mongolia +B29

317 IDIO; c 13th c. CE; **Handbell**; –; –; Europe

318 AERO; c 13th c. CE; **Horn**; ***Alboka (or Zinburra)***; –; Spain (Basque Country)

319 AERO; *before* 1238 CE; **Oboe**; ***Pi Chai Nai***; –; Thailand

320 AERO; c 13th c. CE; **Shepherd's Pipe**; ***Tilinkó***; –; Hungary

321 CHOR; c 13th c. CE; **Zither**; ***Psaltery (or Salterio)***; –; Spain

322 IDIO; c 13th c. CE; **Handbell**; –; –; Europe

323 MEMB; c 13th c. CE; **Drum**; ***Shaman Drum***; –; Siberia +B55

324 AERO; c 13th c. CE; **Bagpipe**; ***Gajdy***; –; Slovakia

325 CHOR; c 13th c. CE; **Harp**; –; –; Egypt

326 AERO; 1248–1521 CE; **Panpipe**; –; Aztec Culture; Peru

327 AERO; c 13th c. CE; **Duct Flute**; Pipe; –; Europe

328 MEMB; c 13th c. CE; **Square Frame Drum**; ***Pandeiro (or Adufe)***; –; Spain

329 AERO; c 13th c. CE; **Duct Flute**; ***Pipe***; –; Europe

330 AERO; 1248–1521 CE; **Panpipe**; –; Aztec Culture; Bolivia

331 IDIO; c 13th c. CE; **Castanets**; –; –; Spain

332 AERO; 1248–1521 CE; **Flute**; ***Chipaktli***; Aztec Culture; Aztec Area

333 MEMB; c 13th c. CE; **Hand Drum**; ***Operenten (or Apentemma)***; –; Ghana

334 AERO; c 13th c. CE; **Panpipe**; ***Nay***; –; Romania

335 AERO; c 13th c. CE; **Shepherd's Pipe**; ***Kanet***; –; Serbia

336 MEMB; c 13th c. CE; **Drum**; ***Ngoma***; –; South Africa

337 CHOR; c 13th c. CE; **Lyre**; ***Rotta***; –; West Europe

338 AERO; c 13th c. CE; **Horn**; ***Alboka (or Zinburra)***; –; Spain (Basque Country)

339 AERO; c 13th c. CE; **Triple Clarinet**; ***Launeda***; –; Sardinia

340 IDIO; c 13th c. CE; **Handbells**; –; –; Europe

341 AERO; 1248–1521 CE; **Panpipe**; –; Aztec Culture; Ecuador

342 CHOR; c 13th c. CE; **Chordophone**; –; –; Portugal, Cantigas de Santa Maria

343 CHOR; c 13th c. CE; **Chordophone**; –; –; Portugal, Cantigas de Santa Maria

344 AERO; 1248–1521 CE; **Leg–shaped Flute**; –; Aztec Culture; Aztec Area

345 CHOR; c 13th c. CE; **Chordophone**; –; –; Portugal, Cantigas de Santa Maria

346 CHOR; c 13th c. CE; **Chordophone**; –; –; Portugal, Cantigas de Santa Maria

347 CHOR; c 13th c. CE; **Chordophone**; –; –; Portugal, Cantigas de Santa Maria

348 CHOR; c 13th c. CE; **Chordophone**; –; –; Portugal, Cantigas de Santa Maria

349 AERO; 1248–1521 CE; **Double Panpipe**; –; Aztec Culture; Latin America

350 IDIO; c 13th c. CE; **Set of Castanets**; –; –; Spain

351 CHOR; c 13th c. CE; **Chordophone**; –; –; Portugal, Cantigas de Santa Maria

352 AERO; c 13th c. CE; **Double Flute**; –; –; Bolivia

353 CHOR; c 13th c. CE; **Chordophone**; –; –; Portugal, Cantigas de Santa Maria

354 IDIO; c 13th c. CE; **Bell**; *Dawal*; –; Abyssinia (Ethiopia) +B36

355 AERO; 13–16th c. CE; **End–blown Flute**; –; Nazca Culture; Peru

356 AERO; 11–14th c. CE; **Bagpipe**; *Gaita de Foles*; –; Portugal

357 MEMB; c 14th c. CE; **Barrel Drum**; –; –; Laos

358 AERO; c 14th c. CE; **Trumpet**; *Anafil*; –; Portugal

359 AERO; c 14th c. CE; **Bagpipe**; –; –; Scotland

360 IDIO; c 14th c. CE; **Scraper**; –; Aztec Culture; Aztec Area +B103

361 AERO; c 14th c. CE; **Horn**; *Paimensarvi (or paimentorvi)*; –; Finland

362 AERO; c 14th c. CE; **Flute**; –; –; Mexico

363 AERO; c 14th c. CE; **Flute**; –; –; Mexico

364 CHOR; c 14th c. CE; **Hurdy Gurdy**; *Tekerolant*; –; Hungary

365 IDIO; c 14th c. CE; **Tambourine**; *Dayre (or Def)*; –; Turkey

366 AERO; 11–14th c. CE; **Bagpipe**; *Gaita de Foles*; –; Portugal

367 IDIO; *before* 1400 CE; **Jew's Harp**; *Maultrommel*; –; Germany

368 AERO; 14–16th c. CE; **Quadruple Flute**; –; Aztec Culture; Mexico

369 CHOR; c 1331 CE; **Hybrid Lute (or Box Zither)**; *Kobza (or Bandura)*; –; Romania +B106

370 AERO; 14–17th c. CE; **Descant Recorder**; –; –; Europe

371 AERO; 14–17th c. CE; **Treble Recorder**; –; –; Europe

372 AERO; 14–17th c. CE; **Tenor Recorder**; –; –; Europe

373 AERO; 14–17th c. CE; **Bass Recorder**; –; –; Europe

374 MEMB; c 14th c. CE; **Conical Drum**; –; –; Uganda

375 MEMB; c 1391 CE; **Drum**; *Damaru*; –; Tibet

376 AERO; c 1391 CE; **Shawm**; *Bo Go Gyaling*; –; Tibet

377 AERO; c 1391 CE; **Trumpet**; **Dung Chen**; –; Tibet

378 CHOR; c 15th c. CE; **Lute**; *Machete (or Cavaquinho)*; –; Portugal

379 IDIO; c 15th c. CE; **Rattle**; –; –; Canada (British Columbia)

380 MEMB; c 15th c. CE; **Conical Drum**; –; –; Congo

381 AERO; c 15th c. CE; **Flute**; –; –; Mexico

382 AERO; c 1430 CE; **Trumpet**; *Karnay*; –; Uzbekistan

383 AERO; 1435 CE; **Pipe Organ**; –; –; Switzerland, Church of Notre Dame de Valere

384 CHOR; c 15th c. CE; **Dotara**; –; –; Bangladesh

385 CHOR; c 15th c. CE; **Bandurria**; –; –; Spain

386 AERO; c 15th c. CE; **Double Vessel Whistle**; –; –; Colombia

387 MEMB; c 15th c. CE; **Drum**; *Tekbang*; –; Indonesia (Java)

388 MEMB; *before* 1460 CE; **Goblet Drums**; *Atungblan (or Atumpan)*; –; Côte d'Ivoire

389 CHOR; c 15th c. CE; **Lyre**; –; –; Ethiopia

390 CHOR; c 15th c. CE; **Mandolin**; –; –; Italy

391 CHOR; 1465–1511 CE; **Harp**; –; Sebastian Virdung (1465–1511); Germany

392 AERO; c 15th c. CE; **Clarinet**; –; –; North America

393 IDIO; c 15th c. CE; **Clapper**; *Bak*; –; Korea

394 AERO; 1465–1511 CE; **Treble Recorder**; –; Sebastian Virdung (1465–1511); Germany

395 AERO; 1465–1511 CE; **Mean Recorder**; –; Sebastian Virdung (1465–1511); Germany

396 AERO; 1465–1511 CE; **Bass Recorder**; –; Sebastian Virdung (1465–1511); Germany

397 CHOR; c 15th c. CE; **Fiddle**; *Rebab (or Rabab)*; –; Morocco +B14

398 AERO; c 15th c. CE; **Panpipe**; –; –; Europe

399 MECH; c 15th c. CE; **Keyed Harp**; *Nyckelharpa (or Nyckelgiga)*; –; Sweden +B25

400 AERO; 1490 CE; **Trumpet**; *Felttrumet*; Sebastian Virdung (1465–1511); Germany

401 AERO; c 15th c. CE; **End–blown Flute**; *Shakuhachi*; –; Japan

402 AERO; 1490 CE; **Trumpet**; *Clareta*; Sebastian Virdung (1465–1511); Germany

403 AERO; c 15th c. CE; **Vessel Flute**; –; Chimù Culture; Peru

404 AERO; 1490 CE; **Trumpet**; *Thurnerhorn*; Sebastian Virdung (1465–1511); Germany

405 IDIO; c 15th c. CE; **Slit Drum**; –; –; Costa Rica +B102

406 AERO; 14–16th c. CE; **Alto Transverse Flute**; –; –; Europe

407 AERO; 14–16th c. CE; **Tenor Transverse Flute**; –; –; Europe

408 AERO; 14–16th c. CE; **Bass Transverse Flute**; –; –; Europe

409 MEMB; 15–17th c. CE; **Pressure Drum**; *Dahomey*; –; Tanzania +B31

410 CHOR; *late* 15th c. CE; **Angular Harp**; –; –; Congo

411 AERO; *late* 15th c. CE; **Duct Flute**; *Tumpung (or Tumpong)*; –; Philippines

412 IDIO; *late* 15th c. CE; **Knee Jingles**; –; Morris Dancers; England

413 AERO; *before* 16th c. CE; **Clarinet**; *Guajiro*; –; Latin America

414 AERO; *before* 16th c. CE; **Trumpet**; –; –; Hungary

415 IDIO; *early* 16th c. CE; **Slit Drum**; *Teponaztli (or Tunkul)*; –; Mexico +B102

416 IDIO; *early* 16th c. CE; **Cymbals**; *Karatala*; –; India

417 AERO; 1510–1553 CE; **Transverse Flute**; –; Claudi Rafi (1510–1553); France

418 CHOR; c 16th c. CE; **Fiddle**; *Rebab (or Rabab)*; –; Egypt +B4

419 IDIO; c 16th c. CE; **Guataca**; –; –; Congo

420 MEMB; c 16th c. CE; **Barrel Drum**; *Dholak*; –; India

421 CHOR; 1511 CE; **Viola**; *Lira da Braccio*; Giovanni d'Andrea; Italy +B12

422 IDIO; c 16th c. CE; **Rattling Cup**; –; –; Peru

423 AERO; c 16th c. CE; **Soprano Shawm**; –; –; France

424 AERO; c 16th c. CE; **Alto Shawm**; –; –; France

425 AERO; c 16th c. CE; **Tenor Shawm**; –; –; France

426 AERO; c 16th c. CE; **Bass Shawm**; –; –; France

427 CHOR; 1535 CE; **Viol**; *Vihuela*; –; Spain

428 MEMB; c 16th c. CE; **Barrel Drum**; –; –; Nigeria

429 CHOR; c 16th c. CE; **Fiddle**; –; –; Angola

430 IDIO; c 16th c. CE; **Clappers**; *Tabletas*; –; Spain

431 AERO; 1538 CE; **Tenor Shawm**; *Rauschpfeife*; Rauschpfeife Family; Germany

432 AERO; 1538 CE; **Bass Shawm**; *Rauschpfeife*; Rauschpfeife Family; Germany

433 AERO; 1538 CE; **Large Bass Shawm**; *Rauschpfeife*; Rauschpfeife Family; Germany

434 MEMB; c 16th c. CE; **Goblet Drum**; –; –; Ivory Coast

435 IDIO; c 16th c. CE; **Jicaritas**; –; –; Cuba

436 AERO; c 16th c. CE; **Alto Cornett in F**; –; –; Germany

437 AERO; c 16th c. CE; **Soprano Cornett in C**; –; –; Germany

438 AERO; c 16th c. CE; **Double Clarinet**; *Urua*; Kamayura Indians; Brazil

439 MEMB; c 16th c. CE; **Kettle Drum**; –; –; USA (New Mexico)

440 IDIO; c 16th c. CE; **Scraper**; *Güiro (or Guayo)*; –; Cuba +B43

441 CHOR; c 16th c. CE; **Chordophone**; *Musical Bow*; –; Africa

442 MEMB; c 16th c. CE; **Drum**; *Repicador*; –; Panama

443 IDIO; c 16th c. CE; **Crystallophone**; –; –; Europe

444 HYBR; c 16th c. CE; **Berimbau**; –; –; Brazil +B98

445 IDIO; c 16th c. CE; **Cymbals**; –; –; Europe

446 CHOR; c 16th c. CE; **Treble Lute**; *Mandore*; –; France

447 AERO; c 16th c. CE; **Cowhorn with Fingerholes**; –; –; Sweden

448 MEMB; c 16th c. CE; **Goblet Drum**; *Tonbak*; –; Iran

449 IDIO; c 16th c. CE; **Hawk Bell**; –; –; Colombia

450 CHOR; 1540–1609 CE; **Double Bass**; –; Gasparo da Salò (1540–1609); Italy +B28

451 AERO; c 16th c. CE; **Tenor Cornett in C**; –; –; Germany

452 AERO; c 16th c. CE; **Alto Cornett in F**; –; –; Germany

453 AERO; *mid* 16th c. CE; **Bass Racket**; –; –; Europe

454 MEMB; c 16*th* c. CE; **Barrel Drum**; *Conga*; –;
Latin America

455 CHOR; 1543 CE; **Clavichord**; –; Domenico da Pesaro; Italy

456 AERO; c 16*th* c. CE; **Cornett in G**; –; –; Germany

457 AERO; c 16*th* c. CE; **Piccolo Cornett in D**; –; –; Germany

458 AERO; c 16*th* c. CE; **Panpipe**; –; –; Papua New Guinea

459 CHOR; c 1550 CE; **Guitar**; –; –; Spain

460 CHOR; 1551 CE; **Lute**; –;
Wendolin Tieffenbrucker (1572–1611); Italy

461 AERO; c 16*th* c. CE; **Trumpet**; *Alphorn*; –; Switzerland

462 IDIO; c 16*th* c. CE; **Scraper**; *Güiro (or Guayo)*; –;
Cuba +B43

463 CHOR; 1560 CE; **Viola**; –; Andrea Amati (1520–1578);
Italy +B12

464 CHOR; c 16*th* c. CE; **Bass Cittern**; –; –; Germany

465 MEMB; c 16*th* c. CE; **Friction Drum with Horsehair**;
Jughorn; –; Russia

466 CHOR; 1562 CE; **Harpsichord**; *Spinet*; Benedetto Floriani;
Italy

467 AERO; c 16*th* c. CE; **Treble Flute**; –; –; Germany

468 AERO; c 16*th* c. CE; **Flute**; *Stabule*; –; Latvia

469 CHOR; c 16*th* c. CE; **Lute**; –; –; Italy

470 MEMB; c 16*th* c. CE; **Drum**; –; Chiriguano Indians;
Argentina and Bolivia

471 MEMB; c 16*th* c. CE; **Barrel Drum**; *Tumba*; –;
Latin America

472 CHOR; 1571–1621 CE; **Harp**; –;
Michael Praetorius (1571–1621); Germany

473 IDIO; c 16*th* c. CE; **Bell**; –; –; Balkan Peninsula

474 IDIO; c 16*th* c. CE; **Bell**; –; –; Balkan Peninsula

475 IDIO; c 16*th* c. CE; **Bell**; –; –; Balkan Peninsula

476 CHOR; 1571 CE; **Harpsichord**; –;
Vito Trasuntino (1526–1606); Italy

477 CHOR; 1574 CE; **Cittern**; –;
Girolamo de Virchi (1523-1574); Italy

478 CHOR; *after* 1580 CE; **Lute**; *Chitarrone (or Tiorba)*; –; Italy

479 AERO; c 16*th* c. CE; **Clarinet**; –; –; Latin America

480 CHOR; 1577 CE; **Lira**; *Lira da Braccio*;
Ventura di Francesco Linarolo; Italy +B12

481 CHOR; *after* 1580 CE; **Lute**; *Chitarrone (or Tiorba)*; –; Italy

482 CHOR; c 1581 CE; **Guitar**; *Vilhuela*; Belchior Dias;
Portugal

483 CHOR; c 16*th* c. CE; **Lute with Additional Bass Strings**; –;
Wendelio Venere; Italy

484 IDIO; c 1583 CE; **Clappers**; *Tabletas*; –; Cuba

485 CHOR; 1584 CE; **Lute**; –; Wendelio Venere; Italy

486 CHOR; c 16*th* c. CE; **Tube Zither**; *Valiha*; –; Madagascar

487 CHOR; c 16*th* c. CE; **Tube Zither**; *Valiha*; –; Madagascar

488 CHOR; c 1590 CE; **Poliphant (or Polyphone)**; –;
Wendolin Tieffenbrucker; Italy

489 MEMB; *after* 1591 CE; **Frame Drum**; *Bendir (or Arbani)*; –; Morocco

490 CHOR; 1592 CE; **Lira**; *Lira da Gamba (or Lirone)*; Antonius Brensius; Italy +B12

491 AERO; 1598 CE; **Garland Trumpet**; –; Antonius Schnitzer; Germany

492 AERO; *late* 16th c. CE; **Racket**; –; –; Italy

493 AERO; 1596–1671 CE; **Bass Slide Trombone**; –; Hans Heinlein; Germany

494 IDIO; c 16–17th c. CE; **Okpelé (or Okuelé)**; –; –; West Africa

495 CHOR; 16–18th c. CE; **Fiddle**; *Gusle*; –; Western Balkans +B15

496 IDIO; c 1600 CE; **Planchuela**; –; –; Angola +B43

497 AERO; c 1600 CE; **Organ**; *Bible Regal*; –; Denmark

498 AERO; 1600–1703 CE; **Bagpipe**; *Volynka (or Volïnka)*; –; Russia

499 CHOR; *early* 17th c. CE; **Spike Fiddle**; *Kokyu*; –; Japan +B5

500 IDIO; 1603–1868 CE; **Gong**; *Gyoban*; –; Japan +B32

501 CHOR; *early* 17th c. CE; **Guitar**; *Venetian Guitar*; –; Italy

502 AERO; 1608 CE; –; *Positive Organ*; –; Italy

503 CHOR; *early* 17th c. CE; **Zither**; *Hummel*; –; Switzerland

504 CHOR; 1610 CE; **Lute**; *Theorbo (or Chitarrone)*; Tieffenbrucker Family; Germany

505 AERO; 1612 CE; **Contrabass Slide Trombone**; –; Isaac Eng; Germany

506 CHOR; *early* 17th c. CE; **Lute**; *Battente Guitar (or Chitarra Battente)*; –; Italy

507 CHOR; *early* 17th c. CE; **Cittern**; –; –; France

508 CHOR; 1617 CE; **Tenor Viol**; –; Ernst Busch; Germany +B12

509 CHOR; 1617 CE; **Virginal**; –; –; Denmark

510 AERO; c 17th c. CE; **Tenor Crumhorn**; –; –; Europe

511 AERO; c 17th c. CE; **Bass Crumhorn**; –; –; Europe

512 CHOR; 1618 CE; **Zither**; *Scheitholt*; –; Germany

513 IDIO; c 17th c. CE; **Gourd Rattles**; *Maracas*; –; Antilles

514 CHOR; c 17th c. CE; **Lute**; *Chitarrone (or Tiorba)*; –; Italy

515 AERO; 1619 CE; **Tenor Slide Trombone**; –; Isaac Ehe; Germany

516 AERO; c 17th c. CE; **Cornett**; –; –; Germany

517 IDIO; c 17th c. CE; **Vessel Rattle**; *Cabaza (or Cabaca)*; –; Nigeria

518 CHOR; c 17th c. CE; **Zither**; *Langleik*; –; Norway

519 AERO; *before* 1629 CE; **Flute**; –; –; Australia

520 IDIO; c 17th c. CE; **Vessel Rattle**; *Cabaza (or Cabaca)*; –; West Africa

521 AERO; c 17th c. CE; **Little Horn**; *Vladimiriskiy Rozhok*; –; Russia (Vladimir and Tver districts)

522 AERO; c 17th c. CE; **Treble Shawm**; –; –; Europe

523 MEMB; 1633–1800 CE; **Vessel Miriliton**; *Flûte D'Oignon*; –; France

524 AERO; c 17th c. CE; **Buzz–disk**; –; –; Latin America

525 CHOR; c 17th c. CE; **Lute**; *Theorbo (or Chitarrone)*; –; Italy

526 AERO; c 17th c. CE; **Trumpet**; –; –; Europe

527 AERO; c 17th c. CE; **Buzz–disk**; –; –; Latin America

528 CHOR; c 1640 CE; **Lute**; –; –; Italy

529 CHOR; c 17th c. CE; **Orpharion**; *Penocorn*; Praetorius; Italy

530 MECH; c 17th c. CE; **Mechanical Harpsichord**;
Geigenwerck; Hans Haiden (1536–1613); Germany

531 CHOR; c 17th c. CE; **Monochord**;
Tromba Marina (or Marien Trompet); –; Germany +B8

532 MEMB; c 17th c. CE; **Frame Drum**; *Bodhrán*; –;
Ireland +B45

533 MEMB; c 17th c. CE; **Cylindrical Drum**; –; –; Ivory Coast

534 CHOR; 1638 CE; **Harpsichord**; –;
Joannes Ruckers (1578–1642); Belgium

535 AERO; c 17th c. CE; **Trumpet**; –; –; Papua New Guinea

536 AERO; 1638–1707 CE; **Natural Trumpet**; –;
Johann Leonhard (1638–1707); Germany

537 CHOR; c 17th c. CE; **Cittern**; –; –; Italy

538 AERO; c 17th c. CE; **Cornett**; –; –; –;

539 CHOR; c 17th c. CE; **Hurdy Gurdy**; *Vielle à Roue*; –; France

540 AERO; c 17th c. CE; **Shawm**; *Double Shehnai (or Sahnai)*;
–; India

541 CHOR; c mid 17th c. CE; **Viola**; *Viola da Gamba*; –;
Italy +B26

542 MEMB; c 17th c. CE; **Conical Drum**; *Daibyoshi*; –; Japan

543 CHOR; c 17th c. CE; **Lute**; *Theorbo (or Chitarrone)*; –; Italy

544 CHOR; c 17th c. CE; **Cittern**; –; –; France

545 CHOR; c 1650–1750 CE; **Guitar**; *Viola Beiroa*; –; Portugal

546 AERO; c 17th c. CE; **Soprano Recorder**; –; –; Europe

547 CHOR; c 17th c. CE; **Discant Viol**; –; Wurfl; –; +B12

548 CHOR; *after* 1650 CE; **Viola**; *Viola d'Amore*; –; England +B8

549 CHOR; 1660 CE; **Double Virginal**; –; Lodewijck Grauwels;
Belgium

550 AERO; c 17th c. CE; **Bass Recorder**; –; –; Czech Republic

551 CHOR; c 17th c. CE; **Lyre**; *Beganna*; –; Ethiopia

552 AERO; c 17th c. CE; **Tenor Recorder**; –; –; Europe

553 MEMB; c 17th c. CE; **Cylindrical Drum**; –; –; Nigeria +B33

554 CHOR; c 17th c. CE; **Guitar**; –; –; Germany

555 CHOR; 1662 CE; **Double Bass**; –;
Gottfried Tielke (1639–1688); Germany +B8

556 AERO; c 17th c. CE; **Trumpet with Telescopic skin cover**;
–; –; Papua New Guinea

557 CHOR; c 17th c. CE; **Bridge Harp**; *Kora (or Korro)*;
Mande People; Gambia, Senegal, Guinea,
Guinea–Bissau and Mali

558 AERO; c 17th c. CE; **Alto Courtaut**; –; –; Italy

559 MEMB; c 17th c. CE; **Drum**; –; –; Haiti

560 AERO; 1667 CE; **Waldhorn in F**; –; Starck (1640–1693);
Germany

561 CHOR; c 17th c. CE; **Guitar**; *Viola Campaniça*;
–; Portugal

562 AERO; c 17th c. CE; **Alto Shawm**; –; –; Europe

563 CHOR; c 17th c. CE; **Fiddle**; –; –; Balkan Peninsula +B7

564 AERO; c 17th c. CE; **Soprano Shawm**; –; –; Europe

565 CHOR; 1668 CE; **Virginal**; –; Stephen Keene (1640–1719); England

566 AERO; c 17th c. CE; **Alto Cornemuse**; –; –; France

567 AERO; c 17th c. CE; **Shawm**; *Shehnai (or Sahnai)*; –; India

568 CHOR; c 17th c. CE; **Chordophone**; *Musical Bow*; –; West Africa

569 AERO; c 17th c. CE; **Small–keyed Flute**; –; –; Germany

570 CHOR; c 17th c. CE; **Lute**; *Mezzo Colascione*; –; Italy

571 AERO; 1669–1743 CE; **Waldhorn in G**; –; Friedrich Ehe (1669–1743); Germany

572 CHOR; c 17th c. CE; **Monochord**; *Tromba Marina (or Trumpet Marine)*; –; Italy +B8

573 AERO; c 17th c. CE; **End–blown Flute**; *Shakuhachi*; –; Japan

574 CHOR; c 17th c. CE; **Mandolin (or Mandola)**; –; –; Spain

575 CHOR; 1680 CE; **Choral Mandolino**; *Cutler–Challen*; Antonio Stradivari (1644–1737); Italy

576 CHOR; 1684 CE; **Bass Lute**; *Mandora*; Petrus Bulocta; Italy

577 CHOR; c 17th c. CE; **Zither**; *Harpanette (Vertical Psalterium)*; –; Europe

578 AERO; c 17th c. CE; **Bass Slide Trombone**; –; –; –;

579 CHOR; c 17th c. CE; **Harp**; *Gusli*; –; Russia

580 AERO; c 17th c. CE; **Tenor Pommer (or Shawm)**; *Bombarde*; –; Europe

581 AERO; c 17th c. CE; **Bass Pommer (or Shawm)**; *Bombarde*; –; Europe

582 CHOR; c 1688 CE; **Long–necked Lute**; *Balalaika*; –; Russia

583 IDIO; c 1680 CE; **Bird–scarer**; *Tréculas*; –; Portugal

584 CHOR; c 17th c. CE; **Lute**; *Bandora*; John Rose; England

585 CHOR; c 17th c. CE; **Viola**; *Viola di Bordone (or Baryton)*; –; Italy +B8

586 CHOR; c 17th c. CE; **Cittern**; *Cittern Pandora*; –; England

587 CHOR; late 17th c. CE; **Lute**; *Tamboura (or Tambura)*; –; Balkan Peninsula

588 IDIO; c 17th c. CE; **Rattle**; –; –; Patagonia

589 CHOR; c 1690 CE; **Fiddle**; *Kit (or Posch)*; –; Germany +B9

590 AERO; late 17th c. CE; **Soprano Chalumeau**; –; –; France

591 AERO; late 17th c. CE; **Alto Chalumeau**; –; –; France

592 AERO; late 17th c. CE; **Bass Chalumeau**; –; –; France

593 AERO; late 17th c. CE; **Tenor Chalumeau**; –; –; France

594 CHOR; 1693 CE; **Violin**; *Harrison*; Antonio Stradivari (1644–1737); Italy +B10

595 AERO; 1695–1735 CE; **Single–keyed Transverse Flute**; –; Johann Christopher Denner (1685–1735); Germany

596 CHOR; c 17th c. CE; **Rebec**; *Husle (or Husla)*; –; Russia +B14

597 IDIO; c 1700 CE; **Rattle**; *Jicotea*; –; Mexico

598 IDIO; c 1700 CE; **Anukué**; –; –; Cuba +B43

599 CHOR; early 18th c. CE; **Fretted Lute**; *Charango*; –; Latin America

600 CHOR; c 1700 CE; **Guitar**; *The Rawlins*; Antonio Stradivari (1644–1737); Italy

601 AERO; *after* 17*th* c. CE; **Vessel Flute**; –; –; Peru

602 MEMB; c 18*th* c. CE; **Long Drum**; –; –; Polynesia

603 IDIO; c 18*th* c. CE; **Scraper**; *Quijada*; –; Cuba +B43

604 AERO; c 18*th* c. CE; **Clarinet**; *Zhaleyka*; –; Armenia

605 AERO; c 18*th* c. CE; **Trumpet**; *Bass Serpent*; –; France

606 CHOR; 1710 CE; **Cello**; *Stradivarius Forma B*;
 Stradivari Family; Italy +B10

607 IDIO; c 18*th* c. CE; **Struck Idiophone**; –; –; Australia

608 CHOR; 1714 CE; **Violin**; *Le Maurien*;
 Antonio Stradivari (1644–1737) Italy +B10

609 AERO; c 18*th* c. CE; **Flute in C**; –; Hotteterre Family;
 France

610 CHOR; c 18*th* c. CE; **Harpsichord**; *Spinet*;
 Thomas Hitchcock (1685–1733); England

611 IDIO; c 18*th* c. CE; **Pellet Bell**; –; –; Mexico

612 MEMB; c 18*th* c. CE; **Friction Drum**; *Sarronca*; –; Portugal

613 CHOR; c 18*th* c. CE; **Angular Harp**; –; –; Russia

614 AERO; c 18*th* c. CE; **Whistle Flute**; –; –; France

615 AERO; c 1720 CE; **English Horn**; *Cor Anglais*;
 J. T. Weigel; Poland

616 IDIO; c 18*th* c. CE; **Bird–scarer**; *Tréculas*; –; Portugal

617 CHOR; c 1720 CE; **Pianoforte**; *Cristofori Pianoforte*;
 Bartolomeo Cristofori (1655–1732); Italy

618 CHOR; c 18*th* c. CE; **Orpharion**; –; –; England

619 AERO; c 18*th* c. CE; **Whistle Flute**; –; –; France

620 CHOR; c 18*th* c. CE; **Kit**; *Pochette*; –; France +B11

621 AERO; 1724 CE; **Oboe**; *Oboe da Caccia*;
 Johann Heinrich Eichentopf (1678–1769); Germany

622 MEMB; c 18*th* c. CE; **Drum**; –; –; China

623 IDIO; c 1725 CE; **Gourd Rattle**; *Erinkundi Nanigas*;
 –; Guinea

624 IDIO; c 18*th* c. CE; **Struck Idiophone**; –; –; Australia

625 CHOR; c 18*th* c. CE; **Lyre**; *Crwth*; –; Wales +B13

626 AERO; c 18*th* c. CE; **Clarinet**; –; –; Germany

627 AERO; 1700–1884 CE; **Bullroarer**; –; –; New Britain

628 IDIO; c 18*th* c. CE; **Anklet**; –; –; India

629 AERO; c 18*th* c. CE; **Hornpipe**; *Pibcorn (or Pibgorn)*;
 –; Wales

630 CHOR; c 18*th* c. CE; **Plucked Lute**; *Cavaquinho Minhoto*;
 –; Portugal

631 IDIO; c 18*th* c. CE; **Jew's Harp**; *Berimbau*; –; Portugal

632 CHOR; 1730 CE; **Viol Bass**; *Viola da Gamba*;
 Antonio Stradivari (1644–1737); Italy +B10

633 MEMB; c 18*th* c. CE; **Kettle Drums**; *Talamba*; –;
 Western Balkans

634 IDIO; *after* 1732 CE; **Orchestral Rattle**; –; –; Europe

635 IDIO; c 18*th* c. CE; **Shield**; –; –; South Africa +B92

636 AERO; c 18*th* c. CE; **Reclamo**; –; –; Portugal

637 IDIO; c 18*th* c. CE; **Rattle**; –; –; North America

638 CHOR; 1732 CE; **Double Bass**; –; –; Switzerland +B10

639 AERO; 1700–1884 CE; **Bullroarer**; –; –; New Britain

640 CHOR; c 18th c. CE; **Guitar**; *Viola Braguesa*; –; Portugal

641 MEMB; c 18th c. CE; **Long Drum**; –; –; Oceania

642 IDIO; c 18th c. CE; **Bell**; –; –; India

643 AERO; 1735–1798 CE; **Oboe**; *Bassoon*; John Blockley (1735–1798); Germany

644 CHOR; c 18th c. CE; **Hurdy Gurdy**; –; –; Czech Republic

645 MEMB; c 18th c. CE; **Friction Drum**; *Ingungu*; Zulu People; South Africa

646 IDIO; c 18th c. CE; **Rattle**; *Rela*; –; Portugal

647 CHOR; c 18th c. CE; **Fiddle**; –; –; Morocco +B17

648 IDIO; 1740 CE; **Metallophone**; *Glockenspiel*; –; England +B75

649 IDIO; 1740 CE; **Nail Harmonica**; –; Johan Wilde; Russia +B27

650 AERO; c 18th c. CE; **Whistle Flute**; –; –; Portugal

651 AERO; 1708–1787 CE; **Single-keyed Transverse Flute**; –; Thomas Lot (1708–1787); France

652 IDIO; c 18th c. CE; **Anklets**; –; –; West Africa

653 MEMB; c 18th c. CE; **Double-headed Drum**; *Kasir Mufaltah*; –; Oman +B93

654 AERO; c 18th c. CE; **Duct Flute**; *Txistu*; –; Spain (Basque Country)

655 CHOR; 1746 CE; **Grand Piano**; –; Gottfried Silbermann (1683–1753); Germany

656 AERO; c mid 18th c. CE; **Bagpipe**; *Dudy (or Bock)*; –; Bohemia

657 CHOR; c mid 18th c. CE; **Pedal Clavichord**; –; Thomas Gluck; Germany

658 MEMB; c 18th c. CE; **Hourglass Drum**; *Dundun*; –; Niger +B31

659 IDIO; c mid 18th c. CE; **Dancing Board**; –; –; Vanuatu

660 CHOR; c mid 18th c. CE; **Mandola**; *Bandolim*; –; Portugal

661 AERO; c mid 18th c. CE; **Piccolo Flute**; *Flauto Piccolo*; –; Italy

662 AERO; c mid 18th c. CE; **Mezzo Soprano Oboe**; *Oboe d'Amore (or Oboe Luongo)*; –; Germany

663 IDIO; c mid 18th c. CE; **Glass Harmonica**; *Armonica*; –; England

664 CHOR; c mid 18th c. CE; **Clavichord**; –; –; Europe

665 CHOR; c mid 18th c. CE; **Lute**; *Bandolim*; –; Portugal

666 IDIO; c 18th c. CE; **Struck Idiophone**; –; –; Australia

667 IDIO; c 1750–1800 CE; **Bell**; *Agógo de Obatalá*; –; Brazil

668 CHOR; c 18th c. CE; **Kit**; *Posch*; Johannes Rauch; Germany +B11

669 CHOR; 1753 CE; **Harpsichord (single-manual)**; –; Antonio Scotti; Italy

670 IDIO; c 18th c. CE; **Glass Harp**; –; –; Europe

671 IDIO; c 18th c. CE; **Gong Chime**; –; –; Borneo +B41

672 MEMB; c 18th c. CE; **Single-headed Drum**; –; –; Papua New Guinea

673 IDIO; c 18th c. CE; **Rattle**; *Maraca de Muñeca*; –; Cuba

674 IDIO; 1756–1791 CE; **Cowbells**; –; –; Austria

675 AERO; c 18th c. CE; **Reclamo**; –; –; Portugal

676 CHOR; c 18th c. CE; **Guitar**; *Filomena*; –; Portugal

677 MEMB; c 18th c. CE; **Single–headed Drum**; –; –;
 North Africa

678 IDIO; c 18th c. CE; **Rattle**; *Réu Réu*; –; Portugal

679 CHOR; 1757 CE; **Spinet**; –; John Harrison; England

680 IMAG; c 18th c. CE; **Guitar**; *Multichord*;
 Munchs & Charpentier; France

681 MEMB; c 18th c. CE; **Barrel Drum**; *Tom–tom*; –; India

682 IDIO; c 1760 CE; **Glass Harmonica**; *Armonica*;
 Benjamin Franklin (1706–1790); USA

683 MEMB; c 18th c. CE; **Goblet Drum**; –; –; Nigeria

684 CHOR; c 18th c. CE; **Drone & String**; *Bumbass*; –; Europe

685 CHOR; 1767 CE; **Pianoforte**; –;
 Johannes Zumpe (1726–1790); England

686 CHOR; 1767 CE; **Cittern**; –; –; The Netherlands

687 IDIO; c 18th c. CE; **Rattle**; –; –; South Africa

688 AERO; c 1770 CE; **Angled Basset Horn**; –; –; Germany

689 AERO; c 1770 CE; **Sickle–shaped Basset Horn**;
 –; –; Germany

690 CHOR; c 18th c. CE; **Lyre Guitar**; *French Lyre*;
 Arras Boulan; France

691 MEMB; *after* 1768 CE; **Frame Drum**; *Dampfu*; –; Nepal

692 MEMB; c 18th c. CE; **Frame Drum**; –; –; USA +B61

693 AERO; *after* 1770 CE; **Double Clarinet**; –; –;
 British Columbia

694 AERO; *after* 1770 CE; **Double Clarinet**; –; –;
 British Columbia

695 AERO; 1772 CE; **Tuning Flute**; –; Delous; France

696 AERO; 1772–1828 CE; **Walking Stick Recorder**; –;
 Stephen Koch (1772–1828); Austria

697 CHOR; 1775 CE; **Piano**; –;
 Johann Andreas Stein (1728–1792); Germany

698 CHOR; c 1782 CE; **Cittern**; –; –; The Netherlands

699 CHOR; *late* 18th c. CE; **Square Piano**; –; –; Europe

700 CHOR; 1789 CE; **Harpsichord**; –;
 Manuel & Joaquim Antunes; Portugal

701 CHOR; 1789 CE; **Bass Cittern**; –; Renault & Chatelein;
 France

702 CHOR; 1789–1875 CE; **Table Piano**; –;
 Jean–Henri Pape (1789-1875); France

703 AERO; *late* 18th c. CE; **Transverse Flute Sword**;
 –; –; Europe

704 MECH; c. 1790 CE; **Bell & Chime**; *Carillon*; –;
 Low Countries

705 IDIO; *late* 18th c. CE; **Turkish Cresent**; *Jingling Johnny*;
 –; Great Britain

706 IDIO; *late* 18th c. CE; **Orchestral Triangle**; –; –;
 Austria +B82

707 CHOR; 1792 CE; **Grand Piano**; –;
 John Broadwood (1732–1812); England

708 IDIO; 1793 CE; **Orchestral Cymbal**; –; –; Austria +B76

709 AERO; c 1796 CE; **Flute**; –; –; British Guiana (now Guyana)

710 AERO; 1796 CE; **Soprano Slide Trombone**; –;
 J. F. Schwabe; Germany

711 CHOR; *late* 18th c. CE; **Square Piano**; –;
Meincke & Pieter Meyer; The Netherlands

712 IDIO; *late* 18th c. CE; **Orchestral Tam–tams**; –; –;
France +B95

713 CHOR; *late* 18th c. CE; **Portable Piano**; *Orphica*;
Joseph Klein; Austria

714 CHOR; *late* 18th c. CE; **Harp–shaped Piano**; –;
Gottfried Maucher (1737–1830); Germany

715 IDIO; *late* 18th c. CE; –; *Tam Âm La*; –; Vietnam +B96

716 MEMB; *late* 18th c. CE; **Kettle Drum**; *Tabala Wolof*;
–; Senegal

717 CHOR; 1798 CE; **Harpsichord**; –; Joseph Kirckmann;
England

718 IDIO; c. 1800 CE; **Rattle**; *Maruga*; –; Cuba

719 IDIO; c. 1800 CE; **Rattle**; *Maruga*; –; Cuba

720 AERO; *early* 19th c. CE; **Serpent**; –; –; France

721 CHOR; *early* 19th c. CE; **Guitar**; –;
Dom António José de Sousa (1792–1860); Portugal

722 CHOR; c. 1800 CE; **Hurdy Gurdy**; *Zanfona*; –; Spain

723 IDIO; c. 1800 CE; **Double Gourd Rattle**; *Double Macara*;
–; Cuba

724 CHOR; c. 1800 CE; **Portable Grand Piano**;
Portable Grand; John Isaac Hawkins (1772–1854); USA

725 IDIO; c. 1800 CE; **Bell**; *Agógo del Dios Olókun*; –; Cuba

726 AERO; *early* 19th c. CE; **Walking Stick Flute**; –; –; Austria

727 CHOR; 1801 CE; **Square Piano**; –; –; Europe

728 AERO; *early* 19th c. CE; **Bass Clarinet**; –; –; Italy

729 CHOR; c 1806 CE; **Lyre–Guitar**; –; –; Italy

730 CHOR; 1808 CE; **Square Piano**; –; Pieter Fabritius;
The Netherlands

731 IDIO; *early* 19th c. CE; **Time–beater**; –; –; USA (Hawaii)

732 AERO; *early* 19th c. CE; **Keyless Transverse Flute**; *Fife*;
–; England

733 CHOR; 1808 CE; **Square Piano**; –;
Meincke & Pieter Meyer; The Netherlands

734 AERO; 1812 CE; **Keyed Trumpet**; –; –; England

735 AERO; *early* 19th c. CE; **Clarinet Basset Horn**;
–; –; Bohemia

736 AERO; c 1815 CE; **Short Trumpet**; –; K.G. Eschenbach;
Germany

737 CHOR; *early* 19th c. CE; **Table Piano**; –; Leopold Sauer;
Czech Republic

738 CHOR; 1812 CE; **Guitar**; –; Domingos José d'Araujo;
Portugal

739 CHOR; 1815 CE; **Piano**; *Apollo Piano*;
Meincke & Pieter Meyer; The Netherlands

740 MEMB; c 19th c. CE; **Batá Drum**; *Okónkolo*; –; Cuba

741 MEMB; c 19th c. CE; **Batá Drum**; *Itótele*; –; Cuba

742 MEMB; c 19th c. CE; **Batá Drum**; *Iyá*; –; Cuba

743 IDIO; c 19th c. CE; **Tap Shoes (Male)**; –; –; USA

744 AERO; c 19th c. CE; **Horn**; –; –; Belgium

745 MEMB; c 19th c. CE; **Frame Drum**; *Banku Raman*;
–; Sri Lanka

746 AERO; c 19th c. CE; **Panpipe**; *Paixiao (or Pai Hsiao)*;
–; China

747 CHOR; c 19th c. CE; **Fiddle**; *Rebab (or Rabab)*; –; Egypt +B3

748 IDIO; c 19th c. CE; **Jew's Harp**; –; –; England

749 MEMB; c 19th c. CE; **Drum**; –; –; Ecuador

750 CHOR; c 19th c. CE; **Plucked Lute**; *Cavaquinho Minhoto*; –; Portugal

751 CHOR; *before* 1820 CE; **Shamisen Lute**; –; –; Japan +B105

752 IDIO; c 19th c. CE; **Zaclitrac**; –; –; Portugal

753 MEMB; c 19th c. CE; **Conical Drum**; *Musundu*; –; Oman

754 CHOR; 1817 CE; **Square Piano**; *Broadwood Square*; Thomas Broadwood (1786–1861); England

755 IDIO; c 19th c. CE; –; *Matraca de Igreja*; –; Portugal

756 MEMB; c 19th c. CE; **Footed Drum**; –; –; West Africa

757 AERO; c 1820 CE; **Trumpet**; –; Sauntenmeister & Muller; France

758 AERO; c 19th c. CE; **Oboe**; –; Triébert; France

759 CHOR; 1820 CE; **Piano**; *Square Piano*; Meincke & Pieter Meyer; The Netherlands

760 MEMB; c 19th c. CE; **Kettle Drums**; *Naqqara*; –; Saudi Arabia

761 AERO; c 1820 CE; **Orchestral Tuba**; –; Stölzel; Germany

762 CHOR; c 19th c. CE; **Psaltery**; *Kantele (or Kannel)*; –; Finland

763 CHOR; c 1820 CE; **Concert Harp**; –; J. George Morley; England

764 MEMB; c 19th c. CE; **Single–headed Drum**; –; –; New Guinea

765 CHOR; 1820 CE; **Piano**; *Empire Piano*; Conrad Graf (1782–1851); Austria

766 CHOR; 1820–1830 CE; **Harp**; *Royal Portable Harp*; John Egan; Ireland

767 CHOR; c 19th c. CE; **Guitar with Cut–away Soundbox**; –; –; –;

768 MEMB; c 19th c. CE; **Double–headed Drum**; –; –; Balkan Penisula +B95

769 IDIO; c 19th c. CE; **Rattle**; –; –; North America

770 AERO; 1824 CE; **Tenor Slide Trombone**; *Buccin*; –; Italy

771 CHOR; 1825 CE; **Square Piano**; –; J. van Raay & Zonen; The Netherlands

772 MEMB; c 19th c. CE; **Barrel Drum**; *Huagu*; –; China +B32

773 MEMB; c 19th c. CE; **Orchestral Tambourine**; –; –; Europe

774 AERO; c 19th c. CE; **Whistling Top**; –; –; Latin America

775 MECH; c 19th c. CE; **Ballerina Music Box**; –; –; Switzerland

776 AERO; c 19th c. CE; **Serpent**; –; –; Europe

777 MEMB; c 19th c. CE; **Conical Drum**; *Musundu Lewa*; –; Oman +B48

778 CHOR; c 19th c. CE; **Zither**; *Yamatogoto (or Wagon)*; –; Japan

779 IDIO; 1800–1850 CE; **Gourd Rattle**; *Maraca*; –; West Africa

780 CHOR; 1829 CE; **Pianoforte (upright)**; *Pyramid Piano*; Conrad Graf (1782–1851); Austria

781 IDIO; C 19th C. CE; **Scraper with Soundbox**; –; –; Africa +B43

782 AERO; C 19th C. CE; **One–keyed Transverse Flute**; *Fife*; –; England

783 IDIO; C 19th C. CE; **Beater**; –; –; India

784 AERO; 1829 CE; **Piano–harmonium**; *Symphonium*; Wheatstone; England

785 AERO; C 1830 CE; **Harmonica**; –; Hohner; Germany

786 IDIO; C 19th C. CE; **Set of Orchestral Gongs**; –; –; Europe +B63

787 AERO; C 1830 CE; **Keyed Trumpet**; –; –; Bohemia

788 AERO; C 1830 CE; **Chromatic Bass Horn**; –; –; Germany

789 AERO; 1830 CE; **Bassonore**; –; Vienen; France

790 CHOR; 1830 CE; **Upright Grand Piano**; *Giraffe Piano*; J. van Raay; The Netherlands

791 AERO; C 19th C. CE; **Clarinet**; –; –; India

792 CHOR; C 19th C. CE; **Plucked Lute**; *Cavaquinho de Lisboa*; –; Portugal

793 MEMB; C 19th C. CE; **Kettle Drum**; –; –; Indonesia

794 AERO; C 19th C. CE; **Trumpet**; –; Davaster; Belgium

795 CHOR; C 19th C. CE; **Square Piano**; –; Johannes van Diepen; The Netherlands

796 MEMB; C 19th C. CE; **Box Drum**; *Zhu*; –; China

797 AERO; *after* 1834 CE; **Modern Oboe**; –; Triébert Family; France

798 CHOR; C 19th C. CE; **Guitar with Extended Soundbox**; –; –; Europe

799 MEMB; C 19th C. CE; **Drum**; *Sulibao*; –; Philipines

800 AERO; C 19th C. CE; **Stopped Duct Flute**; *Piston Flute (or Swanee Whistle)*; –; Europe

801 AERO; 1834 CE; **Bassonore**; –; Nicolas Winnen; France

802 AERO; 1835 CE; **Duct Flute**; *Flageolet*; Thomas Prowse; England

803 AERO; 1835 CE; **Bass Tuba in F**; –; Johann Gottfried Moritz; Germany

804 AERO; 1835 CE; **Trumpet**; *Ophicleide in B Flat*; C. Devaster; Belgium

805 MECH; C 19th C. CE; **Chalet Music Box**; –; –; Switzerland

806 MEMB; C 19th C. CE; **Thimble (novelty)**; –; –; Norway

807 MEMB; C 19th C. CE; **Cylindrical Drum**; –; Iroquois People; USA

808 CHOR; C 19th C. CE; **Guitar**; –; –; England

809 AERO; C 19th C. CE; **Duct Flute**; *Gaita*; –; Portugal

810 CHOR; 1835 CE; **Square Piano**; –; J. van Raay *&* Zonen; The Netherlands

811 AERO; C 19th C. CE; **Duct Flute**; *Gaita*; –; Portugal

812 MEMB; C 19th C. CE; **Orchestral Kettle Drum**; *Timpanum (or Timpani)*; –; Europe +B62

813 IDIO; 1800–1850 CE; **Double Bell**; *Ekón Double*; –; West Africa +B43

814 AERO; 1837–1855 CE; **Alto Saxhorn in E flat**; –; Bartsch; France

815 MEMB; C 19th C. CE; **Barrel Drum**; *Taiko*; –; Japan

816 AERO; C 19th C. CE; **Bagpipe**; *Moshug (or Masak)*; –; India

817 IDIO; 1800–1850 CE; **Double Bell**; *Ekón Double*; –;
West Africa +B43

818 IDIO; C 19th C. CE; **Tap Shoes (Female)**; –; –; USA

819 CHOR; C 19th C. CE; **Lute**; *Bouzouki*; –; Greece

820 IDIO; C 19th C. CE; **Camel Bell**; –; –; Somalia

821 CHOR; 1840 CE; **Upright Grand Piano**; *Pyramid Piano*;
J. van Raay & Zonen; The Netherlands

822 AERO; 1840 CE; **Hand Horn**; –; Thomas Key (1800–1840);
England

823 CHOR; 1840 CE; **Upright Grand Piano**; *Giraffe Piano*;
Bernard Elsenburg; The Netherlands

824 AERO; C 19th C. CE; **Trumpet**; –; –; Papua New Guinea

825 MEMB; C 19th C. CE; **Mustard Container (Novelty)**;
–; –; England

826 AERO; C 1840 CE; **Trombone**; *Tenorposaune in B Flat*;
Adolphe Sax (1814–1894); Belgium

827 AERO; C 1840 CE; **Baritone Saxhorn in B Flat**; –;
Adolphe Sax (1814–1894); Belgium

828 AERO; C 1840 CE; **Soprano Sax Horn in B Flat**; –;
Adolphe Sax (1814–1894); Belgium

829 AERO; C 1840 CE; **Trumpet**; –; Camelli Pistoia; Italy

830 MECH; C 19th C. CE; **Musical Plate**; –; –; Europe

831 CHOR; C 19th C. CE; **Walking Stick Guitar**; –; –; Europe

832 AERO; 1843 CE; **Valved Brass**; *Euphonium*; Sommer;
Germany

833 HYBR; C 19th C. CE; **Vessel Drum**; *Udu*; Igbo & Hausa;
Nigeria

834 AERO; 1843 CE; **Baritone**; *Euphonium in B Flat*;
Sommer; Germany

835 IDIO; C 19th C. CE; **Bell**; –; –; Africa

836 MEMB; C 19th C. CE; **Drum**; *Tamboril*; –; Portugal +B74

837 AERO; C 1845 CE; **Valved Brass**; *Helicon*; Ignaz Stowasser;
Austria

838 CHOR; C 1845 CE; **Concert Zither**; *Salzburg Model*;
George Tiefenbrunner (1812–1880); Germany

839 AERO; C 19th C. CE; **Walking Stick Flute**; –; –; Slovakia

840 AERO; C 19th C. CE; **Penny Whistle**; *Flauta de Bisel*;
–; Portugal

841 AERO; 1846 CE; **Tenor Saxophone**; –;
Adolphe Sax (1814–1894); Belgium

842 AERO; 1846 CE; **Baritone Saxophone in E Flat**; –;
Adolphe Sax (1814–1894); Belgium

843 AERO; 1846 CE; **Soprano Saxophone in B Flat**;
Adolphe Sax (1814–1894); Belgium

844 CHOR; C 19th C. CE; **Plucked Lute**; *Braguinha Madeirense*;
–; Portugal

845 AERO; 1848 CE; **Baritone Oboe**; –;
Guillame Triébert (1770–1848); France

846 AERO; C 1848 CE; **Transverse Flute**; –;
Theobold Boehm (1784–1881); Germany

847 MEMB; C 19th C. CE; **Goblet Drum**; *Darabukka*; –; Egypt

848 MECH; C 19th C. CE; **Liqueur Cabinet Music Box**;
–; –; Europe

849 CHOR; C 19th C. CE; **Tenor Banjo**; –; –; Carribean +B107

850 CHOR; c 19th c. CE; **Long–necked Banjo**; –; –; Carribean +B107

851 CHOR; c 19th c. CE; **Bass Banjo**; –; –; Carribean +B107

852 CHOR; 1849 CE; **Double Bass**; *Octobass*; Jean-Baptiste Vuillaume (1798–1875); France +B6

853 MEMB; c 19th c. CE; **Frame Drum**; *Riqq*; –; Syria

854 MEMB; c 19th c. CE; **Frame Drum**; *Bombo*; –; Portugal +B91

855 IDIO; c 19th c. CE; **Bird–scarer**; *Tréculas*; –; Portugal

856 IDIO; c mid 19th c. CE; **Rattle**; *Chachá*; –; Cuba

857 IDIO; c mid 19th c. CE; **Shaker**; *Yucuyú*; –; Haiti

858 IDIO; c mid 19th c. CE; **Bell**; *Agógo de Ochún*; –; Cuba

859 AERO; c mid 19th c. CE; **Tenor Slide Trombone in B Flat**; –; –; Europe

860 MEMB; c mid 19th c. CE; **Kettle Drums**; *Tikora Drums*; –; India

861 IDIO; c mid 19th c. CE; **Bell**; *Agógo de Yegguá*; –; Cuba

862 AERO; c mid 19th c. CE; **Reed Organ**; *Harmonium*; –; India

863 IDIO; c mid 19th c. CE; **Clappers**; *Tabletas*; –; Guinea

864 IDIO; c 19th c. CE; **Bamboo Pipes Suspended**; –; –; Japan

865 AERO; c mid 19th c. CE; **Shell Trumpet**; *Dung–Dkar*; –; Tibet

866 IDIO; c mid 19th c. CE; **Bell**; *Ekón*; –; West Africa +B43

867 CHOR; c 19th c. CE; **Sanxian Lute**; –; –; China

868 CHOR; c mid 19th c. CE; **Fiddle**; *Rebab*; –; Indonesia (Java) +B20

869 IDIO; 1850–1900 CE; **Rattle**; *Acheré de Ayagú*; –; Cuba

870 CHOR; 1850–1900 CE; **Mute Violin**; –; –; England +B6

871 AERO; 1850–1950 CE; **Bass Trombone**; –; –; England

872 MEMB; c 19th c. CE; **Frame Drum**; *Tamil*; –; Sri Lanka

873 CHOR; c 19th c. CE; **Short–necked Fiddle**; *Rabeca Chuleira*; –; Portugal +B6

874 MEMB; 1850–1950 CE; **Drum**; –; –; Brazil

875 IDIO; c 19th c. CE; **Horse Shoes**; –; –; USA

876 CHOR; 1853 CE; **Piano**; –; Robert Nunns & John Clarke; USA

877 IDIO; c 1853 CE; **Anvil**; –; –; Italy +B94

878 AERO; c 1853 CE; **Tuba**; *Wagner's Tuba*; Moritz; Germany

879 CHOR; c 19th c. CE; **Lyre**; *Endongo (or Entongoli)*; –; Uganda

880 CHOR; 1857 CE; **Harp Piano**; –; Kuhn & Ridgeway; USA

881 CHOR; c 1855 CE; **Piano**; *Square Piano*; Jan Hendrik Hermanus Traut; The Netherlands

882 MECH; c 19th c. CE; **Singing Bird**; –; –; Europe

883 MEMB; c 19th c. CE; **Friction Drum**; *Sarronça*; –; Portugal

884 AERO; c 1856 CE; **Sarussophone**; –; Pierre Auguste Sarrus (1813–1876); France

885 IDIO; c 1855 CE; **Musical Saw**; –; –; USA

886 IDIO; c 19th c. CE; **Lamellophone**; *Ilimba*; –; Zimbabwe +B66

887 AERO; 1858–1947 CE; **Serpent Horn**; *Ranasringa*; –; India

888 AERO; 1858–1947 CE; **Serpent Horn**; *Ranasringa*; –; India

889 AERO; 1858 CE; **Bugle**; –; –; England

890 MEMB; c 19th c. CE; **Conical Drum**; *Musundu Lewa*; –;
Oman +B48

891 IDIO; c 19th c. CE; **Struck Idiophone**; –; –; Australia

892 AERO; c 1860 CE; **Cornet in B Flat**; –; –; USA

893 AERO; c 1860 CE; **Ocarina**; *Little Goose*; –; Italy

894 CHOR; c 19th c. CE; **Lyre–shaped Guitar**; –; –; England

895 IDIO; c 19th c. CE; **Sliding Rattle**; *Sistrum*; –;
West Europe

896 AERO; c 1860 CE; **Sarussophone Soprano**; –;
Pierre Auguste Sarrus (1813–1876); France

897 MEMB; c 19th c. CE; **Friction Drum**; *Cockerel*; –; France

898 AERO; c 1860 CE; **Sarussophone Contrabass**; –;
Pierre Auguste Sarrus (1813–1876); France

899 IDIO; c 19th c. CE; **Xylophone**; *Marimba*; –;
Guatemala +B79

900 AERO; *after* 1860 CE; **Concertina**; –; John Crabb; England

901 AERO; c 19th c. CE; **End–blown Flute**; *Ndere*; –; Uganda

902 AERO; c 1860 CE; **End–blown Flute**; *Kooauau*;
Maori People; New Zealand

903 CHOR; *after* 1860 CE; **Piano**; *Steinway*; Steinway & Sons;
USA

904 MEMB; c 19th c. CE; **Frame Drum**;
Sama (or Duff Al–Kabir); –; Oman

905 MEMB; c 19th c. CE; **Frame Drum**;
Sama (or Duff Al–Kabir); –; Oman

906 MEMB; *before* 1867 CE; **Double–conical Drum**;
Kendhang Batangan; –; Indonesia

907 CHOR; 1867 CE; **Guitar**; –; José Porcel; Spain

908 AERO; 1868 CE; **Alto Saxophone in E Flat**; –;
Adolphe Sax (1814–1894); Belgium

909 IDIO; 1869 CE; **Anvil**; –; –; Germany +B94

910 CHOR; c 1865 CE; **Piano**; *Bechstein*; Bechstein; Germany

911 AERO; c 19th c. CE; **Conch Trumpet**; *Hora*; –; Japan

912 IDIO; *after* 1866 CE; **Tubular Bells**; –; John Hampton;
England +B97

913 MECH; 1870 CE; **Cuckoo Clock**; *Beha Clock*;
Johan Baptist Beha; Germany

914 AERO; 1870 CE; **Reed Organ**; *Harmonium*;
Alexandre Francois Debain (1809–1877); France

915 AERO; c 19th c. CE; **Mouth Organ**; *Shō*; –; Japan

916 CHOR; c 19th c. CE; **Lute**; *Tambura*; –; India

917 CHOR; c 19th c. CE; **Harp–shaped Zither**; –; –; Germany

918 CHOR; 1870–1910 CE; **Mute Violin**; –;
Markneukirchen & Schönbach; Germany +B6

919 AERO; c 19th c. CE; **Double Clarinet**; *Pūngī*; –; India

920 MEMB; c 19th c. CE; **Waist Drum**; *Khishba*; –; Iraq

921 AERO; 1871 CE; **Fanfare Trumpet**; *Aida Trumpet*; –; Italy

922 AERO; c 19th c. CE; **Oboe**; *Bassoon*; –; Switzerland

923 MEMB; c 19th c. CE; **Hourglass Drum**; *Udäkki*; –;
Sri Lanka

924 AERO; c 19th c. CE; **End–blown Flute**; *Gling–bu*; –; Tibet

925 CHOR; 1873 CE; **Violino Harpa**; –;
Thomas Zach (1812–1892); Austria +B6

926 AERO; c 19th c. CE; **Trumpet**; *Zhajiao*; –; China

927 MEMB; c 19th c. CE; **Drum**; *Pow Wow*; –;
North America +B49

928 CHOR; c 19th c. CE; **Fiddle**; *Sindhi Sarangi*; –; India +B23

929 IDIO; 1875–1925 CE; **Lamellophone**; *Sansa (or Mbira)*; –;
Sub-Saharan Africa

930 MEMB; c 19th c. CE; **Drum**; –; –; Latin America

931 IDIO; c 19th c. CE; **Bell**; –; –; New Britain

932 CHOR; c 19th c. CE; **Double Bass**; –; –; Poland

933 IDIO; c 19th c. CE; **Jew's harp**; *Susap*; –;
Papua New Guinea

934 IDIO; 1875–1925 CE; **Lamellophone**; *Sansa (or Zanza)*;
–; Cameroon

935 MEMB; c 19th c. CE; **Barrel Drum**; *Jingu*; –; China

936 IDIO; c 19th c. CE; **Gourd Rattle**; –; –; North America

937 ELEC; 1876 CE; **Single Note Oscillator**;
Musical Telegraph; Elisha Gray (1835–1901); USA

938 MEMB; c 19th c. CE; **Cylindrical Drum**; –; –;
North America +B35

939 CHOR; c 19th c. CE; **Fiddle**; *Kamancha (or Kemanche)*; –;
Azerbaijan +B4

940 AERO; c 19th c. CE; **Bagpipe**; *Dudy*; –; Poland

941 AERO; c 19th c. CE; **Slide Trumpet**; –; Godison; England

942 IDIO; 1875-1925 CE; **Lamellophone**; *Sansa (or Kalimba)*;
–; Sub–Saharan Africa

943 IDIO; c 19th c. CE; **Spur**; –; –; USA

944 IDIO; c 1880 CE; **Washboard**; –; –; USA +B100

945 CHOR; c 1880 CE; **Guitar**; *Guitarra*; Bento Martins Lobo;
Portugal

946 MEMB; c 19th c. CE; **Drum**; *Sulibao*; –; Philipines

947 CHOR; *before* 1882 CE; **Chord Zither**; *Auto Harp*;
Karl August Gütter (1823–1900); Germany

948 CHOR; c 19th c. CE; **Long–necked Drone Lute**; *Tambura*;
–; India

949 IDIO; c 19th c. CE; **Rattle Ball**; *Shouqiu*; –; China

950 MEMB; c 19th c. CE; **Rattle Drum**; *Midalang*; –; China

951 AERO; c 19th c. CE; **Side–blown Trumpet**; –; –; Nigeria

952 IDIO; 1886 CE; **Keyboard Instrument**; *Celesta*;
Auguste Mustel (1815-1890); France

953 AERO; 1886 CE; **Piccolo Trumpet**; *Bach Trumpet*;
Victor-Charles Mahillon (1841–1924); Belgium

954 MEMB; c 19th c. CE; **Barrel Drum**; *Taogu*; –; China

955 IDIO; c 19th c. CE; **Anklets**; –; –; India

956 CHOR; c 19th c. CE; **Guitar**; *Viola Braguesa*; –; Portugal

957 IDIO; c 19th c. CE; **Rattle**; –; –; Africa

958 AERO; 1888–1935 CE; **Cornet**; *Corneta de Barro*;
–; Portugal

959 IDIO; *late* 19th c. CE; **Wind Machine**; –; –; Germany

960 MEMB; c 19th c. CE; **Drum**; –; –; Latin America +B59

961 AERO; c 19th c. CE; **Bagpipe**; *Moshug (or Masak)*; –; India

962 CHOR; *late* 19th c. CE; **Ukulele**; –; –; England

963 CHOR; c 19th c. CE; **Plucked Lute**; *Cavaquinho de Lisboa*; –; Portugal

964 IDIO; 1875–1925 CE; **Lamellophone**; *Sansa (or Mbira)*; –; Nigeria

965 IDIO; c 19th c. CE; **Glass Bell**; –; –; England

966 AERO; *late* 19th c. CE; **Vessel Flute**; *Ocarina*; –; Germany

967 MEMB; c 19th c. CE; **Goblet Drum**; –; –; Sierra Leone

968 AERO; *late* 19th c. CE; **Transverse Flute**; *Fife*; –; USA

969 AERO; c 19th c. CE; **Duct Flute**; *Flageolet*; –; France

970 IDIO; c 1890 CE; **Bell**; *Tipo Arará de Ogán*; –; Cuba +B43

971 MEMB; c 19th c. CE; **Single–headed Drum**; *Trong Cái*; –; Vietnam

972 CHOR; *late* 19th c. CE; **Short–necked Lute**; *Rabab (or Rubab)*; –; Afghanistan

973 IDIO; c 19th c. CE; **Orchestral Slapstick**; –; –; France

974 MEMB; c 1890 CE; **Drum**; *Sioux War Drum*; –; North America +B65

975 AERO; c 1890 CE; **Bass Tuba**; *Sousaphone*; John Philip Sousa (1854–1932); USA

976 IDIO; *late* 19th c. CE; **Xylophone**; *Bila*; –; Estonia +B60

977 MECH; c 19th c. CE; **Keyboard**; *Orchestrion*; Johann Nepomuk Maelzel (1772–1838); Austria

978 CHOR; c 1891 CE; **Pear–shaped Lute**; *Pipa*; –; China +B105

979 AERO; 1892 CE; **Alto Flute**; –; –; Russia

980 AERO; 1892 CE; **Sudrophone**; –; François Sudre (1814–1912); France

981 MEMB; c 19th c. CE; **Long Drum**; –; –; Oceania

982 AERO; c 19th c. CE; –; *Bonecos–Assobios de Barro*; –; Portugal

983 CHOR; 1896 CE; **Domra**; –; Vassily Vassilievich Andreyev; Russia +B107

984 AERO; c 19th c. CE; **Fipple Flute**; *Double Flageolet*; William Bainbridge & John Parry; England

985 IDIO; c 1890 CE; **Xylophone**; –; –; Sierra Leone +B57

986 MEMB; *late* 19th c. CE; **Drum**; –; Fang People; Equatorial Guinea

987 CHOR; *late* 19th c. CE; **Lute**; *Quwaytara*; –; Algeria

988 MEMB; *late* 19th c. CE; **Drum**; –; Fang People; Equatorial Guinea

989 CHOR; 1897 CE; **Harp Guitar**; –; Christopher J. Knutsen (1862–1930); USA

990 CHOR; *late* 19th c. CE; **Harp Zither**; *Bikula*; –; Cameroon

991 MEMB; c 19th c. CE; **Frame Drum**; –; –; Serbia & Montenegro

992 IDIO; *late* 19th c. CE; **Triangle**; –; –; England +B50

993 CHOR; c 19th c. CE; **Guitar**; *Viola Amarantina*; –; Portugal

994 CHOR; *late* 19th c. CE; **Ukulele**; –; –; Portugal

995 MEMB; c 19th c. CE; **Handle Drum**; –; –; New Guinea

996 AERO; *late* 19th c. CE; **Marching Flute**; –; –; Germany

997 IDIO; c 19th c. CE; **Orchestral Xylophone**; –; –; Europe +B57

998 MEMB; *before* 1899 CE; **Frame Drum**; *Wewetowah*; Shoshone People; USA

999 MECH; 1899 CE; **Cylinder Phonograph**; –; Thomas Edison (1847–1931); USA

1000 AERO; *late* 19*th* c. CE; **Double Flute**; *Dvojnice*; –; Bosnia

1001 CHOR; *late* 19*th* c. CE; **Zither**; –; –; Germany

1002 CHOR; *late* 19*th* c. CE; **Bow Harp**; –; –; West Africa

1003 AERO; *late* 19*th* c. CE; **Long Trumpet**; *Dung–Chen*; –; Tibet

1004 MEMB; *late* 19*th* c. CE; **Cylindrical Drum**; *Timbales*; –; Spain +B68

1005 MEMB; *after* 19*th* c. CE; **Drum**; –; Fang People; Equatorial Guinea

1006 CHOR; *after* 19*th* c. CE; **Zither**; –; –; Slovakia

1007 AERO; C 1900 CE; **Bassoon**; –; –; Germany

1008 IDIO; C 1900 CE; **Gourd Rattle**; *Maraca*; –; Cuba

1009 IDIO; C 1900 CE; **Lamellophone**; *Sansa (or Zanza)*; Loango People; Zaire

1010 IDIO; C 1900 CE; **Bell**; *Adyá de Obatalá*; –; Cuba

1011 IDIO; C 1900 CE; **Armlets**; *Manillas*; –; Cuba

1012 CHOR; C 1900 CE; **Arched Harp**; –; –; Congo

1013 MEMB; C 1900 CE; **Single–headed Drum**; *Bongo*; –; Latin America

1014 IDIO; C 1900 CE; **Gourd Rattle**; *Maraca*; –; Venezuela

1015 IDIO; C 1900 CE; –; **Domisoldó**; –; Cuba +B54

1016 AERO; C 1900 CE; **Balladic Horn**; –; –; England

1017 IDIO; C 1900 CE; **Scraper**; *Reque Reque*; –; Portugal +B43

1018 AERO; C 1900 CE; **Bass Trumpet**; *Wagner's Bass Trumpet*; Moritz; Germany

1019 IDIO; C 1900 CE; **Double Bell**; *Ekón Double*; –; Puerto Rico

1020 CHOR; 1901 CE; **Piano**; *Bechstein*; Bechstein; Germany

1021 AERO; 1902 CE; **Accordion**; *Empress*; –; USA

1022 CHOR; 1902 CE; **Guitar**; –; Orville Gibson (1856–1918); USA

1023 MEMB; *early* 20*th* c. CE; **Drum**; *Tom–Tom*; –; China

1024 IDIO; C 1900 CE; –; *Osún*; –; Cuba

1025 MECH; C 1900 CE; **Self–playing Xylophone**; –; Eugene DeKleist; USA

1026 MEMB; 1903 CE; **Frame Drum**; *Ka'nohko'wah*; Seneca People; USA +B67

1027 MEMB; *early* 20*th* c. CE; **Goblet Drum**; *Ozi*; –; Myanmar

1028 AERO; 1903 CE; **Bag–blown Whistle**; –; Haida People; USA

1029 IDIO; *early* 20*th* c. CE; **Clogs**; –; –; The Netherlands

1030 CHOR; 1903 CE; **Guitar**; *Violão*; Bento Martins Lobo; Portugal

1031 AERO; *early* 20*th* c. CE; **Oboe**; *Pi Mon*; –; Thailand

1032 AERO; 1904 CE; –; *Heckelphone*; Wilhem Heckel (1856–1909); Germany

1033 MEMB; *early* 20*th* c. CE; **Cylindrical Drums**; *Timbales*; –; Spain +B69

1034 AERO; *early* 20*th* c. CE; **Melodeon**; *Vienna Style*; Hohner; Germany

1070 ELEC; 1916 CE; **Optical Organ**; *Optophonic Piano*;
Vladimir Baranoff Rossiné (1822–1942); Russia

1071 CHOR; 1916 CE; **Harp Guitar**; –; Gibson; USA

1072 MEMB; C 20*th* C. CE; **Goblet Drum**; *Changgo (or Janggu)*;
–; Korea

1073 CHOR; C 20*th* C. CE; **Bowl Lyre**; *Tanbura*; –; Oman

1074 IDIO; 1917 CE; –; **Bouteillophone**; –; France +B70

1075 CHOR; 1917–1932 CE; **Guitar**; *Guitarra*;
António Victor Vieira; Portugal

1076 IDIO; C 20*th* C. CE; –; **Num Num**; –; Portugal

1077 CHOR; 1917–1932 CE; **Harp Guitar**; *Violão–Harpa*;
António Victor Vieira; Portugal

1078 AERO; C 20*th* C. CE; **Horn**; *Corno*; –; Portugal

1079 IDIO; 1920 CE; **Xylophone**; –; –; Upper Volta +B57

1080 HYBR; *early* 20*th* C. CE; **Drum Set**; –; –; USA +B64

1081 MEMB; C 20*th* C. CE; **Conical Drums**; –; –; Congo

1082 AERO; 1920 CE; **Bell Harmonica**; *Marine Orchestra*;
Hohner; Germany

1083 IDIO; 1920 CE; –; *Pianito (or Ginebra)*; –; Cuba +B55

1084 CHOR; C 1920 CE; **Harp Guitar**; –; Harmony; USA

1085 IDIO; C 1920 CE; **Double Bell**; *Ekón Double*; –; Cuba +B43

1086 MEMB; C 20*th* C. CE; **Orchestral Bass Drum**; –; –;
World +B37

1087 MEMB; C 20*th* C. CE; **Orchestral Side Drum**; –; –;
World +B38

1088 CHOR; C 20*th* C. CE; **Lute**; –; –; Algeria

1089 MEMB; C 20*th* C. CE; **Rattle Drum**; *Kelontong*; –;
Indonesia (Java)

1090 AERO; C 20*th* C. CE; **Modern Recorder Tenor in C**;
–; –; World

1091 AERO; C 20*th* C. CE; **Modern Recorder Alto in F**;
–; –; World

1092 AERO; C 20*th* C. CE; **Modern Recorder Soprano in C**;
–; –; World

1093 CHOR; 1922 CE; **Harp Guitar**; –; Angelo Berardi; USA

1094 CHOR; C 20*th* C. CE; **Lyre**; –; –; Kenya

1095 IDIO; C 20*th* C. CE; **Gourd Rattles**; *Macaras*; –;
Latin America

1096 CHOR; *after* 1924 CE; –; *Whispering Harp*;
Arthur Kerby Ferris (1872–1940); USA

1097 MEMB; C 20*th* C. CE; **Snare Drum**; *Surdo*; –; Brazil +B39

1098 HYBR; C 20*th* C. CE; **Timbales**; –; –; Latin America +B40

1099 AERO; 1925 CE; **Hunting Horn**; –; –; Congo

1100 CHOR; C 20*th* C. CE; **Harp**; –; –; Africa

1101 MECH; 1925 CE; –; *Phonoliszt Violina*; Hupfeld; Germany

1102 IDIO; 1900–1950 CE; **Rattle Necklace**; *Gorgigala*;
Cuna Culture; Panama

1103 IDIO; C 20*th* C. CE; **Xylophone**; *Genebres*; –; Portugal

1104 IDIO; 1928 CE; **Quadruple Rattle**;
Erikunde Cuadruple de Lata; –; Cameroon

1105 AERO; C 1928 CE; **Accordion**; *Morino*; Hohner; Germany

1106 AERO; 1928 CE; **Bandalore**; *Yo–yo*; Pedro Flores; USA

1107 ELEC; 1928 CE; **Monophone**; *Ondes Martenot*;
Maurice Martenot (1898–1980); France

1108 CHOR; c 20th c. CE; **Plucked Lute**; *Cavaquinho Minhoto*;
–; Portugal

1109 AERO; c 20th c. CE; **Duct Flute**; *Gaita*; –; Portugal

1110 CHOR; 1929 CE; **Resonator Guitar**; *National Triolian*;
–; USA (Hawaii)

1111 AERO; *after* 1929 CE; **Glass Trumpet**; –; –; Switzerland

1112 ELEC; *after* 1929 CE; **Monophone**;
Theremin (or Thereminovox);
Lev (Leon) Theremin (1896–1993); Russia

1113 MEMB; c 20th c. CE; **Cylindrical Drum**; *Al Rahmani*;
–; Oman

1114 AERO; c 1930 CE; **Vessel Flute**; –; –; Papua New Guinea

1115 IDIO; c 20th c. CE; **Castanets**; *Naruko*; –; Japan

1116 IDIO; c 1930 CE; **Gourd Rattles**; *Maracas*; –; Puerto Rico

1117 AERO; c 1930 CE; **End–blown Flute**; *Shakuhachi*;
Yamaguchi Shiro (1885–1963); Japan

1118 IDIO; c 1930 CE; **Gourd Rattle**; *Macara*; –; Cuba

1119 MEMB; c 1930 CE; **Single–headed Drums**;
Conga Drum (or Tumbadora); –; Brazil

1120 IDIO; c 1930 CE; **Gourd Rattle**; *Macara*; –; Cuba

1121 MEMB; c 1930 CE; **Mirliton**; *Kazoo*; –; Germany

1122 IDIO; c 1930 CE; **Double Bell**; *Ekón Double*; –; Cuba +B43

1123 IDIO; c 20th c. CE; **Gourd Rattle**; *Macara*; –; Cuba

1124 MEMB; c 20th c. CE; **Long Drum**; –; –; Oceania

1125 CHOR; 1930–1945 CE; –; –;
Arthur Kerby Ferris (1872–1940); USA

1126 AERO; c 20th c. CE; **Flute**; *Furulya*; –; Hungary

1127 ELEC; c 1930 CE; **Electric Hawaiian Guitar**; –; –;
USA (Hawaii) +B107

1128 MEMB; c 20th c. CE; **Frame Drums**; *Uchiwa Daiko*;
–; Japan

1129 MEMB; 1900–1950 CE; **Skull Drum**; *Thod Rnga*; –; Tibet

1130 IDIO; c 20th c. CE; **Scraper**; *Güiro (or Guayo)*; –;
Cuba +B99

1131 IDIO; 1900–1950 CE; **Vessel Rattle**; *Nasis*; Cuna Culture;
Panama

1132 AERO; c 20th c. CE; **Ocarina (Toy)**; –; –; Italy

1133 IDIO; 1900–1950 CE; **Rattle**; *Acheré de Changó*; –;
Cuba and Haiti

1134 CHOR; c 20th c. CE; **Lyre**; –; –; Uganda

1135 MEMB; c 20th c. CE; **Frame Drum**; –; –; India

1136 IDIO; c 20th c. CE; **Orchestral Sleigh Bells**; –; –; Europe

1137 MEMB; c 1933 CE; **Drum**; –; –; Brazil

1138 ELEC; c 1933 CE; **Electric Violin**; –; Vivi–Tone Company;
USA +B6

1139 ELEC; c 1933 CE; **Electric Mandola**; –;
Vivi–Tone Company; USA

1140 ELEC; c 1933 CE; **Electric Mandocello**; –;
Vivi–Tone Company; USA

1141 MEMB; c 20th c. CE; **Drum**; *Madal*; –; Nepal

1142 ELEC; c 1934 CE; **Electric Guitar**; –; Vivi–Tone Company; USA +B107

1143 CHOR; c 20th c. CE; **Plucked Lute**; *Cavaquinho Minhoto*; –; Portugal

1144 ELEC; 1935 CE; **Automatic Harp**; –; Rudolph Wurlitzer (1831–1914); USA

1145 IDIO; c 20th c. CE; **Bangle**; *Al'Adad*; –; Oman

1146 MEMB; c 20th c. CE; **Drum**; –; –; Argentina +B38

1147 AERO; c 20th c. CE; **Harmonica**; –; –; –;

1148 CHOR; 1937 CE; **Guitar**; –; Gibson; USA

1149 IDIO; c 20th c. CE; **Belt**; –; –; Latin America

1150 ELEC; c 20th c. CE; –; **Theremin Cello**; Lev (Leon) Theremin (1896–1993); Russia

1151 ELEC; 1939 CE; **Synthesizer**; *Novachord*; L. Hammond & C.N. Williams; USA

1152 AERO; c 20th c. CE; **Accordion**; *Scandalli*; –; Italy

1153 MEMB; c 20th c. CE; **Drum**; *Skor–Tom*; –; Cambodia +B88

1154 ELEC; 1940 CE; **Keyboard**; *Solovox*; Hammond Organs Company; USA

1155 AERO; c 1940 CE; **Pennywhistle**; *Flauta*; –; Portugal

1156 AERO; 1940 CE; **Harmonica**; *Vermona Harp*; –; Germany

1157 IDIO; c 20th c. CE; **Tube Rattle**; *Chocalho*; –; Portugal

1158 MEMB; c 1940 CE; **Mirliton**; *Bigophone*; Bigot; France

1159 MEMB; c 1940 CE; **Mirliton**; *Bigophone*; Bigot; France

1160 MEMB; c 1940 CE; **Mirliton**; *Bigophone*; Bigot; France

1161 MEMB; c 1940 CE; **Mirliton**; *Bigophone*; Bigot; France

1162 MEMB; c 1940 CE; **Mirliton**; *Bigophone*; Bigot; France

1163 MEMB; c 1940 CE; **Mirliton**; *Bigophone*; Bigot; France

1164 MEMB; c 1940 CE; **Mirliton**; *Bigophone*; Bigot; France

1165 IDIO; c 1940 CE; **Bell**; *Ekón*; –; Cuba +B43

1166 IDIO; c 1940 CE; **Drum**; *Ping Pong*; –; Trinidad & Tobago +B85

1167 IDIO; c 1940 CE; **Drum**; *Guitar Pan*; –; Trinidad & Tobago +B86

1168 IDIO; c 1940 CE; **Drum**; *Bass Pan*; –; Trinidad & Tobago +B87

1169 AERO; c 20th c. CE; **Flute**; –; –; Thailand

1170 AERO; c 20th c. CE; **Whistle Flute**; –; –; Portugal

1171 IDIO; c 20th c. CE; **Tube Rattle**; *Chocalho*; –; Latin America

1172 MEMB; c 1940 CE; **Cocktail Drums**; –; Carlton Drum Co.; England

1173 IDIO; c 20th c. CE; **Wind Bells**; –; –; Myanmar

1174 MEMB; c 20th c. CE; **Drum**; *Tamboril*; –; Portugal +B42

1175 CHOR; 1942 CE; **Piano**; *Model Z*; Steinway & Sons; Germany

1176 CHOR; 1946 CE; **Guitar**; –; Elmer Stromberg; USA

1177 AERO; c 20th c. CE; **Circular Panpipe**; –; –; Oceania

1178 CHOR; 1947 CE; **Guitar**; –; John D'Angelico (1905–1964); USA

1179 MEMB; c 20th c. CE; **Double–headed Frame Drum**; *Bombo*; –; Portugal +B71

1180 IDIO; c 20th c. CE; **Jingle**; –; –; Latin America

1181 MEMB; c *mid* 20*th* c. CE; **Military Drum**; *Side Drum*; –;
World +B58

1182 MEMB; c *mid* 20*th* c. CE; **Military Drum**; *Tenor Drum*; –;
World +B58

1183 MEMB; c *mid* 20*th* c. CE; **Military Drum**; *Bass Drum*; –;
World +B37

1184 IDIO; c *mid* 20*th* c. CE; **Scraper**; *Reque Reque*; –;
Portugal +B43

1185 AERO; c *mid* 20*th* c. CE; **Side–blown Flute**;
Venu (or Pullanguzhal); –; India

1186 IDIO; c *mid* 20*th* c. CE; **Bottle & Fork**;
Garrafa & Garfo; –; Portugal

1187 MEMB; c *mid* 20*th* c. CE; **Mirliton**; *Kazoo*; –; USA

1188 IDIO; c *mid* 20*th* c. CE; **Scraper**; *Reque Reque*; –;
Portugal +B43

1189 CHOR; c *mid* 20*th* c. CE; **Long–necked Fretted Lute**;
Dutar (or Dotar); –; China

1190 ELEC; c *mid* 20*th* c. CE; **Acoustic Guitar**; –;
Gibson–Les–Paul; USA

1191 ELEC; c *mid* 20*th* c. CE; **Double Hawaiian Electric Guitar**;
–; –; USA +B107

1192 AERO; c *mid* 20*th* c. CE; **Clarinet**; *Basset Horn in F*; –;
Europe

1193 MECH; c *mid* 20*th* c. CE; **Typewriter**; –; –; USA

1194 AERO; c *mid* 20*th* c. CE; **Accordion**; *Galotta*; Hohner;
Germany

1195 AERO; c *mid* 20*th* c. CE; **End–blown Flute**; *Kaur*;
–; Vanautu

1196 ELEC; c *mid* 20*th* c. CE; **Acoustic–electric Guitar**; –;
Epiphone; USA

1197 CHOR; c *mid* 20*th* c. CE; –; *Balloon Guitar*;
Bernard & François Baschet; France

1198 MECH; c *mid* 20*th* c. CE; **Chord Harp**; *Harmonetta*;
Hohner; Germany

1199 CHOR; c *mid* 20*th* c. CE; –; *Balloon Guitar*;
Bernard & François Baschet; France

1200 IDIO; c *mid* 20*th* c. CE; –; *Man Flower*;
Bernard & François Baschet; France

1201 ELEC; c *mid* 20*th* c. CE; **Electric Guitar**;
Fender–Stratocaste; Fender; USA +B107

1202 AERO; c *mid* 20*th* c. CE; **Slide Clarinet**; *Baschet*;
Bernard & François Baschet; France

1203 MEMB; c *mid* 20*th* c. CE; **Mirliton**; *Kazoo*; –; Germany

1204 CHOR; c 20*th* c. CE; **Lute**; *Qin Qin*; –; China

1205 AERO; c 20*th* c. CE; **Flute**; –; –; Nigeria

1206 MEMB; 1951 CE; **Drum**; *Bombo das Rogas*; –;
Portugal +B71

1207 IDIO; c 20*th* c. CE; **Slit Drums**; –; –; Africa +B102

1208 IDIO; c 20*th* c. CE; **Tambourine Jingle**; –; –; –;

1209 ELEC; 1952 CE; **Synthesizer**; *Clavivox*;
Raymond Scott (1908–1994); USA

1210 ELEC; 1952 CE; **Monophonic Instrument**;
Mixtur Trautonium; Oskar Sala; Germany

1211 MEMB; c 20*th* c. CE; **Frame Drum**; –; –; Pakistan

1212 IDIO; c 20*th* c. CE; **Gong Chimes**; *Khong Wong Yai*; –;
Thailand +B72

1213 AERO; 1953 CE; **Trumpet with Trumpet Bell**; –;
Martin Company; USA

1214 ELEC; 1953 CE; **Electric Guitar**; –; Fender; USA +B107

1215 AERO; c 20th c. CE; **Flute**; –; –; Hungary

1216 IDIO; c 20th c. CE; **Rattle**; –; –; India

1217 MEMB; c 1956 CE; **Drum**; –; –; Spain +B58

1218 MEMB; c 20th c. CE; **Friction Drum**; *Sarronca*; –; Portugal

1219 AERO; *after* 1956 CE; **Accordion**; *Gola*; Hohner; Germany

1220 AERO; c 20th c. CE; **Flute**; –; –; Papua New Guinea

1221 ELEC; 1958 CE; **Electric Guitar**; *Rickenbaker 325*;
Aldoph Rickenbacker (1886–1976); USA +B107

1222 ELEC; 1958 CE; **Electric Violin**; –; Fender; USA +B6

1223 CHOR; c 20th c. CE; **Lyre**; –; –; Greece +B23

1224 AERO; *after* 1958 CE; **Keyboard Harmonica**;
Soprano Melodica; Hohner; Germany

1225 AERO; *after* 1958 CE; **Keyboard Harmonica**;
Piano Melodica; Hohner; Germany

1226 AERO; c 20th c. CE; **Trumpet**; –; –; Indonesia (Sulawesi)

1227 AERO; 1959 CE; **Tenor Cor in E Flat**; *Mellophone*; –; USA

1228 IDIO; c 20th c. CE; **Orchestral Sliding Rattle**; *Sistrum*; –;
Europe

1229 MEMB; c 20th c. CE; **Drum**; *Grongbong*; –; Vietnam

1230 ELEC; 1959 CE; –; *Cindy Electronium*;
Raymond Scott (1908–1994); USA

1231 AERO; c 1960 CE; *Twin–belled Euphonium*; –; –; USA

1232 IDIO; c 1960 CE; –; *Waterphone*; Richard Waters;
USA +B24 +B60

1233 CHOR; c 20th c. CE; **Fiddle**; –; –; Poland +B12

1234 ELEC; c 1960 CE; **Semi–acoustic Guitar**; –;
Gibson–Les–Paul; USA

1235 AERO; c 1960 CE; **Valved Tenor Trombone**; –; –; Europe

1236 IDIO; c 1960 CE; **Xylophone**; *Roneat Ek*; –;
Cambodia +B73

1237 MEMB; c 20th c. CE; **Single–headed Drum**; *Cactus Drum*;
–; Morocco

1238 IDIO; c 20th c. CE; **Concussion Vessel Clappers**;
Orchestral Castanets; –; Europe

1239 ELEC; 1961 CE; **Double Electric Guitar**; *EDS*;
Gibson–Les–Paul; USA +B107

1240 MEMB; c 20th c. CE; **Waist Drum**; *Darbouka*; –; Turkey

1241 CHOR; c 20th c. CE; **Board Zither**; *Bangwe*; –; Congo

1242 ELEC; c 1962 CE; **Electric Guitar**; *SG*; Gibson–Les–Paul;
USA +B107

1243 HYBR; c 20th c. CE; **Vessel Drum**; *Udu*; Igbo *&* Hausa;
Nigeria

1244 ELEC; c 1962 CE; **Electric Bass Guitar**; *Fender–Precision*;
Fender; USA

1245 AERO; c 20th c. CE; **Harmonica**; –; –; –;

1246 IDIO; 1968 CE; –; *Chùm Mö Quê*; Ta Thâm; Vietnam

1247 MEMB; c 20th c. CE; **Footed Drum**; –; –; Tanzania

1248 ELEC; 1964 CE; **Synthesizer**; *Synket*; Paul Ketoff; Italy

1249 AERO; c 20th c. CE; **Whistle Flute**; –; –; Spain

1250 ELEC; 1968 CE; **Stylophone**; *Dubreq*; Brian Jarvis;
 England

1251 AERO; C 20th C. CE; **Piccolo Trumpet**; –; –; USA

1252 AERO; 1968 CE; –; *Corruga Horn*; Frank Crawford; USA

1253 ELEC; 1968 CE; **Electric Guitar**; *Fender–Telecaster*;
 Fender; USA +B107

1254 AERO; C 20th C. CE; **Transverse Flute**; *Fife*; –; USA

1255 IDIO; C 20th C. CE; **Castanets**; *Qarkabeb*; –; Algeria

1256 IDIO; 1969 CE; **Sound Sculpture**; *Baschet*;
 Baschet Retrospective Chicago Arts Club; USA

1257 MEMB; C 20th C. CE; **Conical Drum**;
 Kobago (or Coboro); –; Ethiopia

1258 IDIO; C 20th C. CE; **Pellet Bell**; –; –; Peru

1259 AERO; C 20th C. CE; **Whistle Flute**; *Shvi*; –; Armenia

1260 AERO; C 20th C. CE; **Whistle Flute**; *Shvi*; –; Armenia

1261 AERO; C 20th C. CE; **Whistle Flute**; *Shvi*; –; Armenia

1262 CHOR; 1969 CE; **Piano**; *M112*; Yamaha; Japan

1263 ELEC; 1970 CE; **Synthesizer**; *Minimoog*;
 Robert Moog (1934–2005); USA

1264 MEMB; 1970 CE; **Goblet Drum**; *Dumbec*; –; –;

1265 IDIO; C 20th C. CE; **Hawaiian Shoe**; –; –; USA (Hawaii)

1266 MEMB; C 20th C. CE; **Treble Drum**; *Al Kasir*; –; Oman

1267 MEMB; C 20th C. CE; **Cylindrical Drum**; *Al Rahmani*;
 –; Oman

1268 AERO; C 1970 CE; **Side–blown Trumpet**; *Kondo*;
 Pokot People; Kenya

1269 ELEC; C 1970 CE; **Electric Bass Guitar**; –; B.C. Rich; USA

1270 AERO; C 1970 CE; **Fipple Pipes**; –; Denny Genovese; USA

1271 AERO; C 20th C. CE; **Clarinet**; –; –; World

1272 AERO; C 20th C. CE; **Clarinet**; –; –; World

1273 IDIO; C 20th C. CE; **Orchestral Castanets**; –; –; Europe

1274 ELEC; 1972 CE; **Autokomp Drum Machine**;
 Keio Mini Pops Junior; Korg; Japan

1275 ELEC; 1972 CE; **Mobile Phone**; –; Motorola; USA

1276 IDIO; C 20th C. CE; **Washtub Bass**; –; –; USA

1277 MEMB; C 20th C. CE; **Single–headed Drum**; *Cununo*; –;
 Ecuador

1278 CHOR; C 20th C. CE; **Tube Fiddle**; *Endingidi (or Adigirgi)*;
 –; Uganda +B21

1279 IDIO; C 20th C. CE; **Chincalhos**; –; –; Portugal

1280 IDIO; 1975 CE; –; *Chùm Mö Canh*; Ta Thâm; Vietnam

1281 AERO; C 20th C. CE; **Harmonica**; *Accorda Harmonica*;
 Hohner; Germany

1282 MEMB; C 20th C. CE; **Drum**; *Ramana*; –; Thailand

1283 MEMB; C 20th C. CE; **Drum**; *Chatri*; –; Thailand

1284 IDIO; C 20th C. CE; **Sliding Rattle**; *Sistrum*; –; Ethiopia

1285 CHOR; C 20th C. CE; **Guitar**; *Violão Baixo*; –; Portugal

1286 AERO; C 20th C. CE; **Nose Flute (Novelty)**; –; –; USA

1287 IDIO; C 20th C. CE; **Scraper**; *Reque Reque*; –;
 Portugal +B101

1288 MEMB; C 20th C. CE; **Double–headed Frame Drum**; *Bombo*; –; Portugal +B63

1289 AERO; C 20th C. CE; **Pennywhistle**; *Flauta*; –; Portugal

1290 IDIO; C 20th C. CE; **Rattle**; *Sonajero*; –; Mexico

1291 CHOR; C 20th C. CE; **Lute**; –; –; Burkina Faso

1292 CHOR; C 1975–1985 CE; **20–string Harp Guitar**; –; William Eatom; USA

1293 CHOR; C 1975–1985 CE; **10–string Lyre**; –; William Eatom; USA

1294 CHOR; C 1975–1985 CE; **26–string Guitar**; –; William Eatom; USA

1295 CHOR; C 1975–1985 CE; –; *O'Ele'n Strings*; William Eatom; USA

1296 CHOR; C 1975–1985 CE; –; *Spiral Clef*; William Eatom; USA

1297 ELEC; C 1975–1985 CE; **Bass Pedal Synthesizer**; *Moog Taurus*; Robert Moog (1934–2005); USA

1298 IDIO; C 20th C. CE; **Bamboo Pipes**; –; –; Japan

1299 AERO; C 20th C. CE; **Recorder**; –; –; Norway

1300 CHOR; C 20th C. CE; **Long–necked Lute**; *Saz*; –; Azerbaijan

1301 MEMB; C 20th C. CE; **Drum**; *Tampun*; –; Peru

1302 IDIO; C 20th C. CE; **Notched Scraper**; *Reco–Reco (or Raspador)*; –; Brazil +B43

1303 ELEC; 1977 CE; **Analog String Keyboard**; *Logan String Melody II*; Logan; Italy

1304 CHOR; 1977 CE; **Guitar**; –; S.L. Mossman Guitars; USA

1305 MEMB; C 20th C. CE; **Drum**; –; –; Haiti

1306 CHOR; C 20th C. CE; **Long–necked Lute**; –; –; Turkey

1307 AERO; C 20th C. CE; **Whistle Flute**; –; –; Cuba

1308 MEMB; C 20th C. CE; **Drum**; –; –; Haiti

1309 CHOR; 1978 CE; **Resonator Guitar**; –; Dobro Brothers; USA

1310 AERO; C 20th C. CE; **Harmonica**; –; –; –

1311 ELEC; C 1978 CE; **Turntable**; *Technics SL1210*; Technics; Japan

1312 IDIO; C 20th C. CE; **Tong Cymbals**; –; –; –

1313 MEMB; C 20th C. CE; **Tambourine**; *Reshoto*; –; Russia

1314 MEMB; C 20th C. CE; **Single–headed Drums**; *Bongos*; –; Morocco

1315 ELEC; 1979 CE; **Synthesizer**; *Prodigy*; Robert Moog (1934–2005); USA

1316 CHOR; 1980 CE; –; *The Semi–civilized Tree*; Nazim Ozel; Turkey +B6

1317 AERO; C 20th C. CE; **Walking Stick Transverse Flute**; –; –; –

1318 CHOR; C 20th C. CE; **Fiddle**; *Gusle*; –; Serbia & Montenegro +B15

1319 MEMB; C 1980 CE; **Drum**; *Tabla*; –; India

1320 MEMB; C 1980 CE; **Drum**; *Baya*; –; India

1321 AERO; C 20th C. CE; **Rotary Valve Trumpet**; –; –; Germany and Austria

1322 MEMB; C 20th C. CE; **Drum**; –; –; Spain +B77

1323 IDIO; C 20th C. CE; **Double Bell**; *Agogo*; –; Cameroon +B78

1324 MEMB; C 20th C. CE; **Footed Drum**; *Tlalpanhuéhuetl*; –;
Mexico +B80

1325 CHOR; C 20th C. CE; **Plucked Lute**; *Gunibri*; –; Morocco

1326 ELEC; C 1980–1985 CE; –; *Terminal Paper Gourd Harp*;
Grant Strombeck; USA

1327 IDIO; C 1980–1985 CE; –; *The Orb*; Grant Strombeck;
USA +B40

1328 IDIO; C 1980–1985 CE; –; *Sound Web*; Grant Strombeck;
USA

1329 IDIO; C 1980–1985 CE; **Kalimba**; *Jawlimba*;
Grant Strombeck; USA

1330 IDIO; C 1980–1985 CE; –; *Old Piano–string Drum*;
Grant Strombeck; USA

1331 AERO; C 20th C. CE; **Orchestral Trombone**; –; –; Europe

1332 IDIO; C 20th C. CE; **Bell**; –; –; Indonesia (Bali)

1333 CHOR; C 20th C. CE; **Fiddle**; –; –; Morocco +B19

1334 MEMB; C 20th C. CE; **Drum**; *Ramanalamtat*; –; Thailand

1335 IDIO; C 20th C. CE; **Scraper**; *Sapo Cubana*; –; Cuba

1336 AERO; C 20th C. CE; **Orchestral Valved Trombone**;
–; –; Europe

1337 CHOR; C 20th C. CE; **Fiddle**; –; –; South Africa

1338 IDIO; C 20th C. CE; **Bells**; *Campainhas*; –; Portugal

1339 CHOR; C 20th C. CE; **Short–necked Fiddle**;
Rabeca Chuleira; –; Portugal +B6

1340 MEMB; C 20th C. CE; **Waist Drum**; *Khishba*; –; Iraq

1341 IDIO; C 20th C. CE; **Tambourine with Jingles**; –; –; Brazil

1342 MEMB; C 20th C. CE; **Cylindrical Drum**; *Tumyr*; –;
Russia +B58

1343 IDIO; C 20th C. CE; **Hand Jingles**; –; –; Russia

1344 CHOR; C 20th C. CE; **Guitar**; *Viola Braguesa*; –; Portugal

1345 CHOR; C 1980–1990 CE; **Gravichord**; *Gravikord*;
Bob Grawi; USA

1346 ELEC; C 1980–1990 CE; **Electric Guitar**; –; Jackson;
USA +B107

1347 AERO; C 1980–1990 CE; **Trumpet**; *Orochi*;
Takayuki Kakizaki; Japan

1348 HYBR; C 1980–1990 CE; **Drum Bass**; –; Ferdinand Försch;
Germany

1349 CHOR; C 1980–1990 CE; –; *Ship*; Ken Butler; USA

1350 AERO; C 1980–1990 CE; –; *Pumpaphone*; Jacques Dudon;
France

1351 CHOR; C 1980–1990 CE; –; *Circular Chordophone*;
Darrell Devore (1939–2005); USA

1352 IDIO; C 1980–1990 CE; –; *Chaker Chime*;
Ward Hartenstein; USA

1353 AERO; C 1980–1990 CE; **Ocarina**; –; Susan Rawcliffe; USA

1354 MEMB; C 1980–1990 CE; **Barrel Drum**; *Conga*; –;
Latin America

1355 ELEC; C 1980–1990 CE; **Electric Guitar**; *Ibanez*;
Ibanez; Japan +B107

1356 CHOR; C 1980–1990 CE; –; *Rock*; Nobuaki Ito; Japan

1357 CHOR; C 1980–1990 CE; **Stick Zither**; *Rudra Vina*;
Matthew Finstrom; USA

1358 CHOR; c 1980–1990 CE; **Zither**; *Shakti Harp*;
Steve Klein; USA

1359 AERO; c 1980–1990 CE; **Whistle**; *Space Whistle*;
Susan Rawcliffe; USA

1360 AERO; c 1980–1990 CE; **Ocarina**; *Triple Space*;
Susan Rawcliffe; USA

1361 CHOR; c 1980–1990 CE; **Steel–string Guitar**; –;
Steve Klein; USA

1362 IDIO; c 1980–1990 CE; –; *Cym–bell Tree*;
Ward Hartenstein; USA +B81

1363 CHOR; 1982 CE; **Guitar**; *Pikasso*; Linda Manzer; Canada

1364 CHOR; 1982 CE; **Horn Harp**; –; Sam Pappas; USA

1365 IDIO; 1982 CE; **Drum**; *First Metal Drum*;
Ferdinand Försch; Germany +B60

1366 AERO; c 1980–1990 CE; –; *Sticollo*; –; USA

1367 ELEC; 1982 CE; **Polyphonic Synthesizer**; *Memorymoog*;
Robert Moog (1934–2005); USA

1368 CHOR; c 1980–1990 CE; **Harp**; *Kora*; Brian Ransom; USA

1369 CHOR; 1982 CE; **Drone Guitar**; –; Linda Manzer; Canada

1370 AERO; c 1980–1990 CE; **Polyglobular Flute**; *4 Balls*;
Susan Rawcliffe; USA

1371 IDIO; 1983 CE; **Drum**; *Magic Drum*;
Ferdinand Försch; Germany +B60

1372 AERO; *after* 1982 CE; **Trumpet**; –; David G. Monette; USA

1373 AERO; c 1980–1990 CE; **Double Flute**; *Crown Flute*;
Susan Rawcliffe; USA

1374 CHOR; c 1985 CE; –; *Drilling (Triplet)*; Ferdinand Försch;
Germany +B24 +B60

1375 HYBR; c 1985–1995 CE; –; *Clamp/Hatchet*; Ken Butler;
USA +B6

1376 HYBR; c 1985–1995 CE; –; *Bicycle Seat Violin*; Ken Butler;
USA +B6

1377 HYBR; c 1985–1995 CE; –; *Hockey/Rackett*; Ken Butler;
USA

1378 HYBR; c 1985–1995 CE; –; *Machine Gun Viola*;
Ken Butler; USA +B6

1379 HYBR; c 1985–1995 CE; –; *Gun Violin*; Ken Butler;
USA +B6

1380 HYBR; c 1985–1995 CE; –; *Handgun Violin*; Ken Butler;
USA +B6

1381 HYBR; c 1985–1995 CE; –; *Chair/Africa/Bass*; Ken Butler;
USA

1382 HYBR; c 1985–1995 CE; –; *T-square/Tray/Cello*;
Ken Butler; USA +B6

1383 HYBR; c 1985–1995 CE; –; *Baseball Bat/Cane/Cello*;
Ken Butler; USA +B6

1384 ELEC; c 1985 CE; –; *Sub Chant Generator*;
Qubais Reed Ghazala; USA

1385 IDIO; 1986 CE; **Sound Object**; *Klangbild III*;
Ferdinand Försch; Germany +B60

1386 ELEC; 1986 CE; **Phase Distortion (PD) Synthesizer**;
Casio CZ1; Casio; Japan

1387 IDIO; 1986 CE; –; *Chùm Mö Nho*; Ta Thâm; Vietnam

1388 IDIO; 1986 CE; **Sound Object**; *Klangbild I*;
Ferdinand Försch; Germany +B60

1389 ELEC; 1986 CE; **Keyboard**; *Sci Prophet VS*;
Sequential (David Smith); USA

1390 ELEC; 1987 CE; **Drum Machine**; *Yamaha RX5*;
Yamaha; Japan

1391 CHOR; 1989 CE; –; *Divine Monogourd*; Elizabeth Was;
USA

1392 AERO; 1989 CE; **Triple Ocarina**; *Multiple Ocarina*;
Susan Rawcliffe; USA

1393 AERO; 1989 CE; **Double Ocarina**; *Multiple Ocarina*;
Susan Rawcliffe; USA

1394 AERO; 1989 CE; **Polyglobular Flute**; *Ball & Tube Flute*;
Susan Rawcliffe; USA

1395 AERO; 1989 CE; –; *Marakan Gourdophone*; Miekal And;
USA

1396 IDIO; 1989 CE; –; **Chùm Song Loan**; Ta Thâm;
Vietnam +B83

1397 ELEC; 1985–1990 CE; **Electric Bass Guitar**; –;
Ned Steinberger; USA

1398 ELEC; 1985–1990 CE; **Electric Bass Guitar**;
Corvette Proline; Warwick; Germany

1399 ELEC; 1985–1990 CE; **Digital Horn**; *DH–100*; Casio;
Japan

1400 CHOR; *late* 1980–1993 CE; **Acoustic Lute**; –; Jeff Bunting;
USA

1401 IDIO; C 1990 CE; **Drums**; *Timbajo*; Oliver Dicicco; USA

1402 MEMB; C 1990 CE; **Mirliton**; *Kazoo*; –; Europe

1403 ELEC; C 1990 CE; **Z–tar**; *Z75*; Starr Labs; USA

1404 ELEC; C 1990 CE; –; *Morphium*; Qubais Reed Ghazala;
USA

1405 HYBR; 1990–1995 CE; –; *Culm*; Richard Waters; USA

1406 AERO; 1990–1995 CE; –; *Whistle Whisteling Football*;
Edge–tone Toys; USA

1407 AERO; 1990–1995 CE; **Nose Whistle**; *Humanatone*;
Grover/Trophy Music; USA

1408 CHOR; C 1990 CE; –; *The Bass*; Oliver Dicicco; USA

1409 IDIO; C 1990 CE; –; *Fountain*; Jim Doble; USA +B84

1410 IDIO; C 1990–2000 CE; **Clacker Flexer (Toy)**;
Froggy; –; USA

1411 AERO; *early* 1990 CE; –;
Spring–mounted Doll's Head Whistle;
Edge–tone Toys; USA

1412 IDIO; *early* 1990 CE; **Spiralphone**; *Espiralofone*;
Victor Gama; Portugal/Angola

1413 CHOR; C 1990–2000 CE; –; *Bumble Bee*; Bill Reid; USA

1414 IDIO; C 1990–2000 CE; –; *Percussion Tree*; Oliver Dicicco;
USA

1415 ELEC; C 1990–2000 CE; –; *Achilles*;
Fred "Spaceman" Long; USA

1416 IMAG; C 1990–2000 CE; –;
Get Your Kitten's Tune Pitched Early;
Hall Rammel & Davey Williams (Cloud Eight); USA

1417 IMAG; C 1990–2000 CE; –; –;
Hall Rammel & Davey Williams (Cloud Eight); USA

1418 MEMB; C 1990–2000 CE; **Mirliton**; *Kazoo*; –; China

1419 IMAG; C 1990–2000 CE; –; *Woodwind Machine*;
Hall Rammel & Davey Williams (Cloud Eight); USA

1420 CHOR; C 1990–2000 CE; –; *Abdul*; Oliver Diciccio; USA

1421 ELEC; C 1990–2000 CE; –; *Atlas*; Fred "Spaceman" Long; USA

1422 IMAG; C 1990–2000 CE; –; *Brass*; Hall Rammel & Davey Williams (Cloud Eight); USA

1423 IMAG; C 1990–2000 CE; –; *Woodwind*; Hall Rammel & Davey Williams (Cloud Eight); USA

1424 IMAG; C 1990–2000 CE; –; *Militarised' Woodwind Machine*; Hall Rammel & Davey Williams (Cloud Eight); USA

1425 CHOR; C 1990–2000 CE; –; *Cat's Cradle*; John Gzowski; USA

1426 IMAG; C 1990–2000 CE; –; *Liquid Pectra Toilet*; Hall Rammel & Davey Williams (Cloud Eight); USA

1427 AERO; C 1990–1995 CE; **Single, Double and Triple Flutes**; *Rack of Flutes*; Susan Rawcliffe; USA

1428 AERO; C 1990–1995 CE; **Double Flute**; *Space Flute*; Susan Rawcliffe; USA

1429 AERO; C 1990–1995 CE; **Double Flute**; *Space Flute*; Susan Rawcliffe; USA

1430 IDIO; 1991 CE; **Drum**; –; Oliver Dicicco; USA +B77

1431 AERO; 1991 CE; –; *Due Capi*; Oliver Dicicco; USA

1432 IDIO; 1991 CE; **Kalimba**; –; Oliver Dicicco; USA

1433 ELEC; 1991 CE; **Triolin**; –; Hall Rammel; USA +B24

1434 MEMB; 1991 CE; **Goblet Drum**; –; –; –;

1435 IDIO; 1991 CE; **Sound Object**; *Klangwand I*; Ferdinand Försch; Germany +B60

1436 ELEC; 1991 CE; **Keyboard**; *Z–Board*; Starr Labs; USA

1437 CHOR; 1991 CE; –; *Waterharp*; Richard Waters; USA

1438 MEMB; 1991 CE; **Double–conical Drum**; *Kendhang Ciblon*; –; Indonesia

1439 IDIO; 1991 CE; –; *Metal Cone*; Peter Whitehead; USA +B60

1440 IDIO; 1991 CE; *Drone Drum*; –; Oliver Dicicco, USA +B77

1441 IDIO; 1991 CE; **Sound Object**; *Klangwand II*; Ferdinand Försch; Germany +B89

1442 CHOR; *after* 1991 CE; **Ukulele**; *Arachnopatch*; Brian Stapleton; USA

1443 CHOR; *after* 1991 CE; **Ukulele**; *Flounderlin*; Brian Stapleton; USA

1444 CHOR; *after* 1991 CE; **Ukulele**; *Enighmaphon*; Brian Stapleton; USA

1445 AERO; 1992 CE; **Ocarina**; *Whiffle*; Susan Rawcliffe; USA

1446 CHOR; 1992 CE; **Panjo (or Canjo) with Pick Up**; –; Peter Whitbread; USA

1447 HYBR; 1992 CE; –; *The Busker*; Ken Lovelett; USA +B60

1448 AERO; 1992 CE; **Ocarina**; *Whiffle*; Susan Rawcliffe; USA

1449 AERO; C 1993 CE; **Concertina**; –; –; Czechoslovakia

1450 ELEC; 1993 CE; **Jitter Ball (toy)**; –; Lanard Toy Ltd; United Kingdom

1451 HYBR; 1993 CE; –; *T-square Quartet*; Ken Butler; USA +B6

1452 AERO; 1993 CE; **Flute**; *Water Flute*; Susan Rawcliffe; USA

1453 IDIO; 1994 CE; –; *Guineo*; Victor Gama; Portugal/Angola

1454 CHOR; 1994 CE; **Piano**; *Model 8*; Bechstein; Germany

1455 AERO; 1994 CE; **Double Chamber Duct Flute**; *Sea Beastie*; Susan Rawcliffe; USA

1456 AERO; 1994 CE; **7 Ocarinas**; *Flute Pile*; Susan Rawcliffe; USA

1457 CHOR; 1994 CE; **Guitar**; –; Fender; USA

1458 AERO; 1994 CE; **Trumpet**; *Polyglobular Trumpet*; Susan Rawcliffe; USA

1459 HYBR; 1994 CE; **Industrial Drumset**; –; Keith Spears; USA +B58

1460 ELEC; 1994 CE; **Electro Magnetic Pickup**; –; Steve Ball; USA

1461 AERO; 1994 CE; **Siren**; *Musical Siren*; Bart Hopkin; USA

1462 CHOR; 1994 CE; **Musical Bow**; –; Peter Whitehead; USA

1463 ELEC; 1996 CE; **Diamond Xylophone**; –; Jeff Bunting; USA +B60

1464 IDIO; 1996 CE; –; *Dancer*; Richard Cooke; USA +B90

1465 ELEC; 1996 CE; **Slide Guitar**; –; Jeff Bunting; USA +B104

1466 IDIO; 1996 CE; –; *Galvanophone*; Curtis Settino; USA

1467 IDIO; 1996 CE; **Imbarimba**; –; Richard Cooke; USA +B84

1468 IDIO; 1996 CE; –; *Zulão*; Victor Gama; Portugal/Angola

1469 IDIO; 1996 CE; –; *Aquaggaswack*; Curtis Settino; USA +B60

1470 IDIO; 1996 CE; **Mbira**; *Embira*; Lucinda Ellison; USA

1471 CHOR; C 1990–2000 CE; **Long–necked Lute**; *Ramkie*; –; South Africa

1472 ELEC; C 1997 CE; **Z–tar**; *Mini–Z*; Starr Labs; USA

1473 CHOR; C 1997 CE; –; *Double Harp with Light–shade Resonator*; Peter Whitehead; USA

1474 CHOR; C 1990–2000 CE; **Panjo (or Canjo)**; –; Peter Whitehead; USA

1475 CHOR; C 1990–2000 CE; –; *Ski Tamboura*; Peter Whitehead; USA

1476 ELEC; C 1990–2000 CE; **Breath Controller Headset**; *BC3A*; Yamaha; Japan

1477 CHOR; 1997 CE; –; *Abra*; Victor Gama; Portugal/Angola

1478 CHOR; C 1990–2000 CE; –; *Rebab with Salad Bowl Resonator*; Peter Whitehead; USA

1479 ELEC; C 1998 CE; **Z–tar**; *Mark III*; Starr Labs; USA

1480 CHOR; C 1990–2000 CE; –; *Rebab with Ice Bucket Resonator*; Peter Whitehead; USA

1481 CHOR; C 1990–2000 CE; –; *Lawn Lyre*; Peter Whitehead; USA

1482 CHOR; C 1990–2000 CE; –; *Lyre with Oil Pan Resonator*; Peter Whitehead; USA

1483 CHOR; C 1990–2000 CE; –; *Wash Tub Bass*; Peter Whitehead; USA

1484 IDIO; 1998 CE; –; *Bidon 4*; Victor Gama; Portugal/Angola

1485 IDIO; 1998 CE; –; *Dialogue Table*; Victor Gama; Portugal/Angola

1486 IDIO; 1999 CE; –; *Sturn*; Victor Gama; Portugal/Angola

1487 ELEC; 1999 CE; –; *Resonator III*; Brian Ransom; USA

1488 MEMB; 1999 CE; **Congas**; *Dragon Congas*; Brian Ransom; USA

1489 ELEC; 1999 CE; –; *Whistling Pads*; Brian Ransom; USA

1490 AERO; 1999 CE; **Resonator**; *Deities of Sound "Travler"*; Brian Ransom; USA

1491 AERO; 1999 CE; **Resonator**; *Deities of Sound "Singing"*; Brian Ransom; USA

1492 AERO; 1999 CE; **Pot Flutes**; *Nest of Hooters*; Brian Ransom; USA

1493 AERO; 1999 CE; **Pipe Organ**; –; Noack Organ Company (USA); Iceland

1494 IDIO; 1999 CE; –; *Acrux*; Victor Gama; Portugal/Angola

1495 IDIO; c 1995–2000 CE; –; *Shaker*; Brian Ransom; USA

1496 IDIO; c 1995–2000 CE; –; *Shaker*; Brian Ransom; USA

1497 IDIO; c 1995–2000 CE; –; *Plucked Sound*; Tibor Budahelyi; Hungary

1498 IDIO; c 1995–2000 CE; –; *Alto*; Tibor Budahelyi; Hungary

1499 IDIO; c 1995–2000 CE; –; *Shaker*; Brian Ransom; USA

1500 IDIO; c 1995–2000 CE; –; *Voice of Kassak*; Tibor Budahelyi; Hungary

1501 IDIO; c 1995–2000 CE; –; *Shaker*; Brian Ransom; USA

1502 ELEC; c 1995–2000 CE; –; *Sound Transmitter*; Tibor Budahelyi; Hungary

1503 ELEC; c 1995–2000 CE; –; *Slim Voice Changer*; Berwick Industrial Co Ltd; China (Hong Kong)

1504 MEMB; 2000 CE; **Talking Drum**; *Tama*; Mark Shepard; USA +B31

1505 CHOR; 2002 CE; –; *Toha*; Victor Gama; Portugal/Angola

1506 IDIO; 2002 CE; **Drum**; *Water Drum*; Ferdinand Försch; Germany

1507 CHOR; 2003 CE; –; *Epsilon Lyrae*; Victor Gama; Portugal/Angola

1508 ELEC; 2004 CE; **Turntable**; *QVO*; Vestax; Japan

1509 ELEC; 2004 CE; **Video Game with Bongo-shaped Controller**; *Donkey Konga*; Nintendo; Japan

1510 CHOR; 2004 CE; –; *Dino*; Victor Gama; Portugal/Angola

1511 ELEC; 2004 CE; –; *Audio Shaker*; Mark Hauenstein & Tom Jenkins; England

1512 CHOR; 2004 CE; –; *Cosmovisão*; Victor Gama; Portugal/Angola

1513 ELEC; 2005 CE; **Digital Trumpet**; *MDT*; Steve Marshall & James Morrison; Australia

1514 ELEC; 2005 CE; **Open Architecture Synthesis Studio**; *OASYS*; Korg; Japan

1515 ELEC; 2006 CE; **Touchpad MIDI Controller, Sampler & Effects Processor**; *Kaoss Pad KP3*; Korg; Japan

1516 ELEC; 2006 CE; **Interactive Music Video Game**; *Electroplankton*; Toshio Iwai (Nintendo); Japan

1517 ELEC; 2006 CE; **Intercreative Sound Installation**; *16:9*; Martin Romori & Daniel Teige; Germany

1518 ELEC; 2006 CE; **Music Video Game with Guitar-shaped Peripheral**; *Guitar Hero II*; Harmonix Music Systems; USA

1519 ELEC; 2007 CE; **Z-tar**; *Z7*; Starr Labs; USA

1520 HYBR; 2007 CE; **Mutant Trumpet**; *Mutantrumpet*; Ben Neill; USA

Recommended Reading & Museums

Weiterführende Literatur und Museen

Lectures et musées recommandés

Leituras e museus recomendados

Lecturas y museos recomendados

Pubblicazioni e musei consigliati

Рекомендуемая литература и музеи

参考文献と美術館

Recommended Reading

Weiterführende Literatur

Lectures recommandées

Leituras recomendadas

Lecturas recomendadas

Pubblicazioni consigliate

Рекомендуемая литература

参考文献

Acht van, R.J.M.
Volksmuziek en Volksinstrumenten in Europa
The Netherlands: Gemeentedrukkerij van 's Gravenhage, 1983

Bordas Ibáñez, C.
Instrumentos Musicales en Colecciones Españolas
Spain: Centro de Documentación de Música y Danza, 1999

Clark, M.
Sounds of the Silk Road, Musical Instruments of Asia
USA: MFA Publications, 2005

Coates, K.
Geometry, Proportion and the Art of Lutherie
USA: Oxford University Press, 1985

Cockayne, E.V.
The Fairground Organ
UK: David & Charles, year unknown

Dearling, R.
The Encyclopedia of Musical Instruments, Non-western and Obsolete Instruments
United Kingdom: Carlton Books Ltd, 2001

De Oliveira, E.V.
Instrumentos Musicais Populares Portugueses
Portugal: Fundação Calouste Gulbenkian, 1982

Diagram Group
**Musical Instruments of the World :
an Illustrated Encyclopedia**
United Kingdom: Paddington Press, 1976

Diamond, B., Cronk, M.S. & von Rosen, F.
**Visions of Sound, Musical Instruments of First Nations
Communities in North-eastern America**
USA: The University of Chicago Press, 1994

El-Mallah, I.
Omani Traditional Music
Germany: Hans Schneider Verlag, 1998

Haags Gemeentemuseum
Pianofortes from the Low Countries
The Netherlands: Frits Knuf Bv., 1980

Haags Gemeentemuseum
Traditional Musical Instruments from Japan
The Netherlands: Frits Knuf Bv, 1979

Haspels, J. J.
Daar zit Muziek in
The Netherlands: Bosh & Keuning Bv., 1981

Instituto Português do Património Cultural
**Instrumentos Musicais 1747–1807, uma Colecção à procura
de um Museu**
Portugal: Palácio Nacional de Queluz, 1984

Lievense, W.
Het Muziekinstrument
The Netherlands: de Alk Bv, year unknown

Marcuse, S.
Musical Instruments, a Comprehensive Dictionary
United Kingdom: Country Life Ltd, 1966

Musikinstrumenten-Museum Berlin
Germany: Westermann Verlag, 1986

Museum Guide to the National Museum 'From Musical Clock to Street Organ'
The Netherlands: Nationaal Museum van Speelklok tot Pierement, 2005

Oling, B. and Wallisch, H.
The Complete Encyclopedia of Musical Instruments
USA: Chartwell Books Inc., 2003

Ortiz, F.
Los Instrumentos de la Música Afrocubana
Spain: Musica Mundana Maqueda S.L, 1996

Rimmer, J.
Ancient Musical Instruments of Western Asia in the British Museum
United Kingdom: The Trustees of the British Museum, 1969

Russell, R.
Early Keyboard Instruments
United Kingdom: W & J Mackay Ltd, 1976

Trasher, A.R.
Chinese Musical Instruments
USA: Oxford University Press, 2000

Elliot, J. & Lacock, J.
Música, a História e a Evolução dos Instrumentos Musicais, dos mais Primitivos aos mais Recentes
United Kingdom: Dorling Kindersley Ltd, Editorial Verbo, 1988

Wade-Matthews, M.
The World Encyclopedia of Musical Instruments,
United Kingdom: Anness Publishing Ltd, 2000

Young, P.T.
The Look of Music
USA: Vancouver Museums and Planetarium Association, 1980

Recommended Websites

Empfohlene Webseiten

Sites web recommandés

Sítios na web recomendados

Páginas web recomendadas

Siti web consigliati

Рекомендуемые интернет-страницы

参考ホームページ

120 Years of Electronic Music
www.obsolete.com/120_years

Bechstein
www.bechstein.de

Ben Neill
www.benneill.com

Brian Ransom
home.eckerd.edu/~ransombc

The Dayton C. Miller Flute Collection
memory.loc.gov/ammem/dcmhtml/dmintro.html

Digital Violin
www.digitalviolin.com

Experimental Musical Instruments
www.windworld.com

Fender
www.fender.com

Ferdinand Försch
www.klanghaus-ff.de

Gary H. Musical Instruments
instruments.garyhendershot.com

Gibson
www.gibson.com

Glossary of Folk Musical Instruments
www.hobgoblin-usa.com/info/glossary.htm

Grant Strombeck
grantstrombeck.dyndns.org

Grove Music Online
www.grovemusic.com

Harmonica Museum
www.ginab.com/rbharper/Museum.htm

Ian Fritz
home.comcast.net/~ijfritz/index.htm

The International Harp Guitar Gathering
www.harpguitars.net

Jim Doble
www.tidewater.net/~xylojim/index.html

John Gzowski
www.johngzowski.com

Keith Spears
www.keithspears.com

Ken Butler
www.mindspring.com

Korg
www.korg.com

Linda Manzer
www.manzer.com

Mark Hauenstein
www.nurons.net

Marko Ettlich
www.retrosound.de

Musica Mecanica
www.musicamecanica.org

Moog
www.moogmusic.com

Museo Internazionale e Biblioteca della Musica
www.museomusicabologna.it

New Directions for World Music
www.asza.com

The Noack Organ Company
www.noackorgan.com

Oliver Dicicco
www.mobiusmusic.com/instruments.html

Peter Whitehead
www.outofroundrecords.com

Qubais Reed Ghazala
www.anti-theory.com

Richard Cooke
www.freenotes.net

Susan Rawcliffe
www.artawakening.com/soundworks

Starr Labs
www.starrlabs.com

Steinway & Sons
www.steinway.com

Tom Jenkins
www.tom-jenkins.net

Vestax
www.vestax.com

Vintage Guitars
www.provide.net/~cfh/gallery.html

Victor Gama
www.victorgama.org
www.pangeiainstrumentos.org

Warwick
www.warwickbass.com

Yamaha
www.yamaha.com

Museums with Musical Instrument Collections

Museen mit Musikinstrumenten-Smmlungen

Musées possédant une collection d'instruments de musique

Museus com colecções de instrumentos musicais

Museos con colecciones de instrumentos musicales

Musei con collezioni di strumenti musicali

Музеи с коллекциями музыкальных инструментов

楽器のコレクションを収蔵している美術館

AUSTRIA

Kunsthistorisches Museum Wien
Sammlung alter Musikinstrumente
Neue Burg, A–1010 Vienna, Heldenplatz
www.khm.at

BELGIUM

Muziekinstrumentenmuseum (MIM)
Hofberg 2
B–1000 Brussel
www.mim.fgov.be

DENMARK

Musikhistorisk Museum og Carl Claudius' Samling
Frederiksholms Kanal 12
DK 1220 Copenhagen K
www.natmus.dk

FINLAND

Sibeliusmuseum
Biskopsgatan 17
FIN–20500 Turku
www.abo.fi

FRANCE

Cité de la Musique
221 Avenue Jean Jaurès
75019 Paris
www.cite-musique.fr

GERMANY

Musikinstrumenten-Museum
Tiergartenstr. 1
10785 Berlin
www.sim.spk-berlin.de

Musikinstrumenten-Museum
University of Leipzig
Taubschenweg 26
04317 Leipzig

ITALY

Museo degli Strumenti Musicali
Via Ricasoli 58–60
50122 Firenze
www.polomuseale.firenze.it

Museo degli Strumenti Musicali
Castello Sforzesco
20121 Milano

JAPAN

Hamamatsu Museum of Musical Instruments
108–1, Itaya-machi, Hamamatsu-shi
430–7790 Shizuoka

THE NETHERLANDS

Gemeentemuseum Den Haag
PO Box 72
NL–2501 CB Den Haag
www.gemeentemuseum.nl

Nationaal Museum van Speelklok tot Pierement
Steenweg 6
3511 JP Utrecht
www.speelklok.nl

Ringve Museum
Lade Allé 60
N–7041 Trondheim
www.ringve.com

POLAND

Muzeum Instrumentów Muzycznych
Stary Rynek 45
61–772 Pozna
www.mnp.art.pl

PORTUGAL

Museu da Música
Estaçào do Metropolitano Alto dos Moinhos
Rua João de Freitas Branco
1500–359 Lisbon
www.museudamusica-ipmuseus.pt

RUSSIA

State Museum of Theatre and Music
6, Pl. Ostrovskogo
St. Petersburg 191011
www.theatremuseum.ru

SWEDEN

Musikmuseet
Sibyllegatan 2
Box 16326
103 26 Stockholm
www.stockholm.music.museum

SWITZERLAND

Historisches Museum Basel – Musikmuseum
Im Lohnhof 9 (Postadresse: Steinenberg 4)
CH–4051 Basel
www.musikmuseum.ch

UNITED KINGDOM

The Horniman Museum
100 London Road
London SE23 3PQ
www.horniman.ac.uk

Royal College of Music
Museum of Instruments
Prince Consort Road
London SW7 2BS
www.rcm.ac.uk

UNITED STATES OF AMERICA

Museum of Fine Arts
Avenue of the Arts
465 Huntington Avenue
Boston, Massachusetts 02115–5597
www.mfa.org

National Music Museum
The University of South Dakota
414 E. Clark Street
Vermillion, SD 57069
www.nmmusd.org